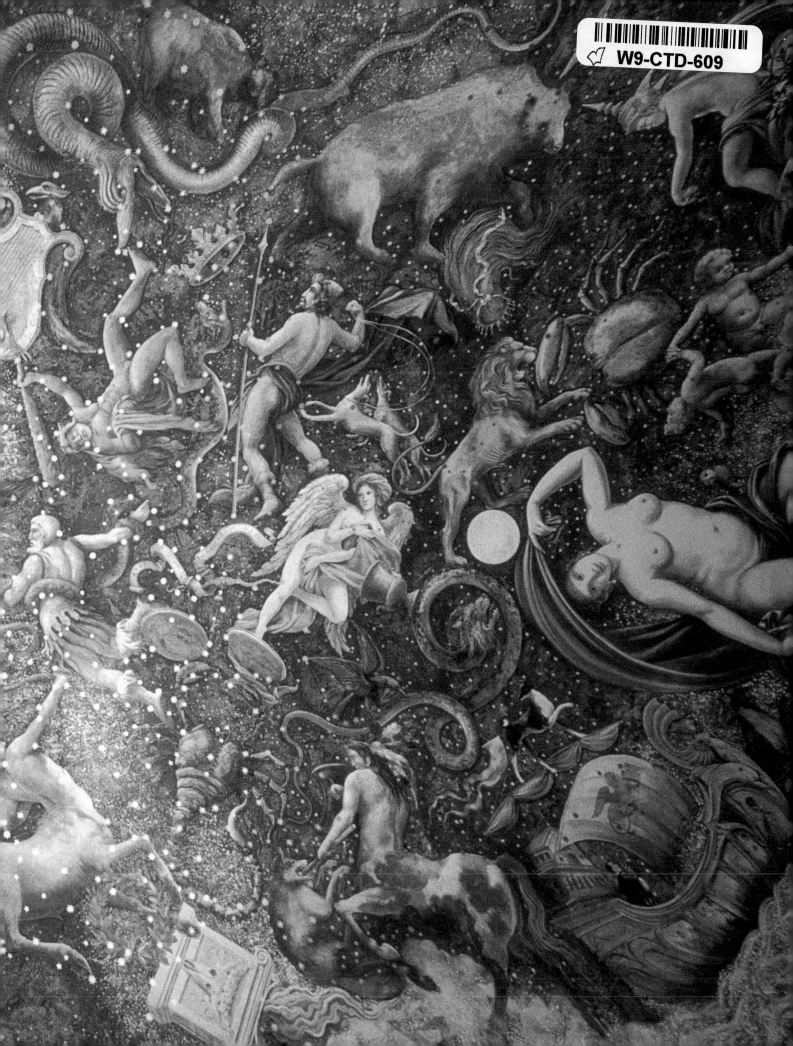

FESTA VENEZIANA A
CA'TOGA

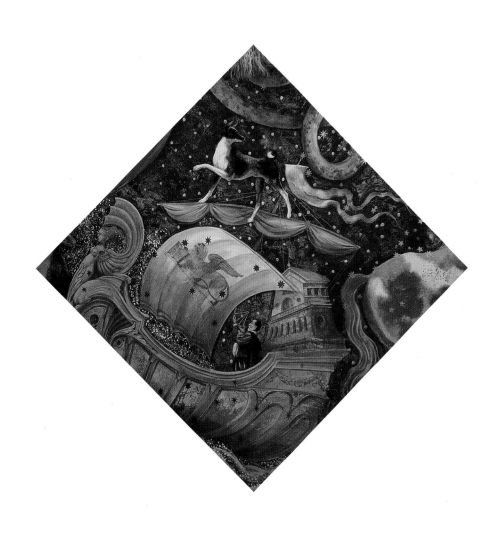

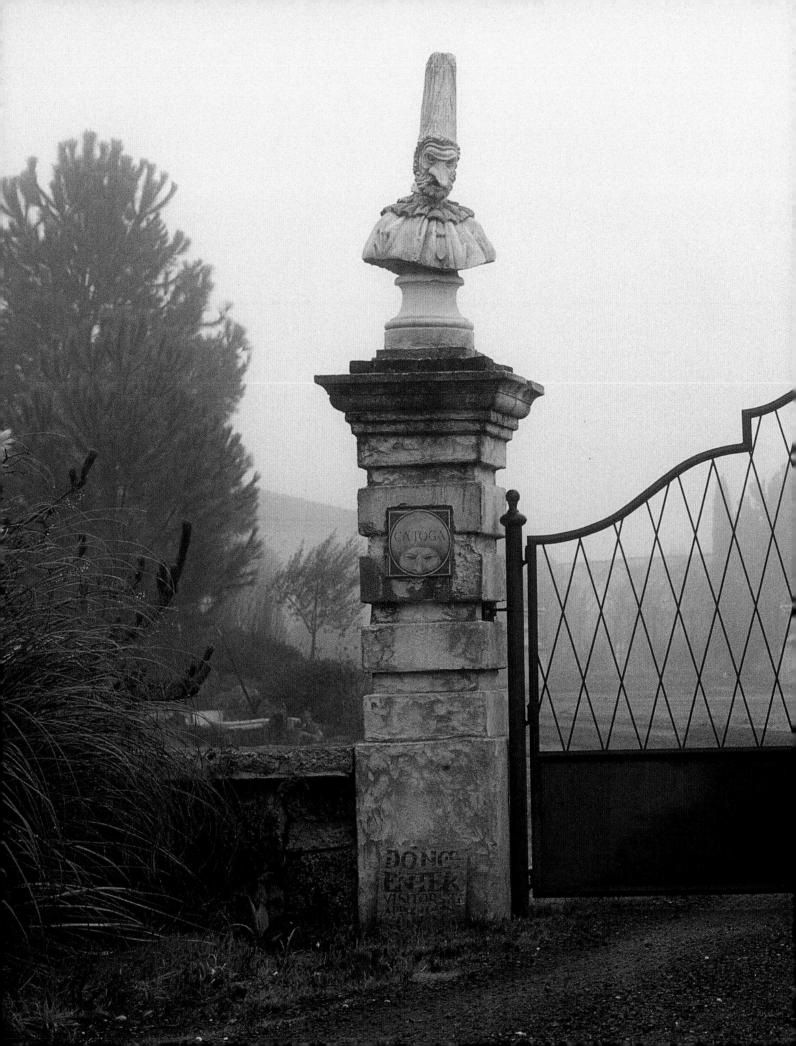

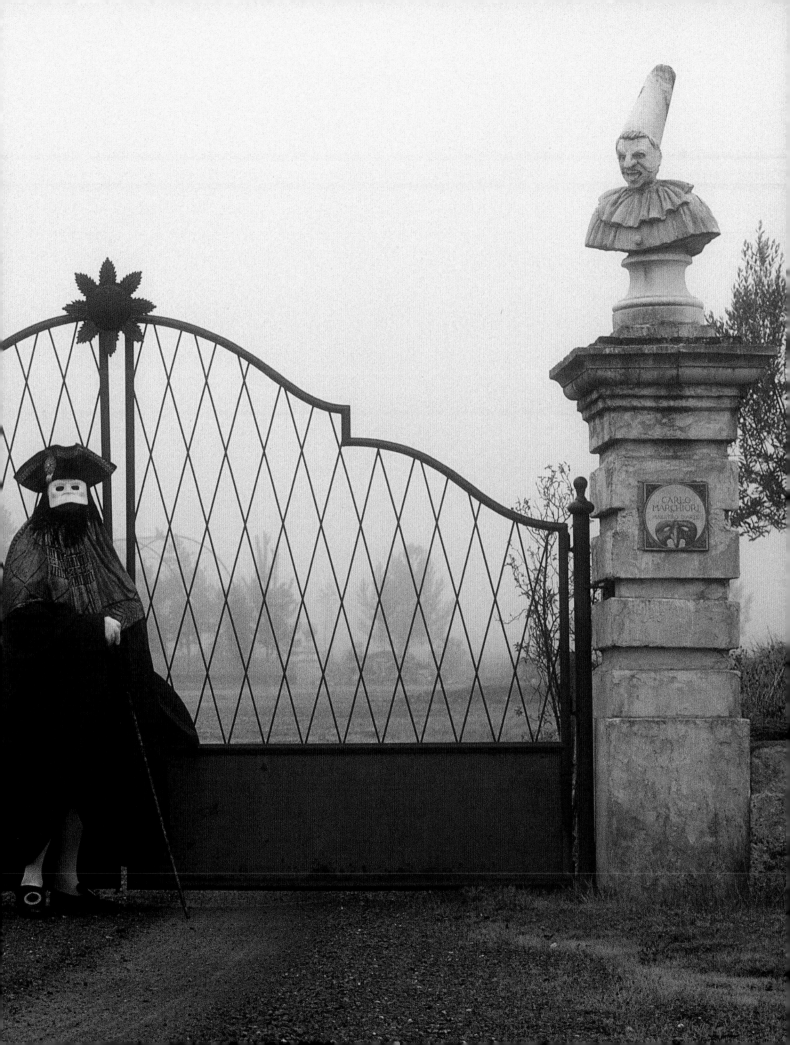

I have surprised a masked figure by the front gates of Ca'Toga.
My gardener waves, *"Bon dì, Sior Mascara! Riverisso!"* (Good day,
Gentleman Mask! I revere you!)—saluting respectfully as he

continues on his way to the Bassano market. Later, the figure reappears out of the winter fog by the front steps of the villa. Was that only last winter, or was it two centuries ago?

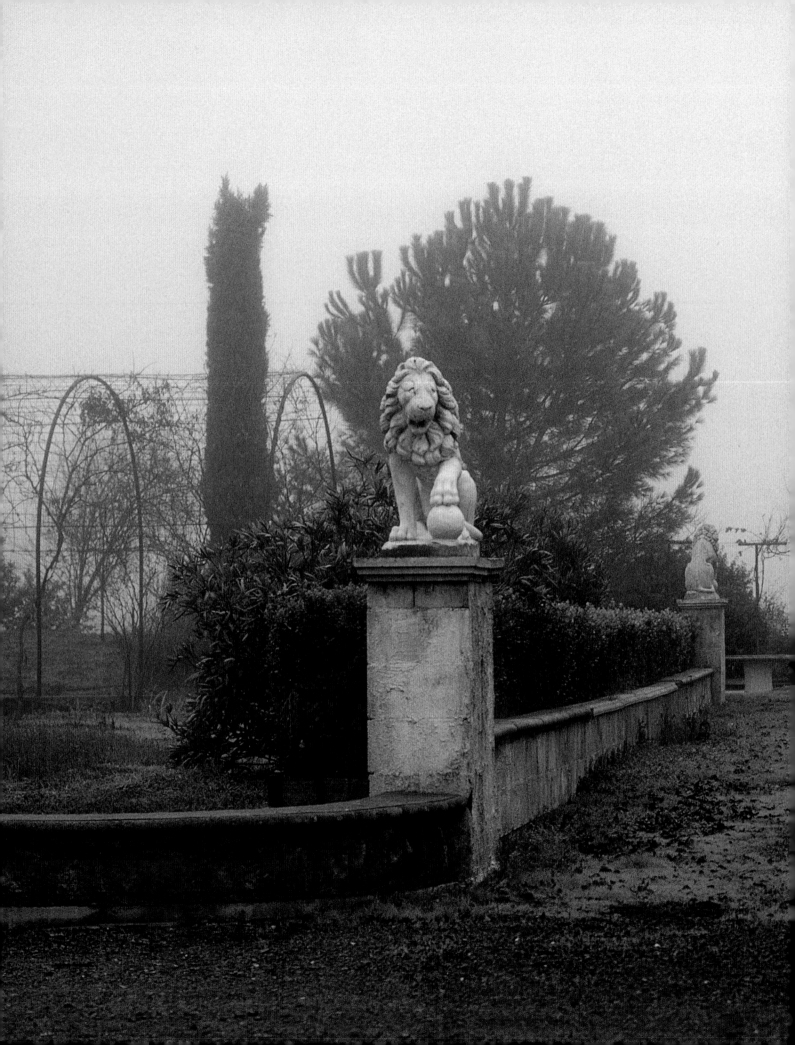

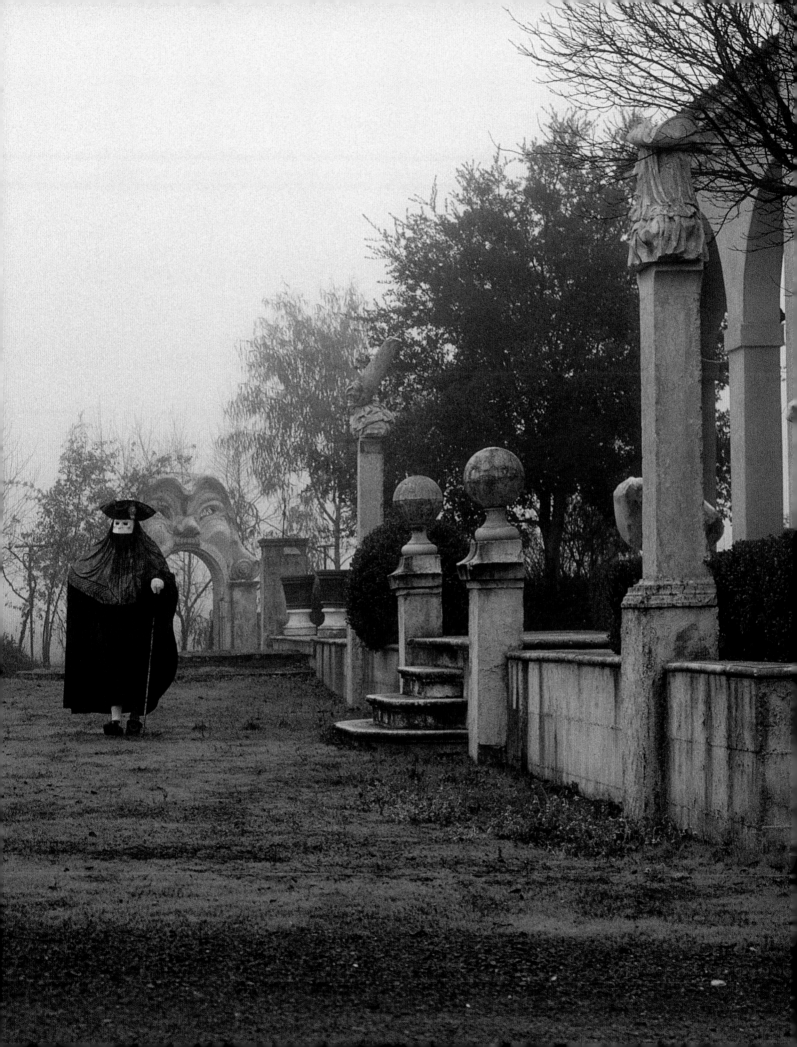

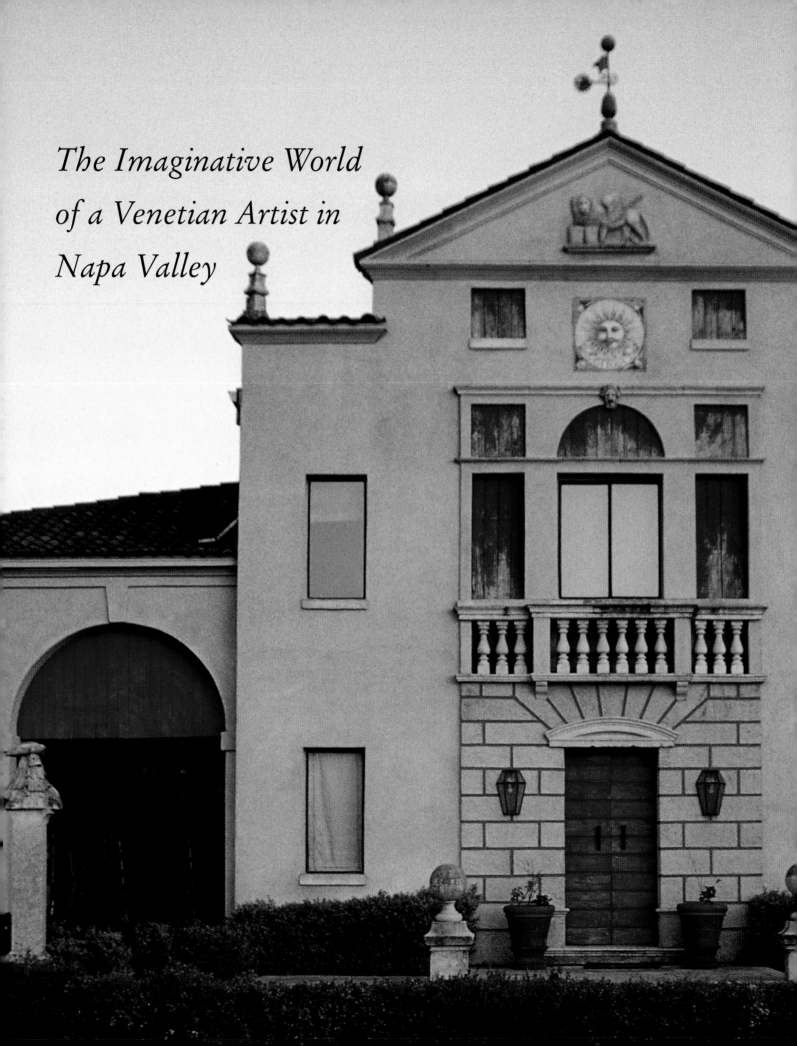

The Imaginative World of a Venetian Artist in Napa Valley

FESTA
VENEZIANA
A
CA'TOGA

CARLO MARCHIORI

TEN SPEED PRESS
Berkeley / Toronto

Ten Speed Press
Box 7123
Berkeley, California 94707
www.tenspeed.com

Distributed in Australia by Simon & Schuster Australia, in Canada by
Ten Speed Press Canada, in New Zealand by Southern Publishers Group,
in South Africa by Real Books, in Southeast Asia by Berkeley Books, and
in the United Kingdom and Europe by Airlift Book Company.

Cover and text design by Nancy Austin

Library of Congress Cataloging-in-Publication Data on file with the publisher.

Printed in Singapore
First printing, 2002

1 2 3 4 5 6 7 8 9 10 – 06 05 04 03 02

Photo Credits appear on page 188.

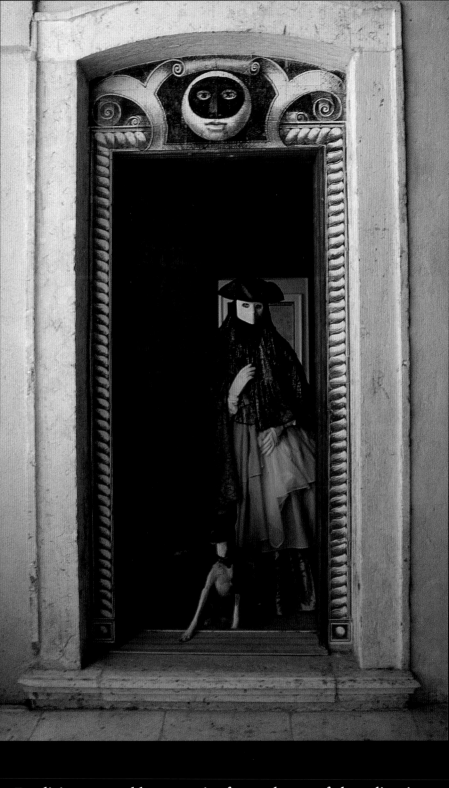

Realities created by art arise from the careful application of illusion. When does illusion become reality, and reality an illusion?

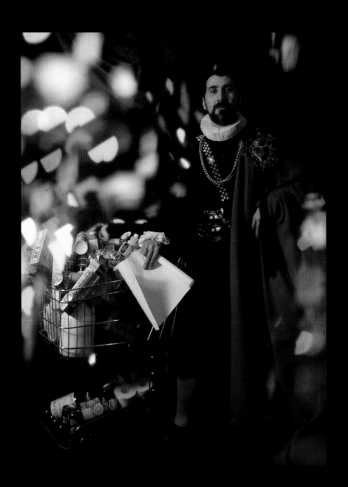

I think of the Past and the Future as two mirrors, between which I stand, precariously balanced on Now . . . an ephemeral state that in another second will already have turned into Then. Now demands constant attention, commits me to immediate concerns. Now keeps me on my toes. If I were a gambler, an adventurer, a warrior, I would go to the mirror of the Future and await my fortune. But the Past seduced me long ago. I've been comfortable in that mirror warp ever since I can remember. My education consists in art history. Art is a recorded song, a carved stone fragment, or a poem in hieroglyphics, and remains the enduring oracle of a past that has never left me. Growing up in Italy, one simply surrenders to the past. Silent monuments, statues everywhere, all of them presenting a riddle or whispering tales.

Venice is a city lost in time. There, the automobile got declared *machina non grata*, and the city has always gone on, a conceited narcissist, seduced by her own water reflections. When I remember Venice, my mind races backwards. I walk the narrow *calle*, turning into a *campiello* where the clock has stopped sometime in the eighteenth century. The girls at the fruit stand are wearing *zendal*, the vendor dons a three-

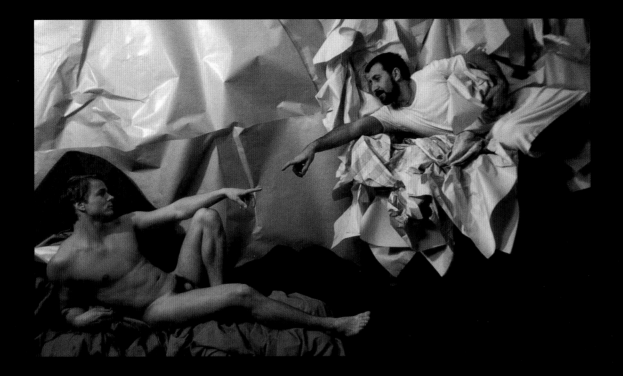

cornered hat. In the courtyard of a *palazzo*, I witness an invisible ceremony of Venetian gallantries. I don't look for Harry's Bar to keep up with the Now jet-setters. Instead, I keep wandering about, lost, looking for the *Ridotto a San Moisè*, or the convent where Guardi painted the *Parlatorio delle Monache*. I speculate where Giandomenico Tiepolo peeped at the *Mondo Novo* in dioramas at the Carnival fairs.

Any intriguing *calle* invariably ends up at the water. I can wait for the gondola to ferry me back to reality. Instead it takes me into the labyrinth of narrow canals. From upper windows and balconies, laughter resonates with echoes of *Carnevale*, when masks were another device to evade the moment. But I cannot evade the echoes of Venice. They followed me here to this faraway refuge of Northern California.

Once hooked on the past, I almost forget how or when I arrived here. I feel a guilty irresponsibility, indulging in this romantic sentimentalism. To look back is a reticence to look forward, and I have to strain myself to keep an eye on the road of time. The road has stopped here at these five acres. Sober deductions tell me that fifteen years must have sneaked by since. What am I doing in this blessed Napa landscape? I have created a sanctuary to escape the hyped American high-speed computer, forever devouring its future. Fifteen years have been taken in embroidering the illusion of a Palladian villa, room after room filled with dedicated labor, full of votive candles to our Lady of Mannerism and San Barocco, my patron saint.

Locked in these rooms, I have pretended to live, think, and paint as if it were hundreds of years ago. Ancient music and old books with chronicles of long-gone heroes keep me company. From the pages of art books, a parade of past wonders and luminous personages streams along. All the great masters are my teachers, so at times I cannot help but interpret them in hot flashes of inspiration. Titian, Michelangelo. My identification results only in quickly improvised tableaux recorded in a snapshot.

In the *brolo* and gardens, nature consoles the homesick monuments I have smuggled in, seized by my greedy imagination and pillaged from the decrepit culture of the Old World, the Old World I had abandoned at the smart-aleck age of eighteen, back in the 1950s, with who knows what dreams in my terrified heart. I had made the fatal move to challenge a North American Future. In the mirror of the Past, I remember the ocean liner *Saturnia* approaching the bleak shores of Nova Scotia, where I got dumped off at the port of Halifax with a band of immigrants in 1956.

First in Canada, later in Japan and the United States, I faced some tough times, mumbling broken English at first, and working in a dog-food plant. But I clung to my art, my crafts, my most valid and vital form of expression. To guarantee myself a secure independence, I always worked, striving to advance from the privations and miserable memories of wartime. Commercial art appealed to me as a realistic approach to security. The prospect of a future in fine arts, art for art's sake, never convinced me on the economic level. I am proud of the work I had to do for a living, all done with passion and enjoyment, even if, toward the end of my career, commercial art deluded me a little. Magazine illustrations, television cartoon commercials, window displays—art at the service of mass production. My efforts were going into precious wrapping paper to promote the sales marketing packages, all gone to the dumps through the black hole of consumerism. Disposable art? Should I instead engrave my dreams on a block of stone-finished cement? "Why not?" approved Giambattista Tiepolo the other day. "There is nothing wrong with a little self-glorification."

I have taken to talking and listening to the wisdom of my ancient compatriots who now come frequently into my stark white canvases, helping me in the background composition, always with a good hint for reinterpreting my past. Just the other night, the painter Veronese, Pantalone, Rosalba Carriera, and Antonio Vivaldi came for dinner and *quatro ciacole* (gossip). It's like I never left my Veneto. I hear steps on the gravel path and a knock on the door. *"Chi xe?"* (Who is there?) I open to Giacomo Casanova, escorting two ladies in *bauta* all done up in Carnival finery. *"La riverisso, Sior Giacometo. Siore Mascare lustrissime, le vegna avanti."* (I revere you, Signor Giacomo. Illustrious Lady Masks, do come in.)

"Schiavo vostro, Sior Carlo." (I am your slave, Signor Carlo.)

And the Past comes out of the mirror right through my front door.

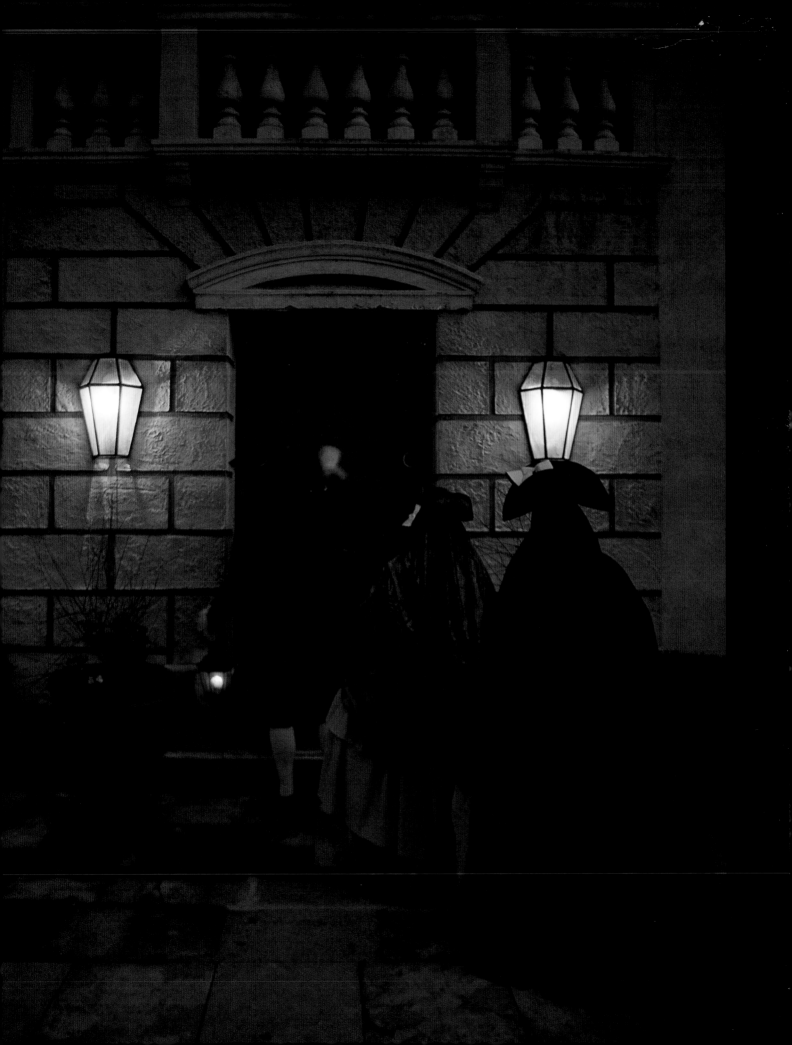

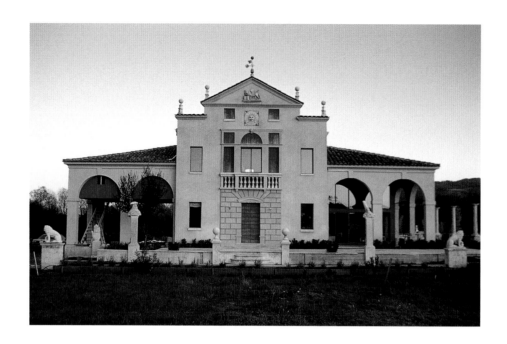

Summer California skies are Technicolor blue, a fierce blue that turns the façade of Ca'Toga into a cutout, making it appear like a flat in a movie set. In the dreamy fog of winter, Ca'Toga looks authentic. You'd swear you were in the Veneto. But I love summers: that is why I am here, after years in Canada and many foggy summers in San Francisco.

I created this Ca'Toga illusion with much hard work and pleasure, even if the bright light exposes my futile attempt at grandeur. Pitiless sunshine gives me away, revealing my fraud, my stucco-over-two-by-four framing, my stone-finished cement ruins, and my house paint frescoes. Maybe I should have imported a dismantled antique villa from the Veneto, each stone numbered. Too late. Done it is. I've planted palm trees in Antarctica!

I shrug off my academic qualms, and at sundown, a glass of California wine reassures me that Ca'Toga is after all real. Another glass declares it as back to the eighteenth century. Amazing power for a relatively new vintage wine. Well—*ciao*, visitor. Welcome to Ca'Toga. Sip some wine with me, and let's toast to my most serene—*serenissima*—California.

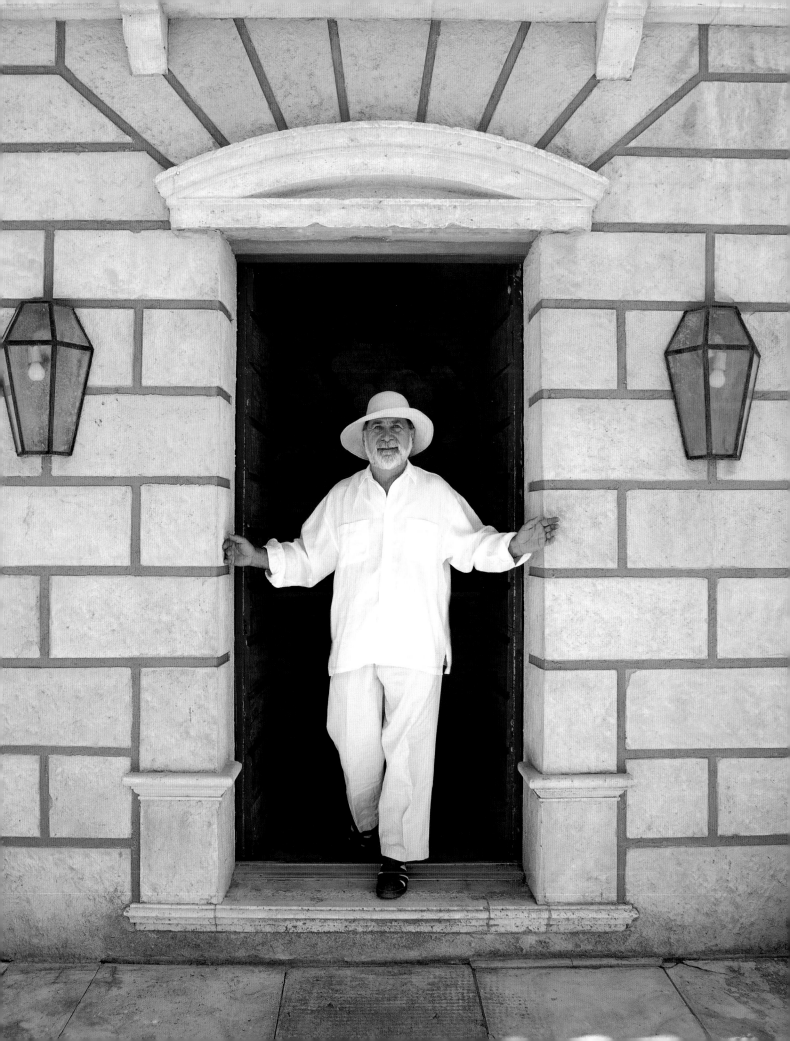

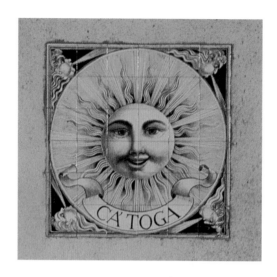

People all over the world utter the name "California" with awe, for the sublime oasis they believe it to be. By luck, I literally stumbled onto my own California retreat, this fabulous five acres tucked away in a small town in the northernmost end of the Napa Valley. I arrived on this spot in the early 1980s, spellbound ever since by the rim of lush hills to the west that melds into the Palisades Range off to the northeast, and by a neighboring geyser that salutes me constantly with a cheerful plume. This was the port I had longed for and had reached with immense relief after years of world peregrinations. It may be a patch of sticky black clay, but I kiss the ground, and I love it here.

Once I had acquired the land, the desire to build overtook my soul and my senses. I envisioned a house in harmony with the hills, shaped by memories of my old country, my culture, and the Past. First thing, though, in the entrance hall, I decided to dedicate a propitiatory shrine to the local deity, a fresco painting of the "geyser god," a Titan spouting skyward against a backdrop that mirrors Mt. St. Helena, my beautiful mountain next door.

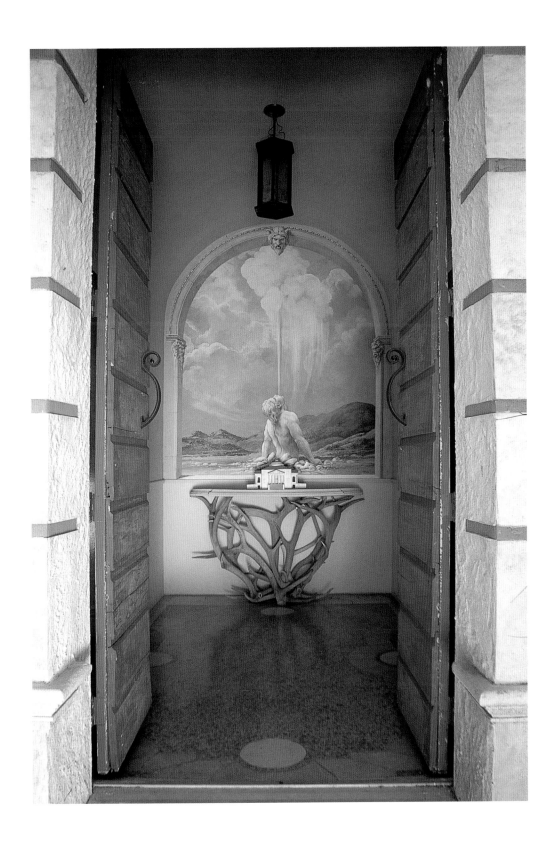

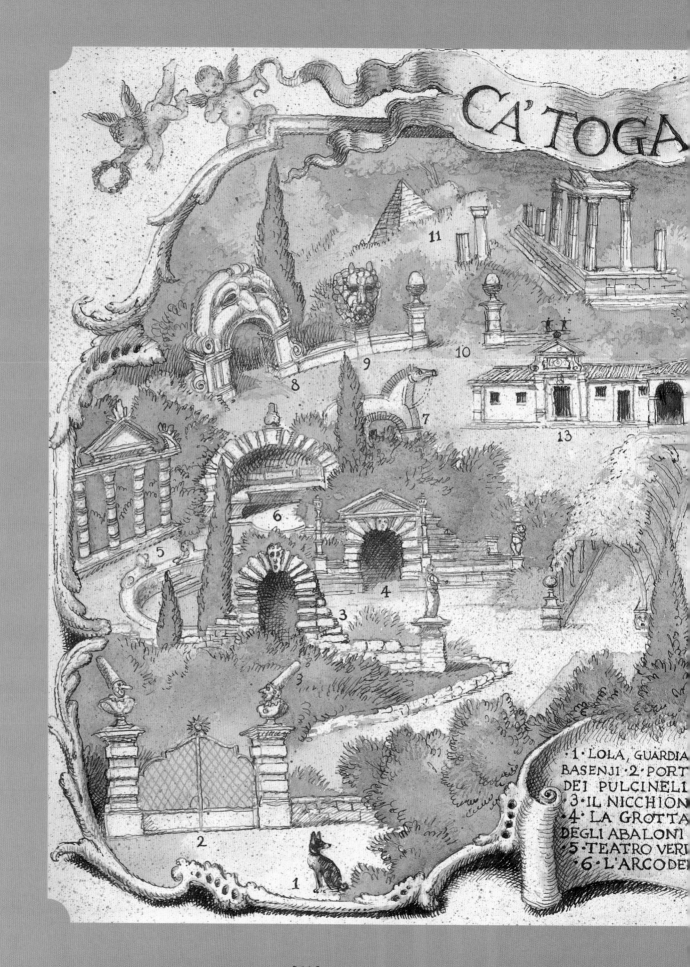

CA'TOGA

1 · LOLA, GUARDIA
BASENJI · 2 · PORT
DEI PULCINELI
· 3 · IL NICCHION
· 4 · LA GROTTA
DEGLI ABALONI
5 · TEATRO VER
· 6 · L'ARCO DE

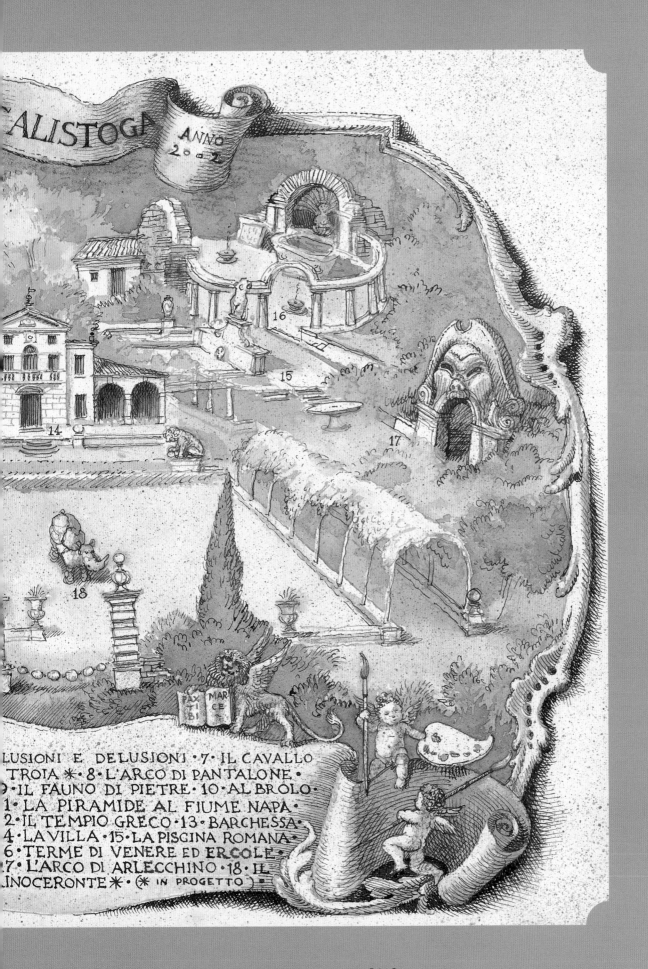

ALISTOGA

ANNO
2002

16

15

17

14

18

LUSIONI E DELUSIONI · 7 · IL CAVALLO
TROIA ✱ · 8 · L'ARCO DI PANTALONE ·
9 · IL FAUNO DI PIETRE · 10 · AL BROLO ·
11 · LA PIRAMIDE AL FIUME NAPA ·
12 · IL TEMPIO GRECO · 13 · BARCHESSA ·
14 · LA VILLA · 15 · LA PISCINA ROMANA ·
16 · TERME DI VENERE ED ERCOLE ·
17 · L'ARCO DI ARLECCHINO · 18 · IL
RINOCERONTE ✱ · (✱ IN PROGETTO)

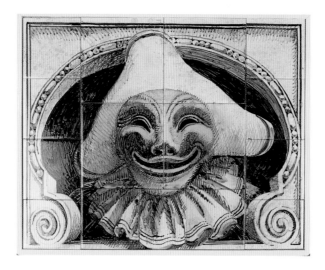

The villas in the Veneto shine with the unpretentious splendor that Andrea Palladio idealized when he married a palace to the countryside. In his schema, symmetry reassures with the simplicity of the façade, all in harmony with nature, with echoes of pagan nostalgia. The villa was a haven, a shelter for the humanist, where his mind turned to classical ideals and visions of pastoral serenity. It was inevitable for me: It had to be a Palladian villa—all space, proportions, balance.

Creative enthusiasm set me on the path to reconsider and re-create a world I had overlooked when I was young. In a prodigal return to my roots, I had a vision of classical architecture and frescoed interiors, tinged with a bit of apprehension at tackling such an enormous project. The architectural plans came with the help of Paul Bonacci and Lucy Schlaffer, who had just returned from an Italian vacation around Asolo and Venice. They dared me to hew to the grand and high scale, respecting that I was possessed by a major personal inspiration, and were cooperative and considerate when my inevitable *improvvisato finale* occurred. In this way, the villa evolved.

The floor had to be polished terrazzo. That is absolutely Venetian. Through painted Palladian door frames flanked by *bricole* (gondola mooring poles), I could not resist the desire to see playful vistas in the painted cabinet and the view of the Campanile, or *El Paron de Casa,* "The Master of the House," as it is called by the Venetians.

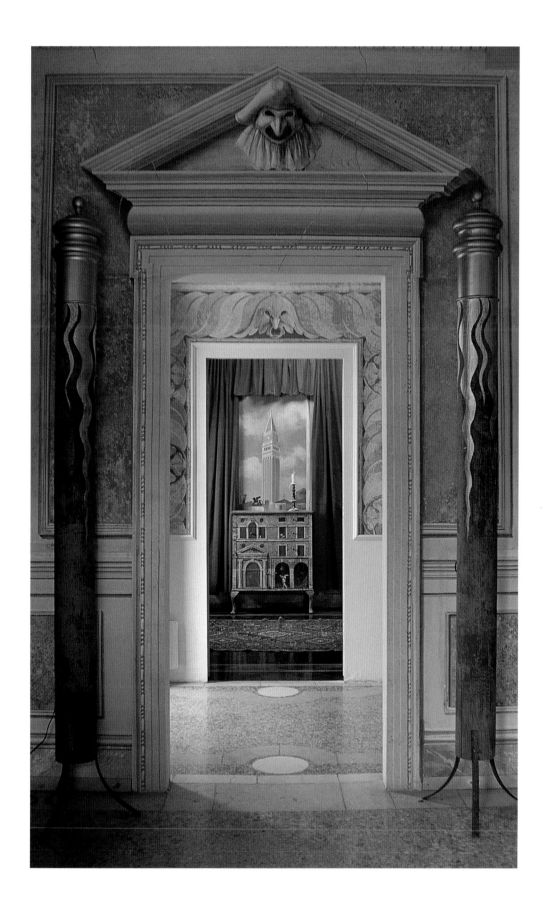

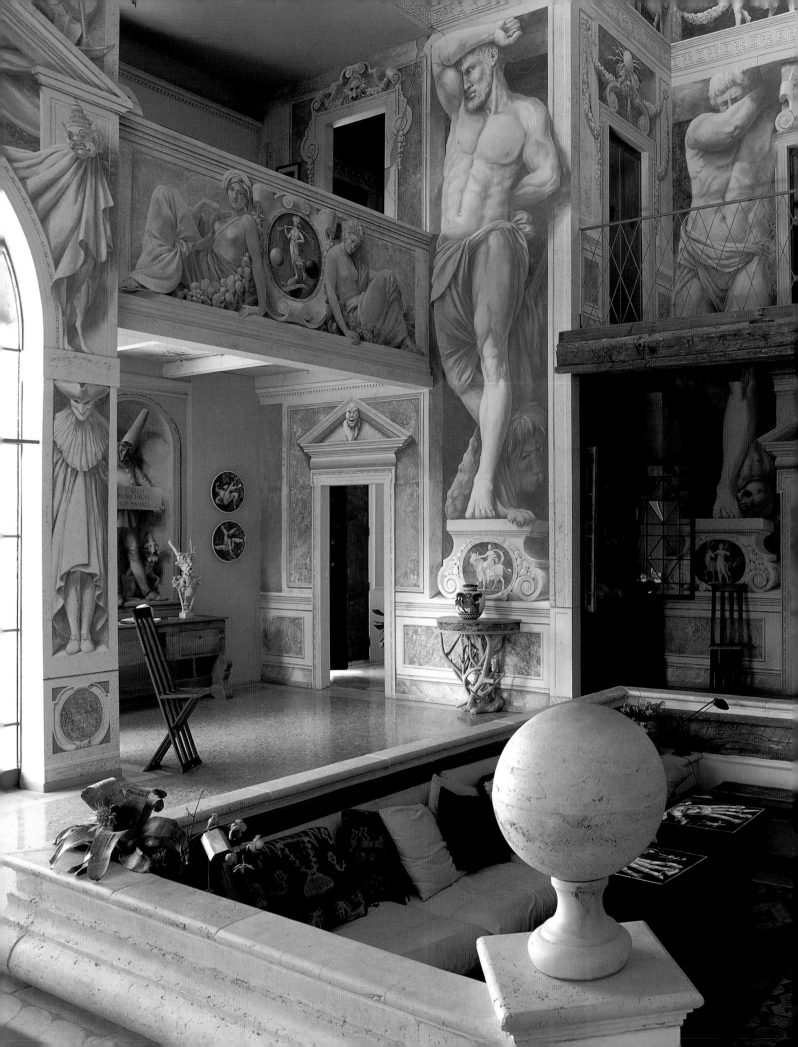

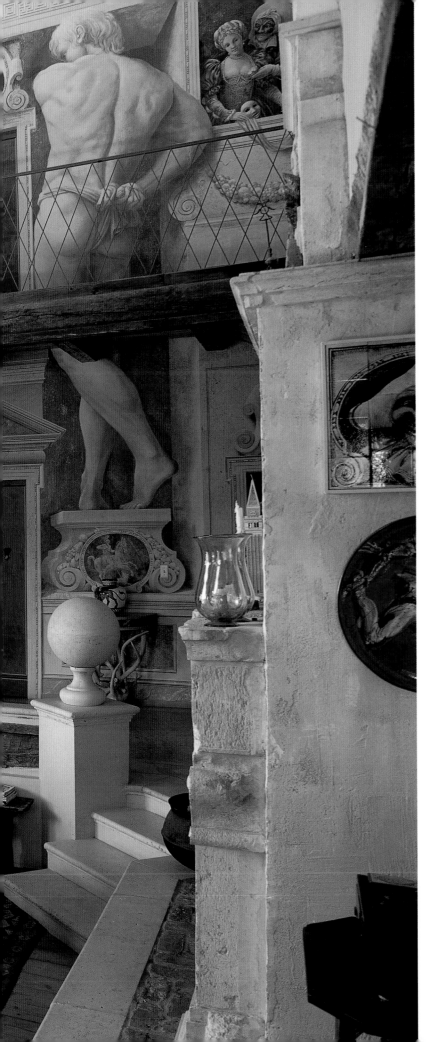

Space was made for Hercules to hold up the ceiling cornice, helped by his best supporting Titans. Rustic ancient beams from Spain had a desecrating impact on the sixteenth-century trompe l'oeil order of formal *inquadrature* (framing), as if during some improbable history of the villa, Philistine farmers had hacked it into condominiums. *Il sacro e il profanato,* the sacred and the desecrated.

The complex fresco decoration in the *salone* was done on sections of canvas, the large pieces made on my studio floor, the smaller ones on worktables. The seams run along vertical elements of the pictorial scheme; heavy-duty adhesive secured the canvas to the wall like wallpaper. I used regular flat latex house paint, keeping to a range of natural earth tones. The final effect is virtual fresco.

The subjects in the murals are in the inevitable Venetian repertoire that I love and repeat again and again, over and over. The only saving note, possibly, is that I work in a flash, quickly and spontaneously. I refrain from overpolishing a painting with a zeal for perfection of technique or a super-detailed rendition. The best jokes are told in a few words, so I rush around the subject in order not to sentimentalize, and in the end *how* I painted remains more interesting than *what* I painted. Major cracks and fallen chunks of plaster are deliberately introduced in order to desecrate the pomposity of the melodramatic themes. The whole setting is mixed profusely with the mythological, allegorical, and theatrical relief of the *commedia dell' arte.*

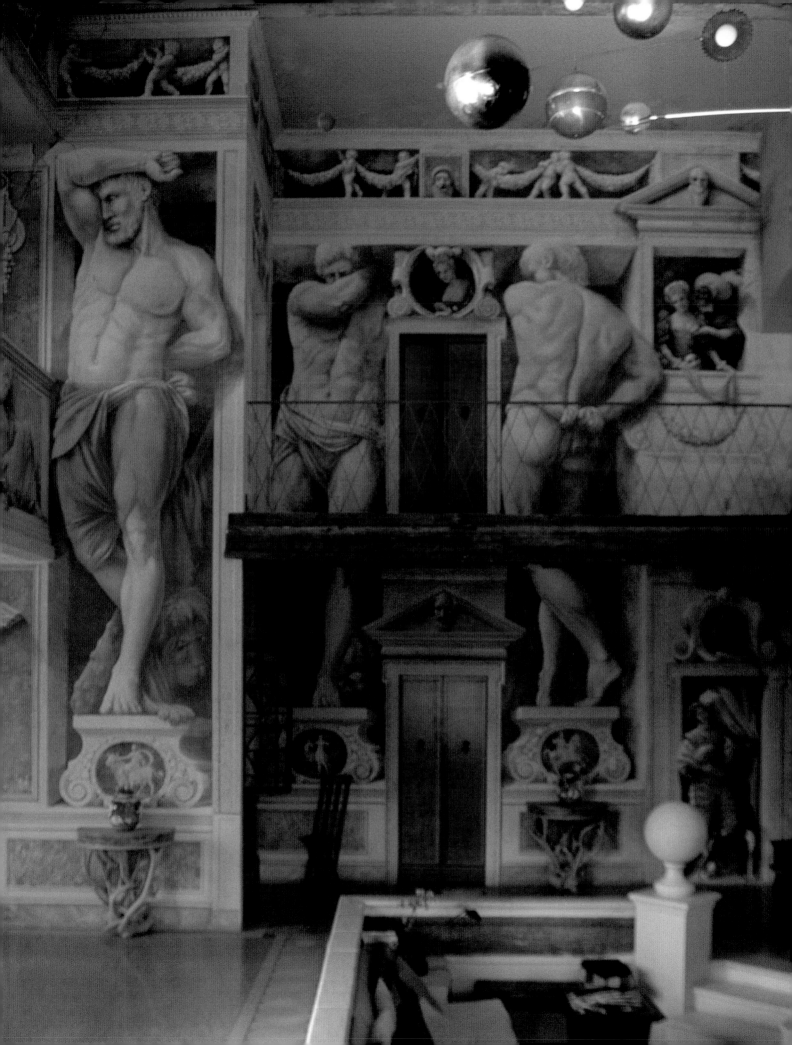

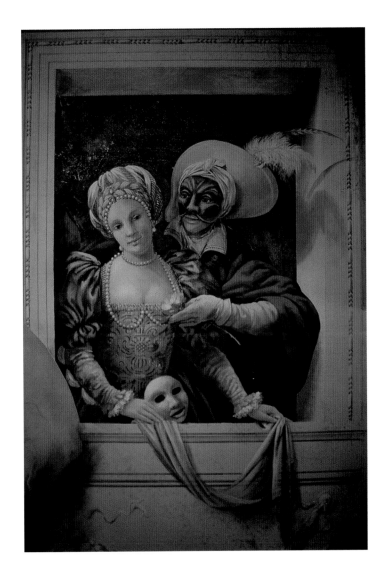

Above, the *zanni* Arlecchino presents his *innamorata* with a rose. The *commedia dell' arte* troupes would bill the standard roles of the lovers as *Innamorati,* the first lady as *Prima Donna,* and the first and second clowns as *Primo e Secondo Zanni.* The English word *zany* comes from the Italian *zanni.*

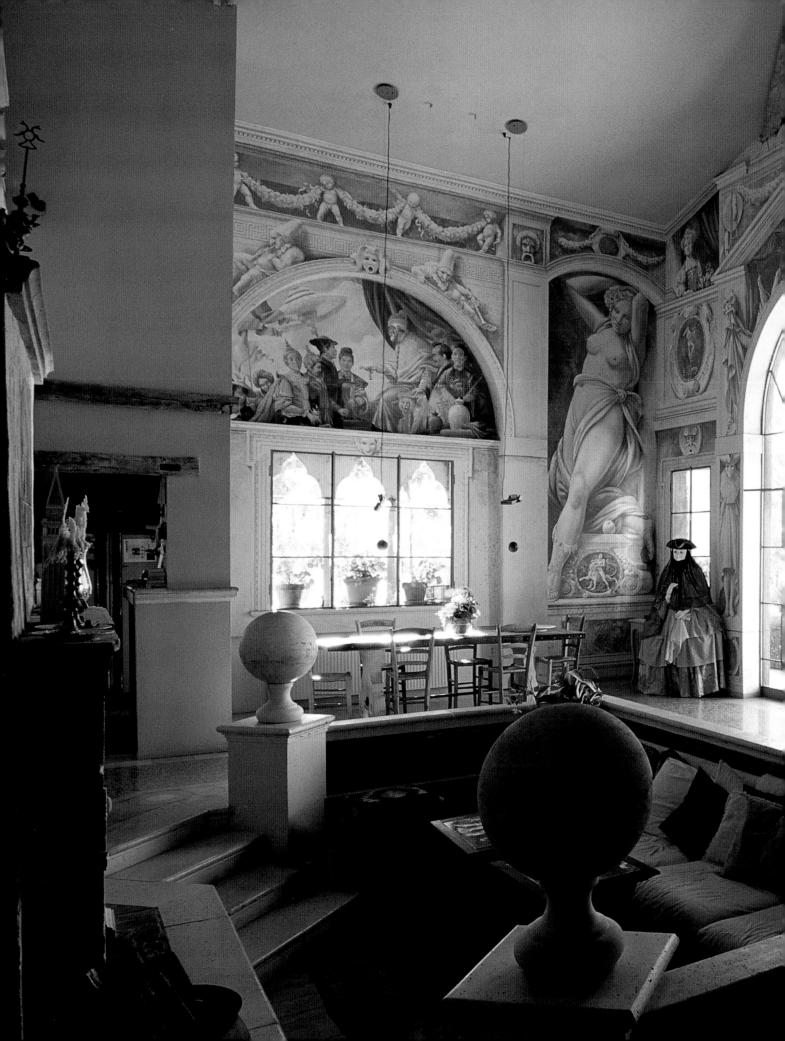

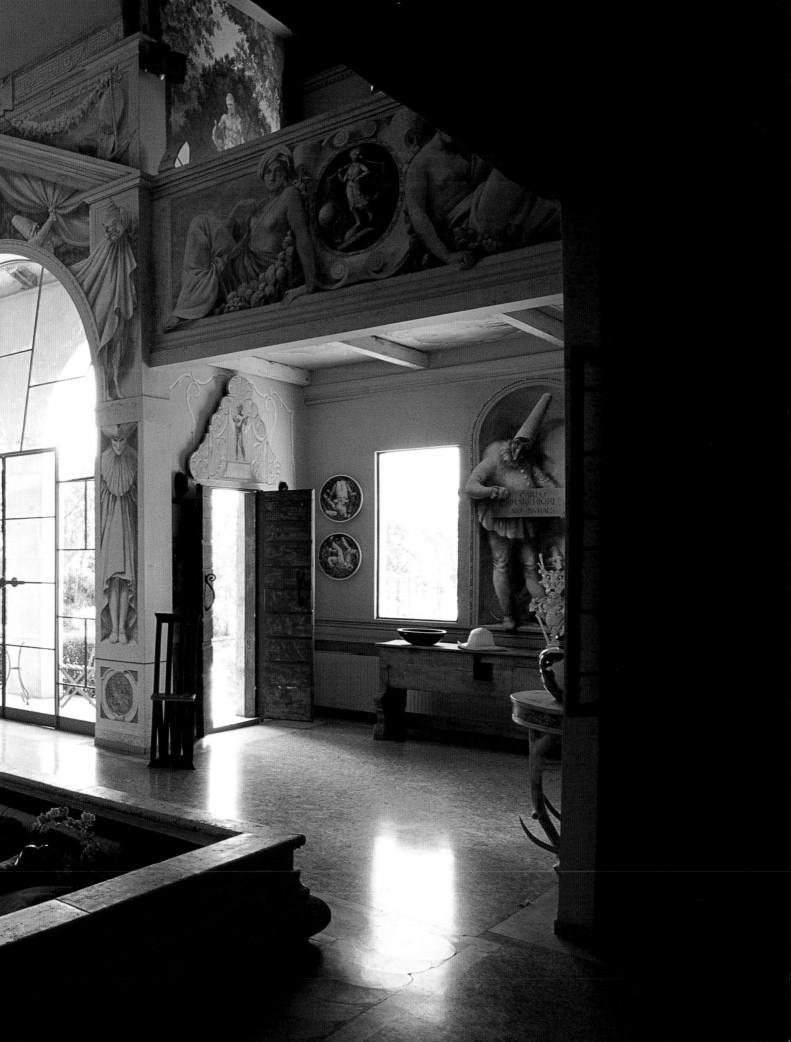

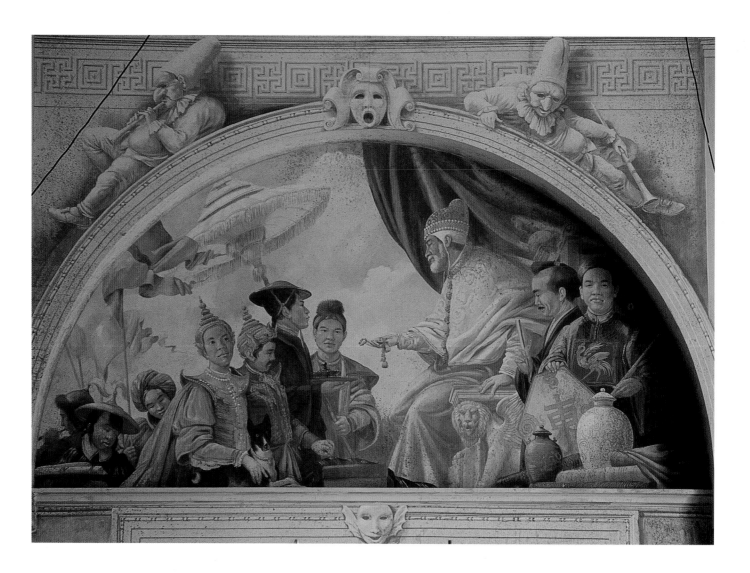

In Palladian villas such as the Villa Barbaro at Maser, fresco decoration invariably presented themes that glorified historic events in the family or portrayed illustrious family members for posterity. On the right, my friend Sam Nakamura and the *basenji* Togo I seem to return from a basketball game. And in the lunette above, I dare to impersonate a doge receiving various ambassadors from Asia. Holding the dog Togo II, my partner Tony Banthutham represents his native country of Thailand.

In 1905, Admiral Heihachiro Togo of Japan defeated the Russian fleet at the Battle of Tsushima. This victory much impressed the Venetians, and the word *Togo* became part of their dialect, a synonym for a smart guy, a winner, someone who is capable and with it. *Ca'* is short for *casa,* meaning "house," and *Togo* is spelled with an *a* to match the feminine *casa.* Stick the two together, and they become Ca'Toga, the name I have bestowed on my villa. Take three of the middle letters out of *Calistoga,* and you get Ca'Toga again, a tribute to the town in which the villa is situated.

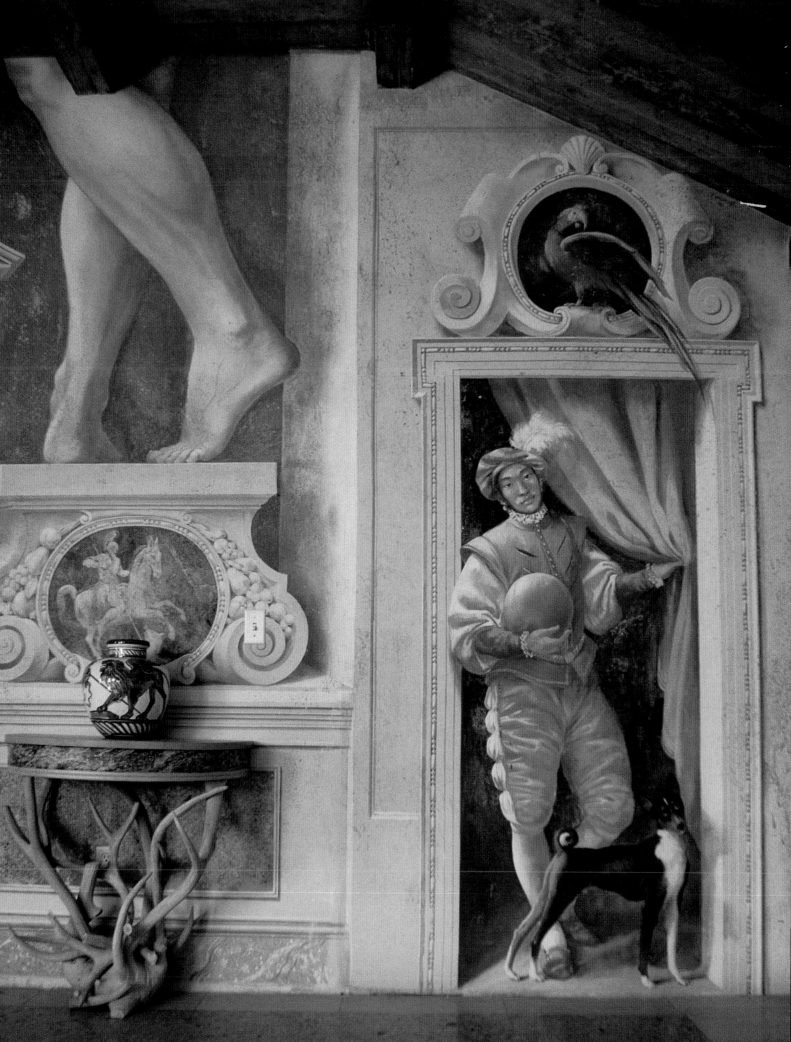

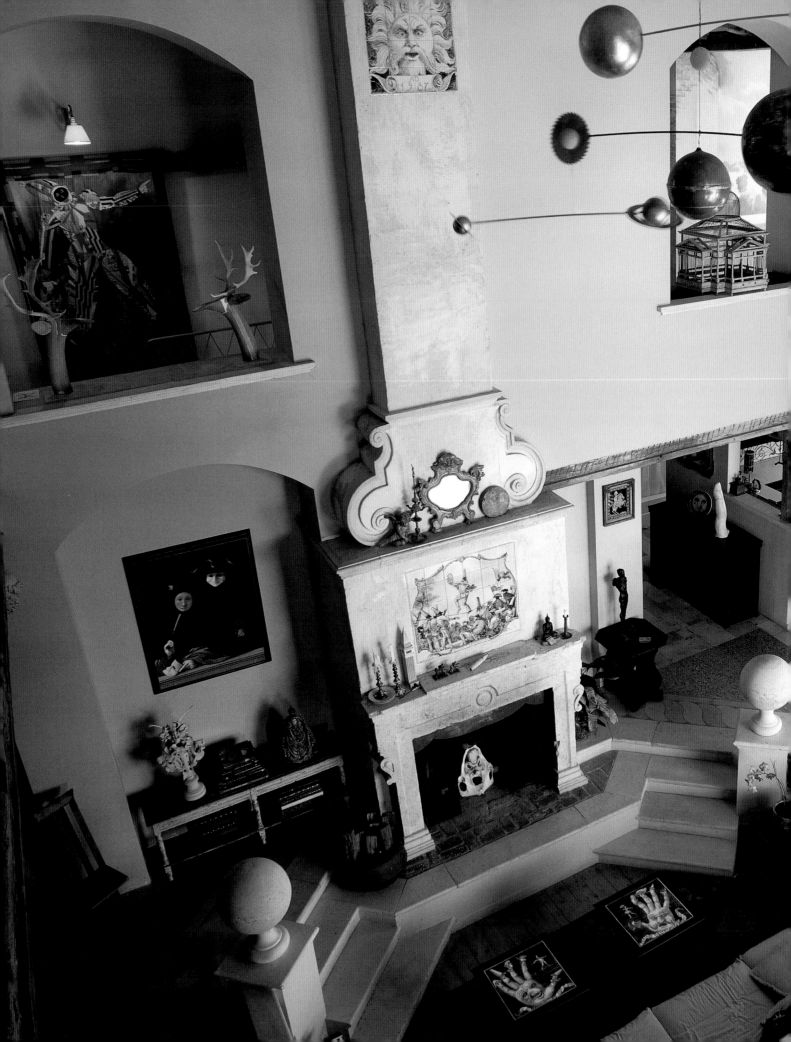

Smack in the middle of the *salone,* with apologies to Palladio, a very Now California conversation pit was dug to stay. It faces a *cinquecento*-like fireplace whose mantel is made from the posts and lintels of a stone doorway from a wrecking yard in Lisbon. The fireplace top trim, the steps, all the finials, and the sides of the pit were molded in stone-finished cement, easily promoted to real stone by a good glass of wine. In the open ceiling space hangs an improvised "Copernican" mobile that I managed to assemble out of balls, globes, and other asteroid-like objects. A happier choice than the cliché grand chandelier.

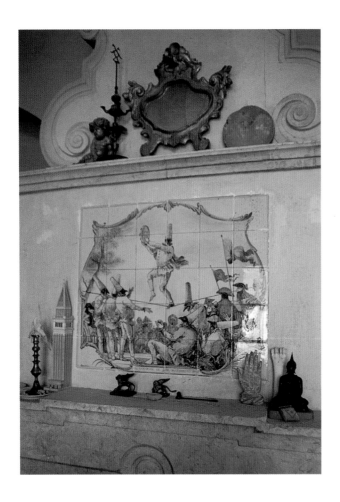 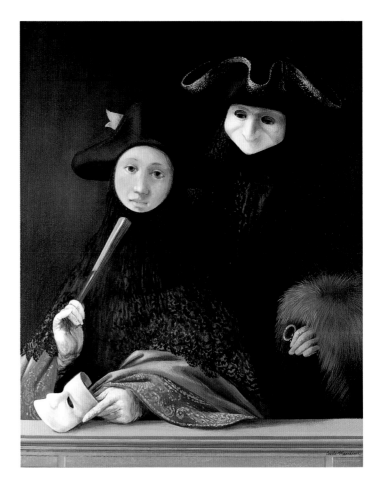

The tapestry on the right was a new experience in zigzag stitching on a super-speed electric sewing machine. Bright bits of vintage Japanese fabric were a motivation to assemble this figure of a *zanni,* or clown, from the *commedia dell' arte.*

More *zanni* or Pulcinella frolic at Carnival on the ceramic tile panel above the fireplace. This panel is a tribute to Giandomenico Tiepolo, the son, while a work from Giambattista Tiepolo, the father, was the inspiration for *Bauta at the Theater Box,* the painting next to it.

In Venice, the *bauta* was customary attire for the Carnival, and also a kind of uniform for freedom through anonymity. It covered the head with a hood or cape falling over the shoulders. The face was hidden by a wide half-mask called *volto* or *larva.* The three-cornered hat would complete the elegant if a bit spooky attire.

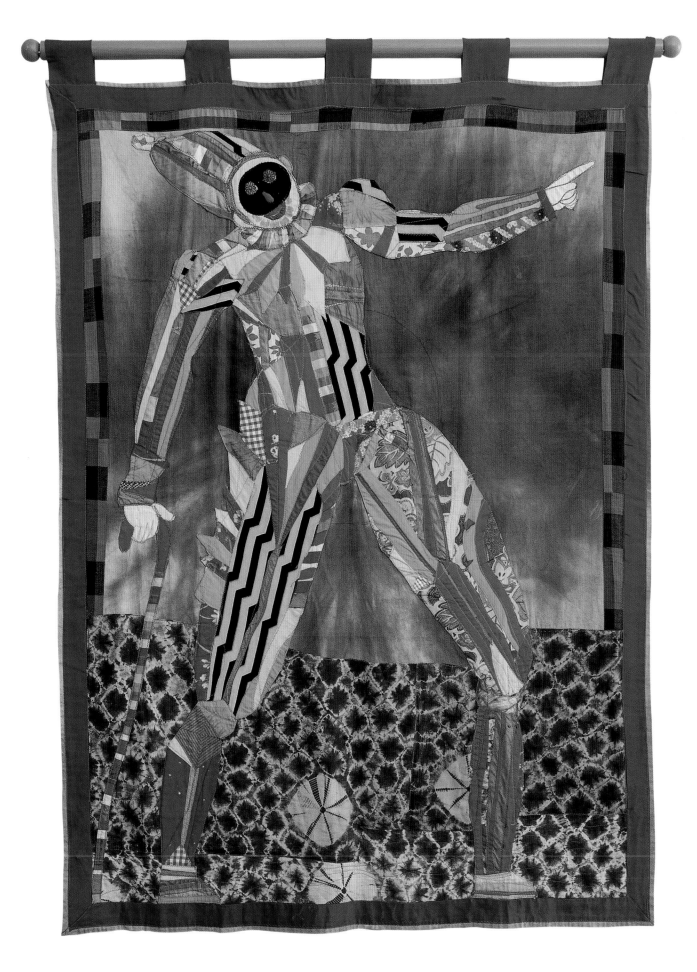

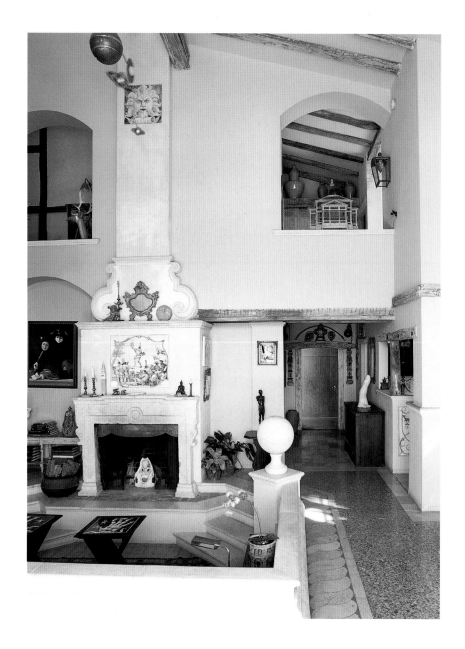

The old Spanish beams are a cosmetic device, a false ceiling to conceal the new construction lumber above it. The floor appears rustic next to the terrazzo of the *salone*. It is made with tinted cement pavers, polished smooth by a grinding machine. Japanese *tansu* pieces fit well as kitchen cupboards and as furniture here and throughout the house. A moderate sprinkling of antique furniture from Italy and Portugal helps maintain the illusion of remoteness in time.

On the right, a pass-through opens the kitchen up to the living room, just like in today's trendy restaurants, so that communication with guests flows as I stir the risotto. Still, guests are not always happy with this limited participation. They usually end up invading the kitchen anyway, oblivious to the index finger of a Roman emperor pointing them to other interests, more visual than gustatory.

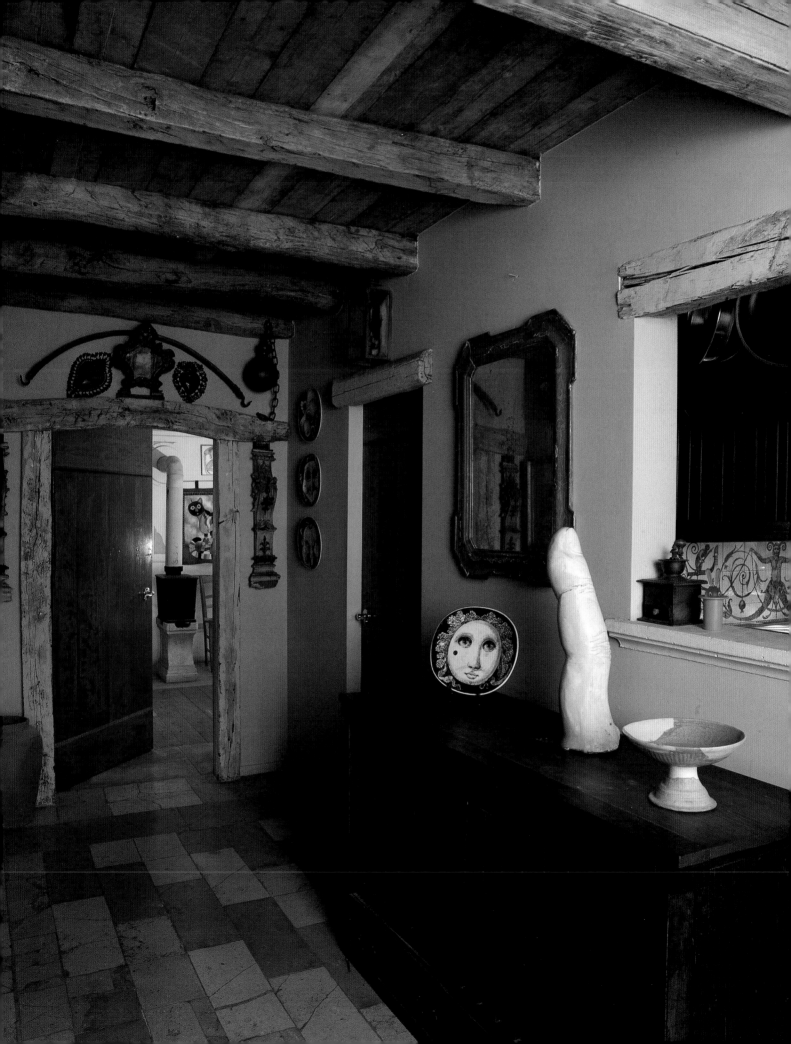

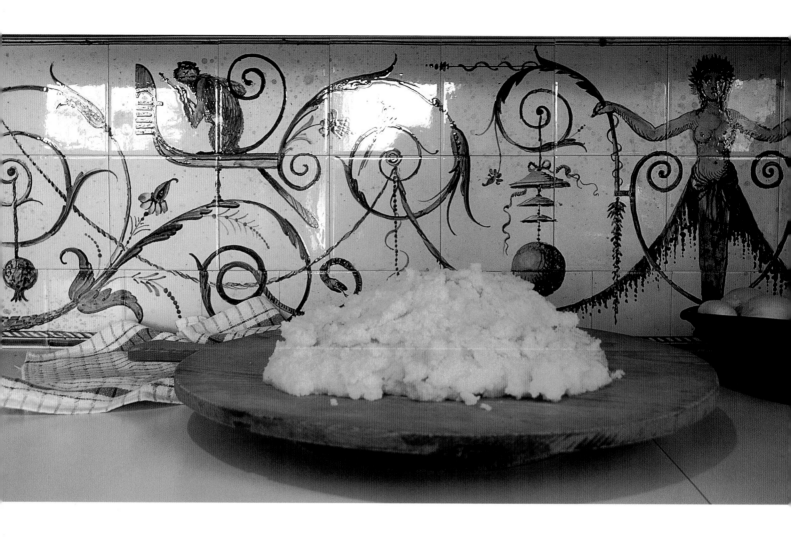

"Oh, if only the ocean were gravy, and the mountains were made of polenta," goes an old Venetian folksong, humming the love affair Venetians have had for this plain cornmeal dish ever since Columbus brought corn back from America. Venetians are nicknamed *polentoni* (polenta-stuffed) after this food that is so like them—plain, solid, mellow, and jovial.

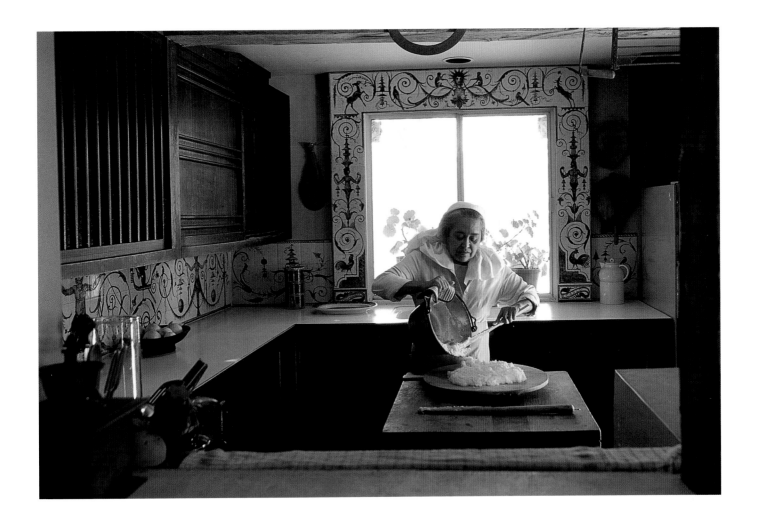

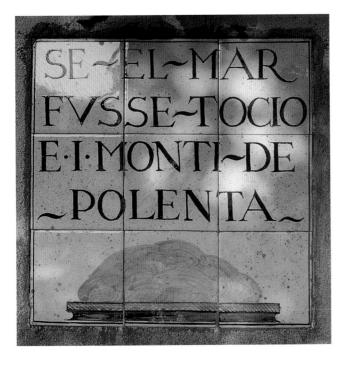

SE ~ EL ~ MAR
FVSSE ~ TOCIO
E·I·MONTI ~ DE
~ POLENTA ~

This humble staple complements all dishes on the tables of patricians and bumpkins alike. Its preparation is approached with a reverence for our traditions, in a silent contemplation of things humble, very much as the Chinese pour themselves a cup of tea. Corn flour, salt, and water are stirred with a ladle for at least twenty minutes over the fire. Whenever I prepare it, the first savoring invariably connects me with memories of my childhood in a happy land of milk and—polenta.

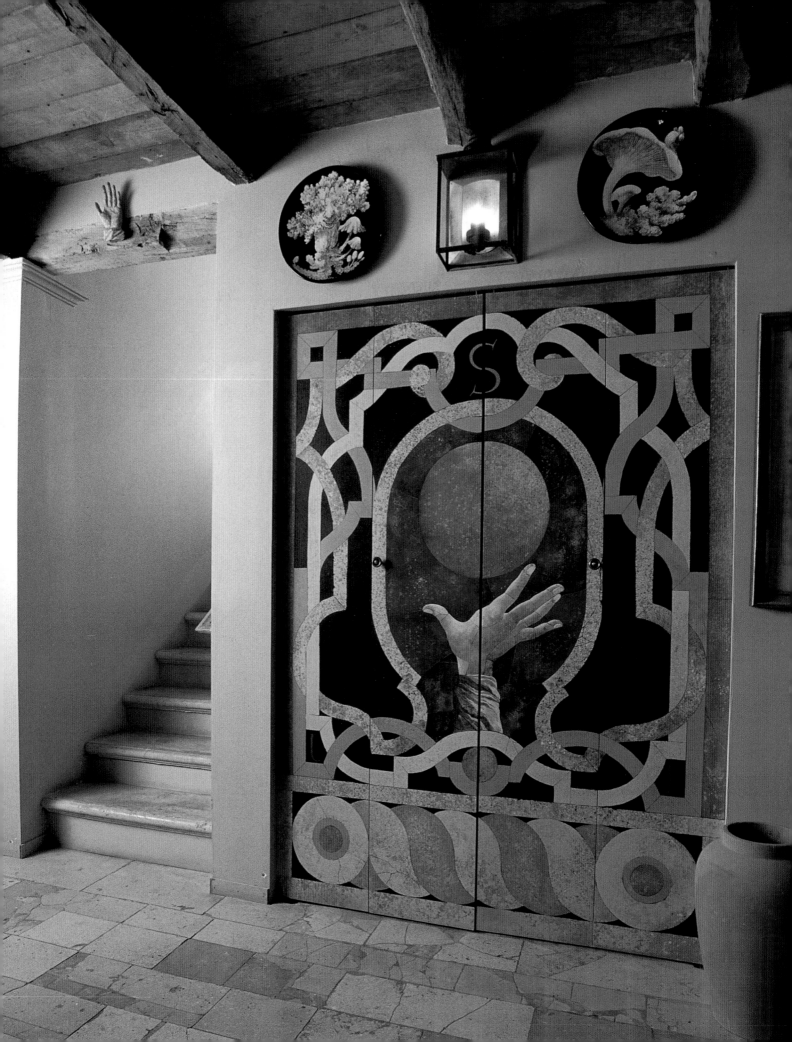

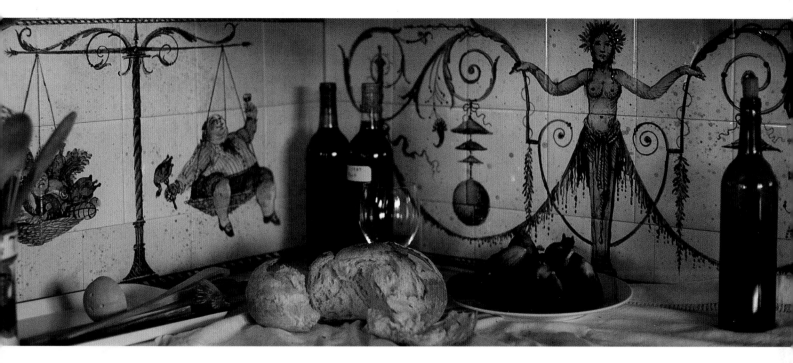

The doors of a closet are an excuse for an exuberant Baroque pattern in faux scagliola, with Sam Nakamura's hand and a basketball in the hoop.

Under the *tansu* cupboard in the kitchen, seen above and on the preceding pages, runs an eighteen-inch-high frieze or backsplash in ceramic tiles. I enjoy decorating tile panels and ceramic dishes. The traditional painting done on bisqueware with water and colored powder requires the immediate stroke of the watercolor technique. Quick strokes produce, once the tile is glazed and fired, a luminous, fresh effect.

I grew up near a ceramic factory where I enjoyed a periodic summer job. Much of what I know about ceramics I learned there. But by then, in the back of my mind, I envisioned myself stuck there for the rest of my working days, applying brushstrokes to a perpetual line of Rococo cups on the conveyor belt of the Italian cottage industry. A dull prospect for an ambitious green artist.

Fortunately, destiny replaced cups with tiles, and on the following pages, off I go on a cobalt-blue gondola ride. A Vivaldi sonata in the background accompanies the gondoliers and my narrative . . . all in the Venetian dialect.

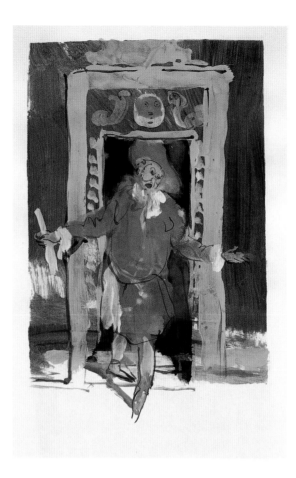

Dottor Balanzone bursts appropriately out of the library as if in a comedy by Carlo Goldoni. In some of his numerous plays, the Venetian playwright favored characters from the *commedia dell' arte,* even if his intentions were to modernize this ancient form of improvised popular theater, and do away with its stock masked characters. Quite a few times, he presented hilarious scenes in which the Bolognese Balanzone chums with his buddy Pantalone.

The Dottor is a gibbering quack, all misquotes, pidgin Latin, inflated pedantry, and farcical nonsense. Pantalone, the old merchant, supports him: he is an ultraconservative scrooge, grumpy, but with a soft spot for Colombina.

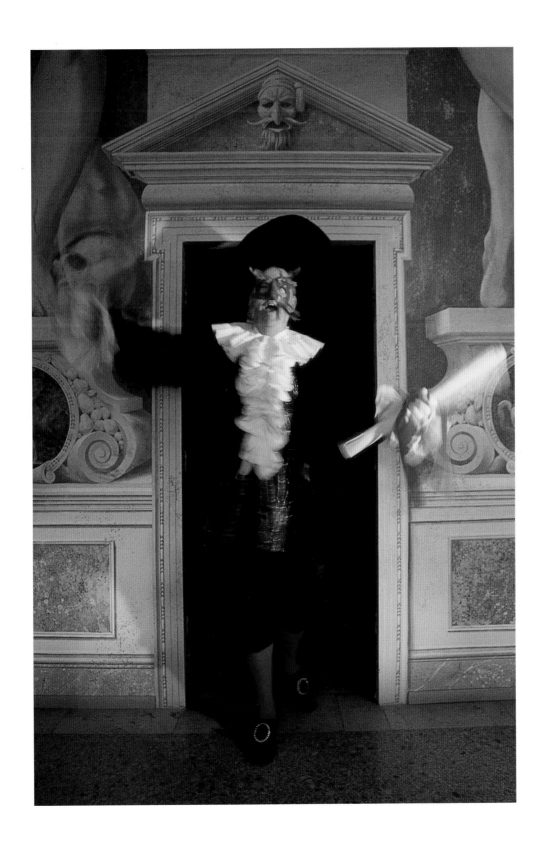

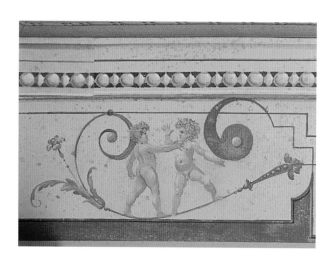

This library is resolved simply: stone posts and lintels around plain doors. A *grottesca* frieze continues around the wall with the zodiac signs and allegorical panels. The floor is faux marble inlaid patterns, as bold and strong as the two surreal portraits of the Shell Man and the Squash Man.

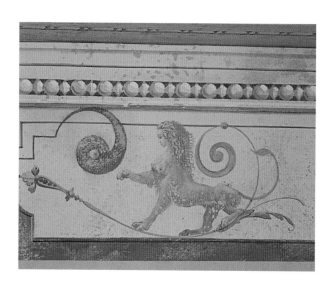

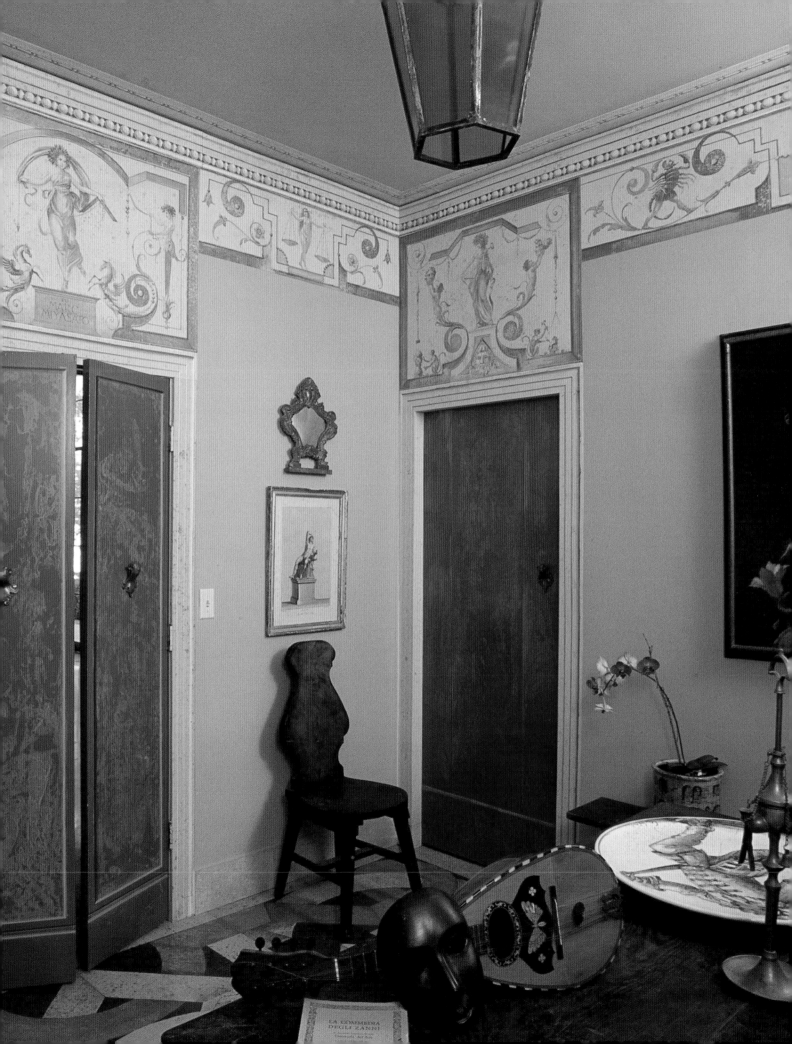

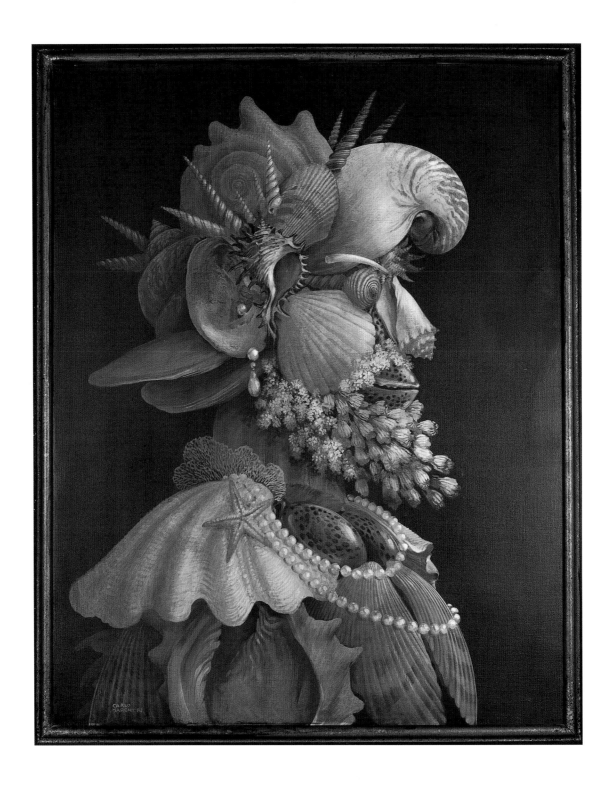

These two portraits are a loving homage to the brilliant master of illusion, Giuseppe Arcimboldo. Here again, the desire to identify with and to emulate the work of an artist I revere compelled me to present my own *invenzione fantastica*. If I were to borrow and put on Fred Astaire's shoes, would I be able to dance like him? Oh well. I'll stick to my painting tricks.

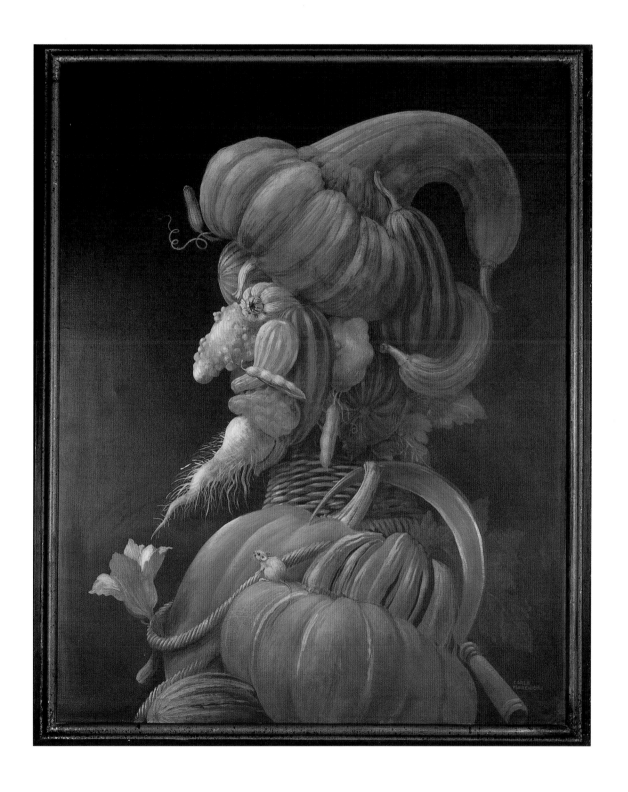

The discovery of Pompeii in the mid-eighteenth century was a great revelation and inspired a cultural reconnection with the classical world. By then the Rococo style had exhausted itself in decorative giggles, and this revival in architecture, murals, and mosaics gave impetus to the neoclassic movement. Every villa would make space for a Pompeian room, and I couldn't deny it to Ca'Toga.

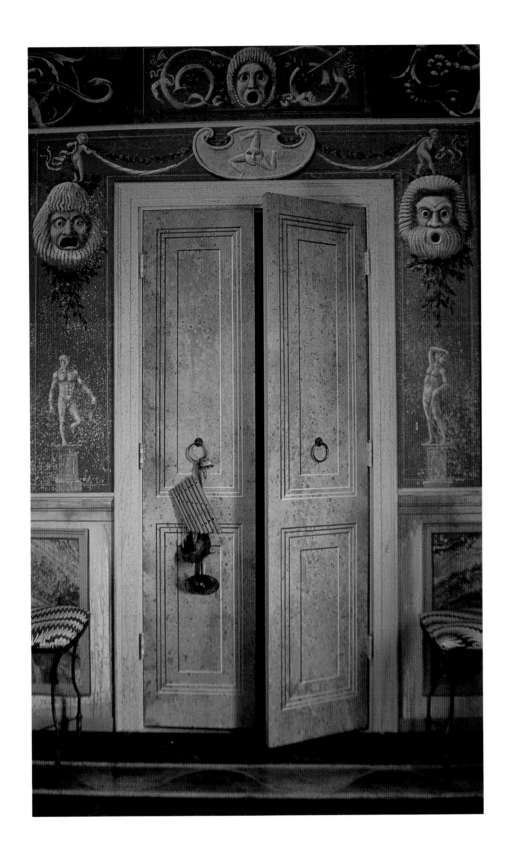

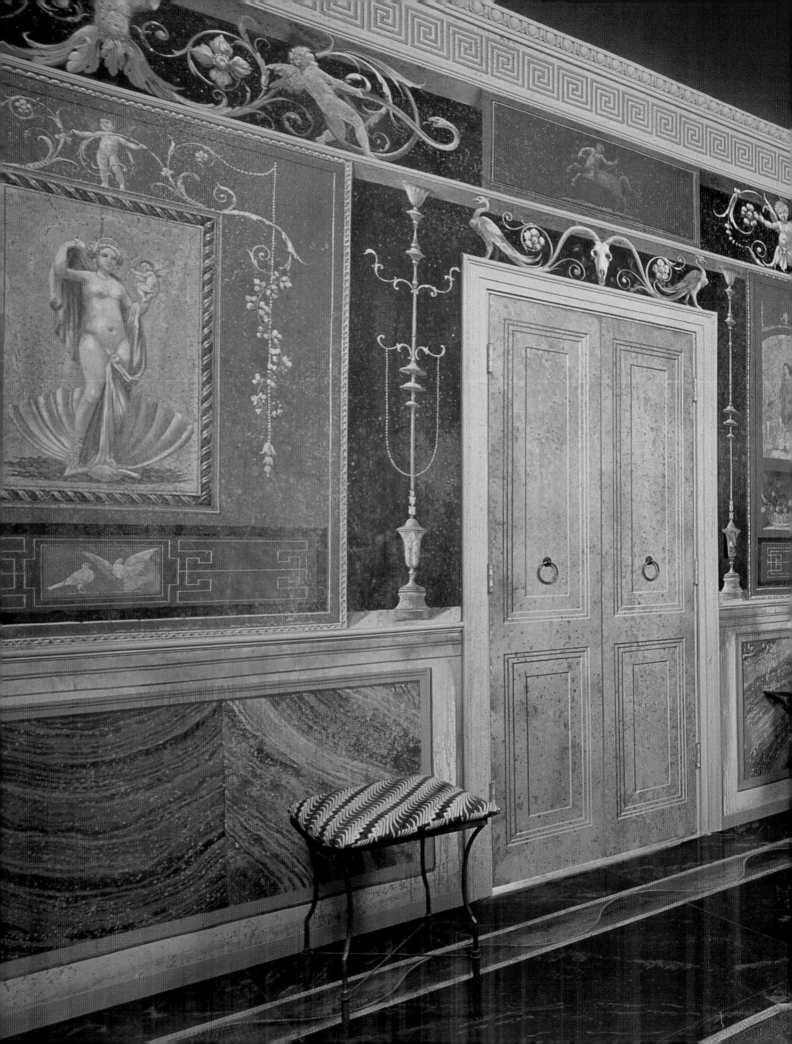

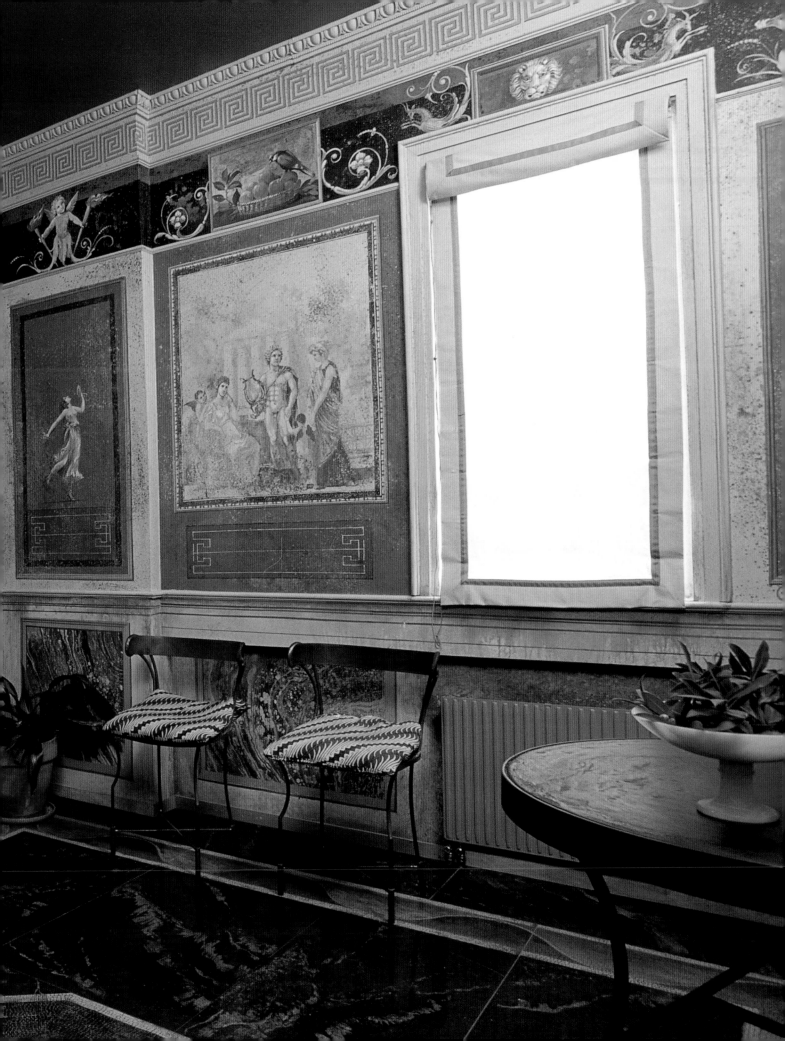

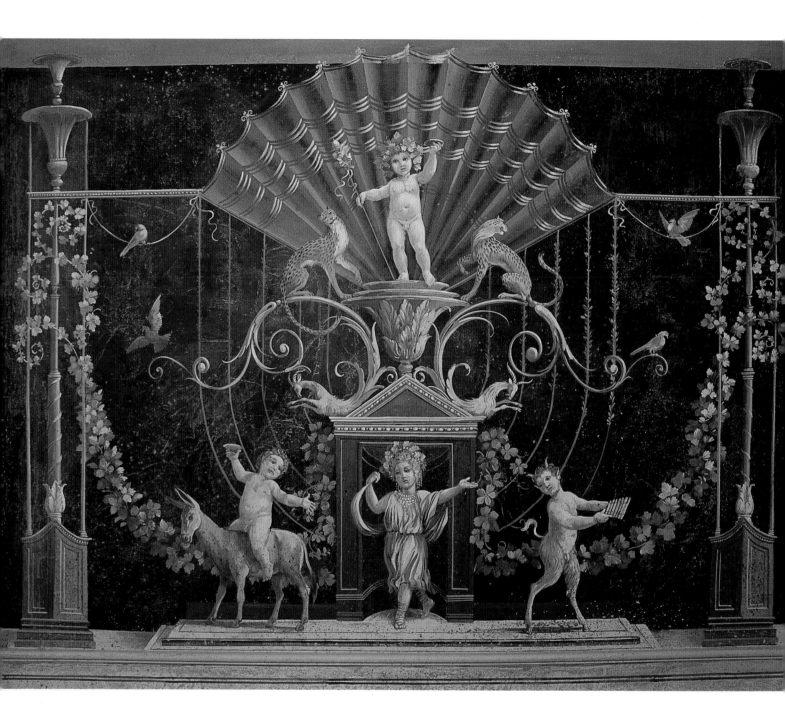

To interpret Pompeian aesthetics is a bit of a challenge. One has to think back to that period, and try to ignore all the cultural baggage we have accumulated since then. To copy is not creative, and too much academic concern is pedantic. So, keeping an eye on classic references, I let my own version flow and play my own tune, trying to keep away from romantic sentimentalism with a sprinkle of wit and whimsical surprises.

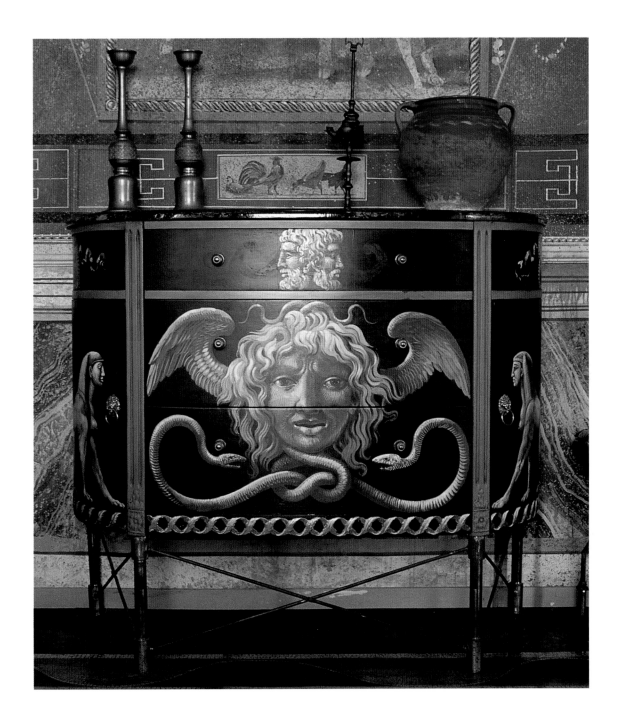

Wrought iron furniture redesigned with my best classical intentions: a legless wooden cabinet, refinished and painted, raised on a new metal base, competes with the murals on the wall.

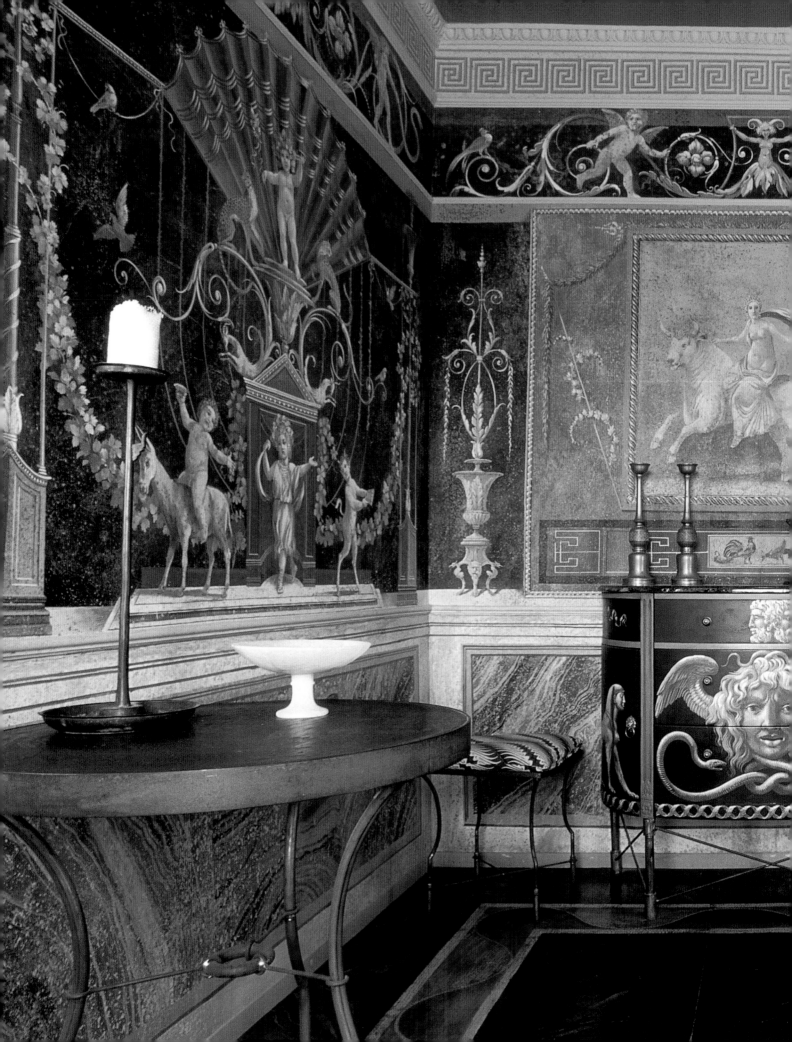

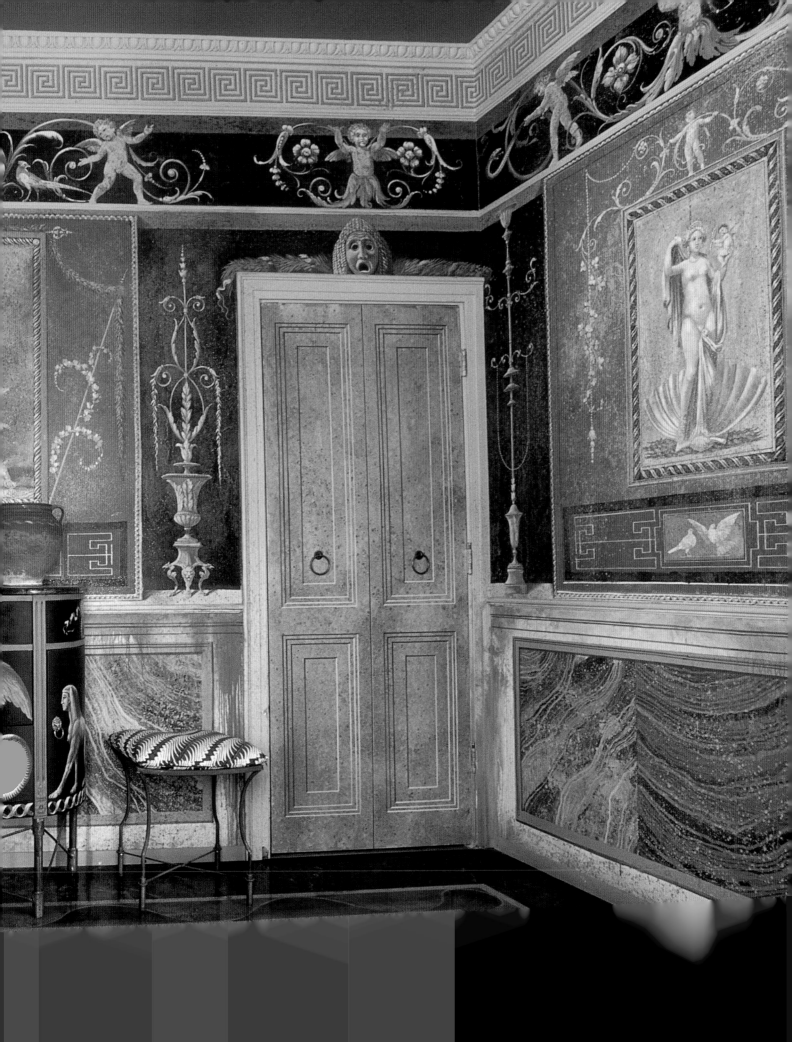

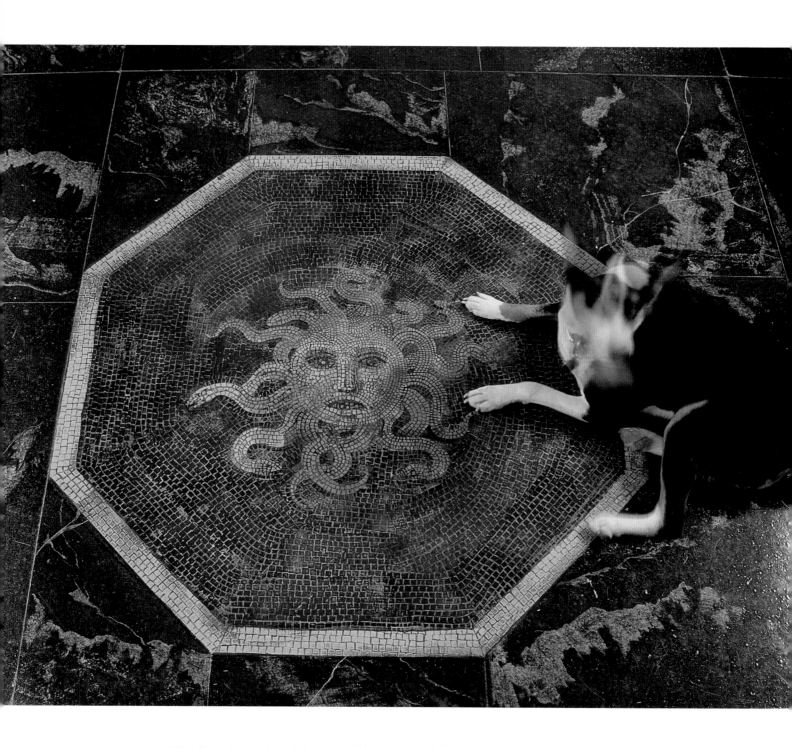

The floor is made of faux marble slabs and faux mosaic strips, painted on four-by-four pieces of Masonite, varnished, and glued onto the floor. All these elaborate creative processes were undertaken to make the gods and goddesses depicted on the walls feel at home—the infant Dionysus and Ariadne, Pan and Silenus as *putti* (page 56), Europa on

the bull (page 58), and Venus (page 59), the faux mosaics of a Medusa on the floor, and Bacchus crowned by a garland of grapes. All these gods in their ancient detachment welcome visitors into pagan contemplation.

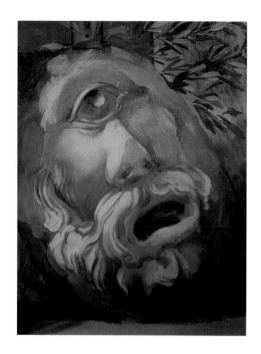

Childhood curiosity made me reach for a volume on mythology with dramatic photographs by Alinari, a book on Greek and Roman statuary. My senses were swept away in a seduction that waived any previous interest I had in Christian iconography. All those virtues and saints bound up in modesty and abnegation were no match for the naked splendors of the Greek gods and goddesses. I had found my religion.

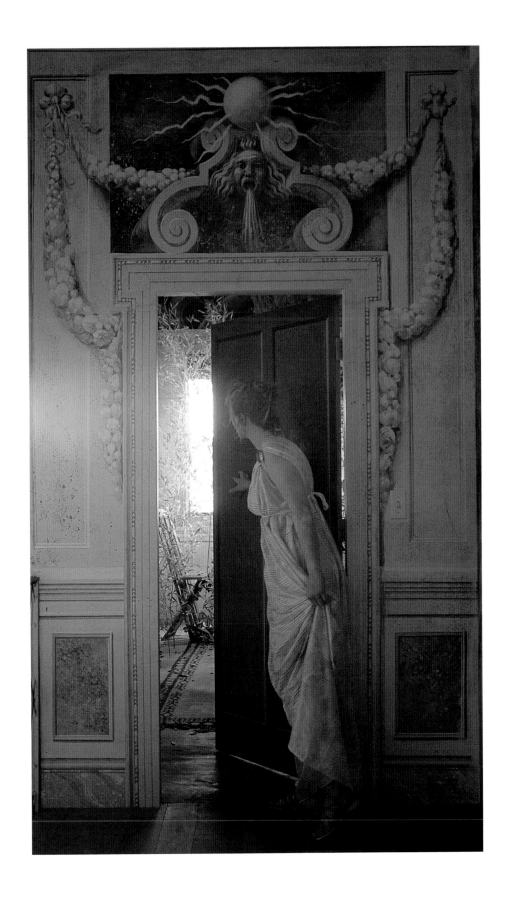

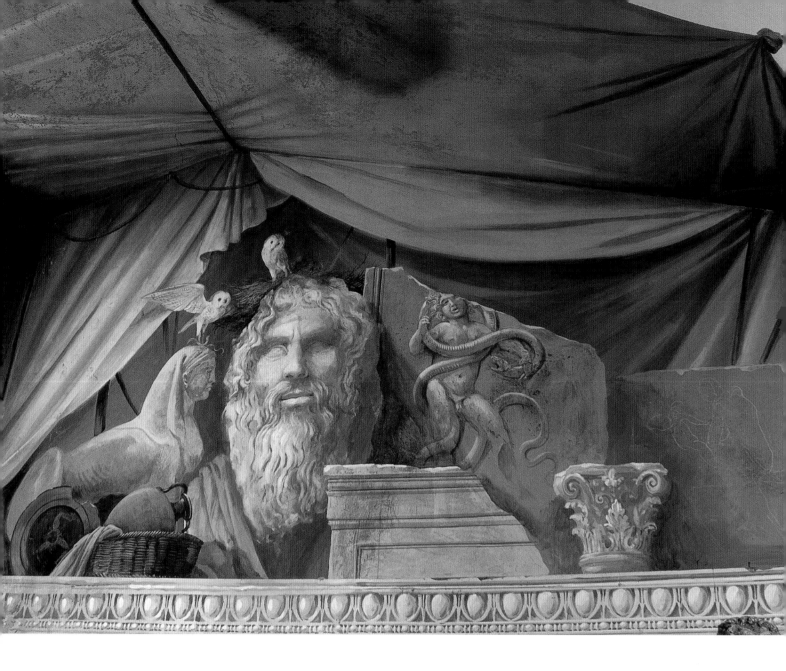

Here I painted my Greek world on the casual theme of an archaeological dig shaded by tents and laurels. I have unearthed Oedipus and the Sphinx, who whispers a riddle in his ear. The infant Hercules struggles with the snakes, and the owls, sacred to Minerva, have nested in their midst. Two-faced Janus looks at the past and at the future. The mood is Olympian. I relish the thought that, in this room, my guests will awaken from their dreams into an ancient vision and, for a second, see Pan and hear him playing his reeds in the thicket.

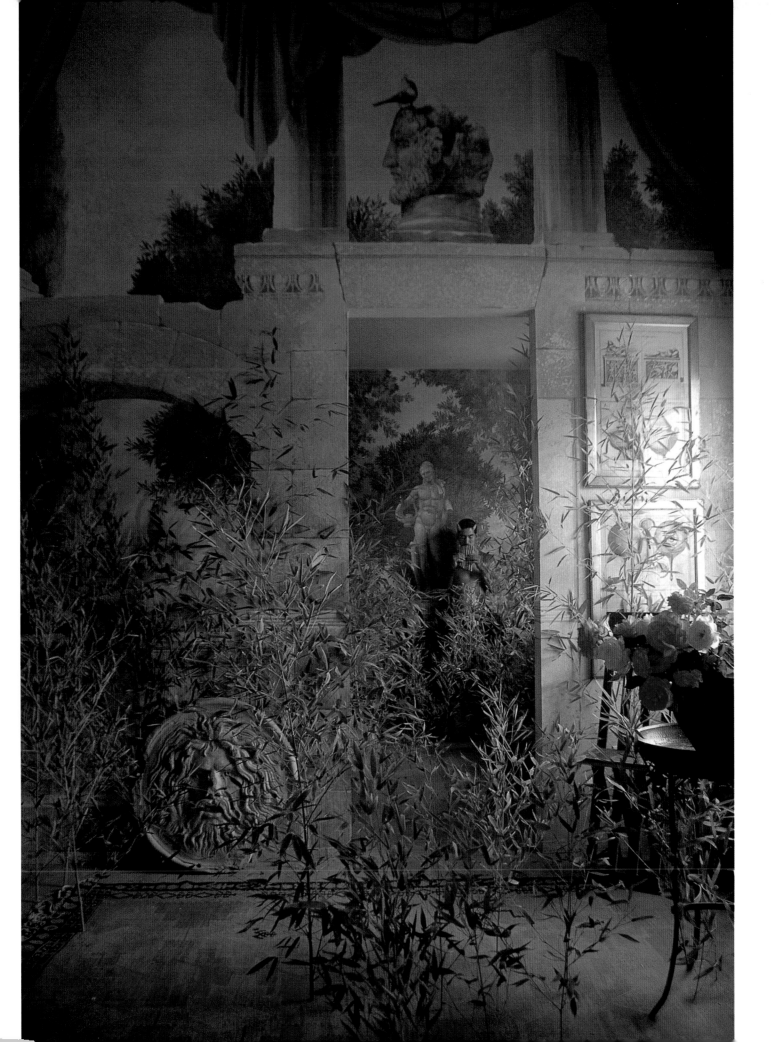

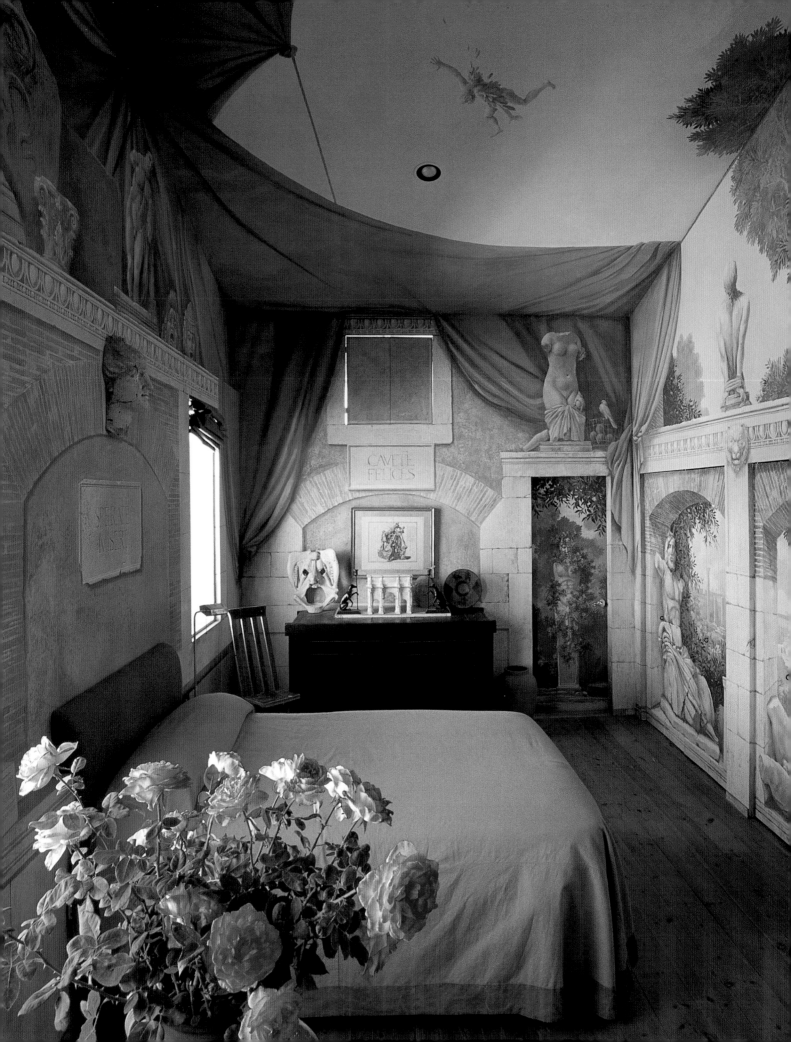

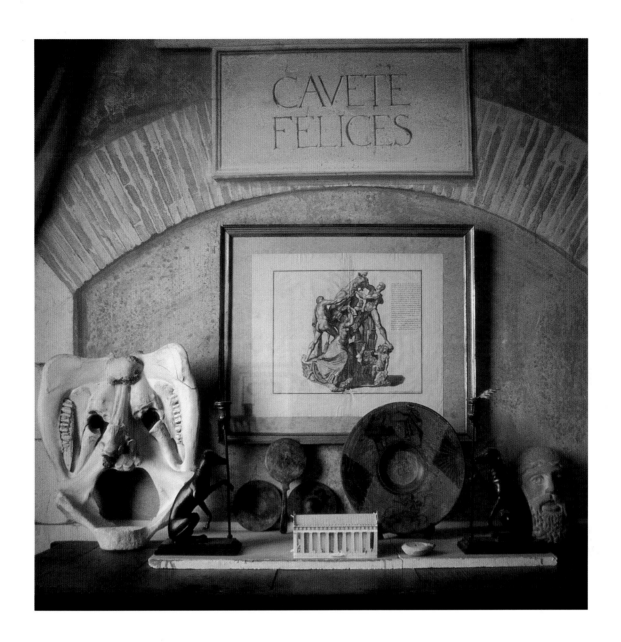

In the distance, a painted herm guards the gate to the garden of Hesperides. Prometheus bound is flanked by the vulture. Poseidon, the Minotaur, Venus, Hercules, and the Trojan horse are oblivious to Icarus tumbling out of the sky into the Aegean. Stone inscriptions stoically warn *SPERATE MISERI* (Miserable Ones, Hope!) and *CAVETE FELICES* (Happy Ones, Beware!)

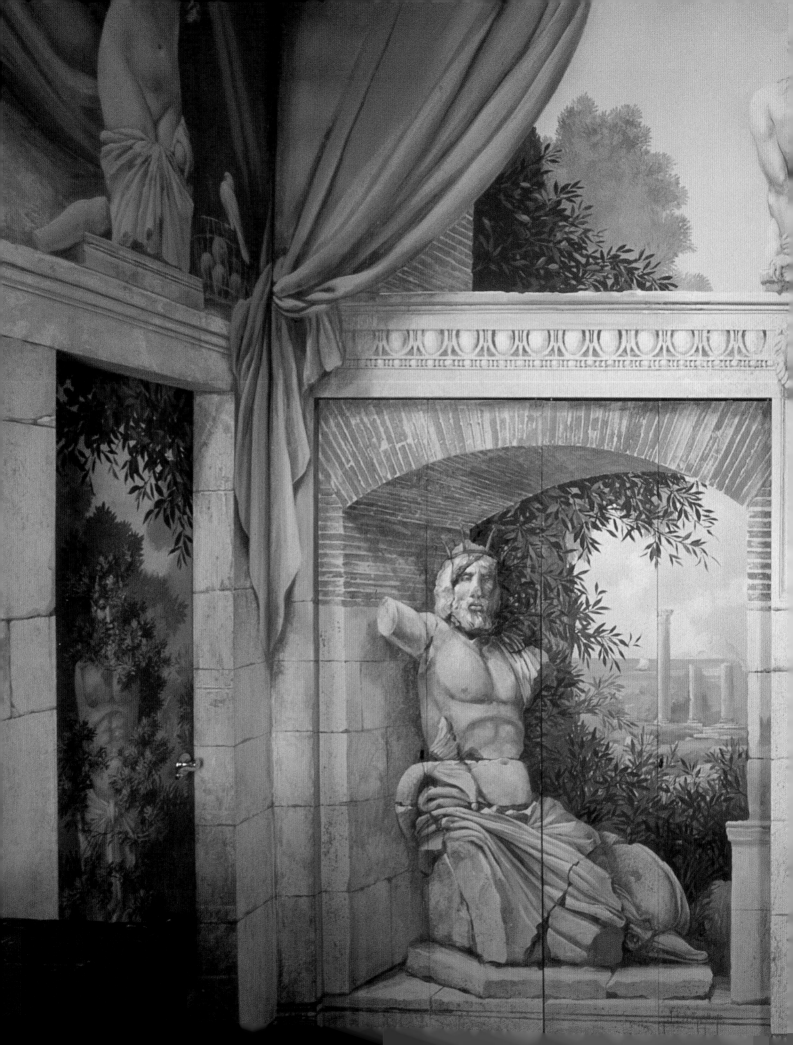

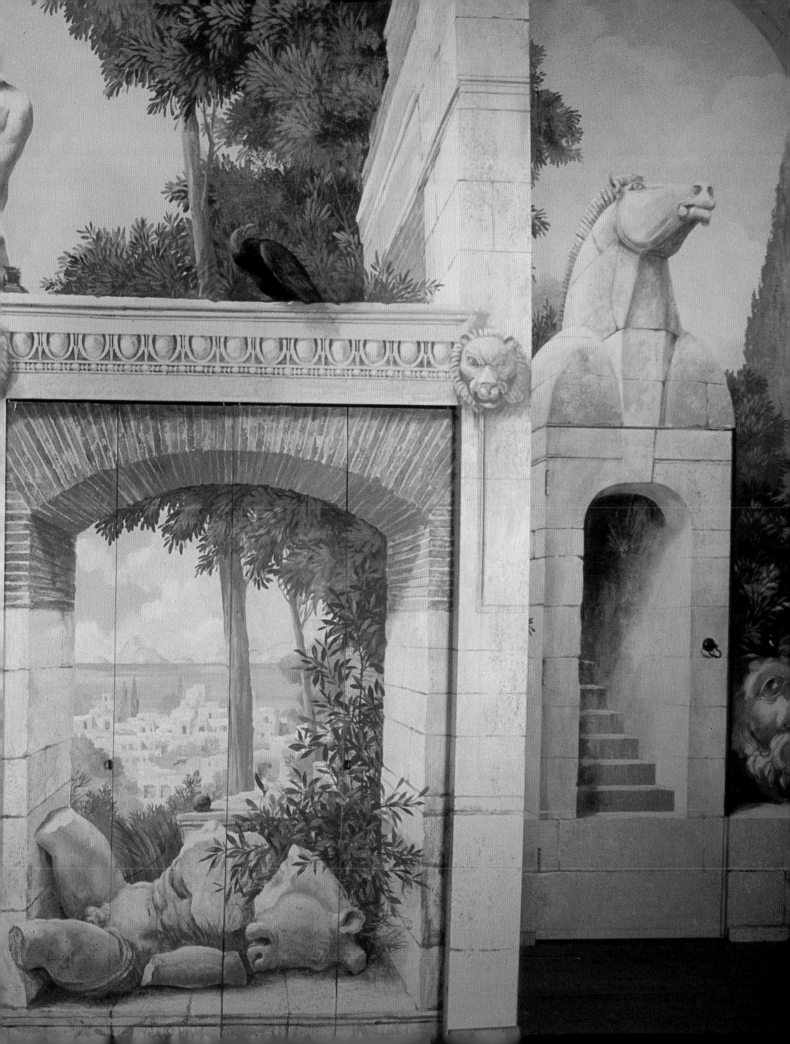

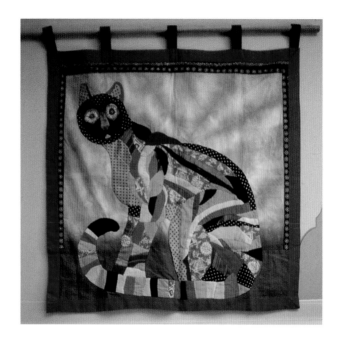

No matter how one frills it up, a room is nothing more than a box in which we lock ourselves up with all precautions for safety and articles for comfort. It's a haven, a nest that we supply with our personal household gods to protect us from wolves and nightmares and the icy winds of fears. In it, we line up our own symbols and fetishes to keep the flickering light of security from sputtering out.

I suppose I could have turned this particular box into an Egyptian crypt, for ultimate security, or into a house of bricks for one of the Three Little Pigs. But no, I thought. With a little house paint, I'll turn this room into a cage. Though one might be captive in a cage, a cage is a shield from dangers that lurk without.

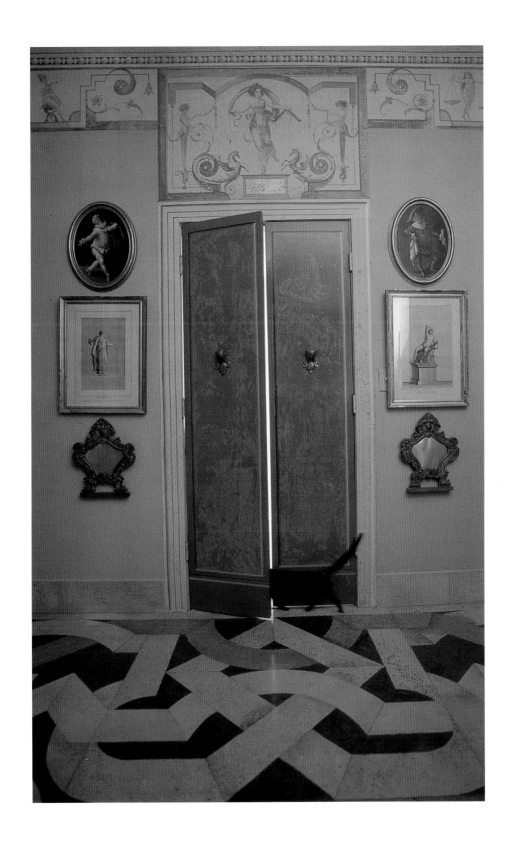

Decorating the cage was a very simple matter. A birdbath, a lettuce leaf (really a rolling "romaine" blind) over the window, a perch, a cuttlefish bone for a headboard, and canary yellow pajamas are for my guests the ultimate bird transformation experience. This room is—"for the birds."

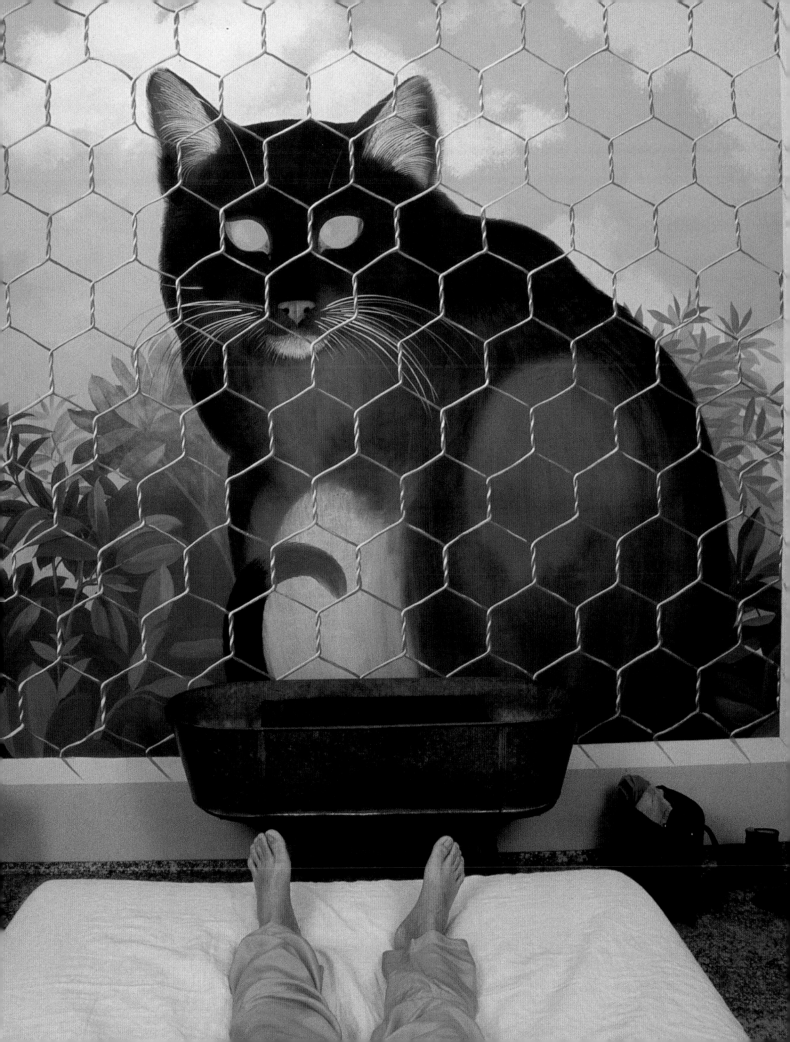

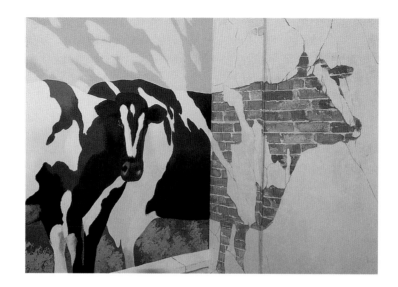

My mother was born in 1898 in Asolo, a beautiful town on a hilltop north of Venice. After World War II, my parents would send me to Asolo to spend my summer vacations. There, on my uncle's ancient farm, I lived my happiest days, days full of earth and sun. I slept on an enormous mattress made of cornhusks: by morning, I would have sunk to the bottom of it, and would have to ruffle it up again. No electricity, no running water . . . the chickens would drop eggs everywhere, a sow would unexpectedly present a dozen piglets . . . and I picked peaches, figs, and hazelnuts right off the branches of the trees. The farmers would let me ride on top of a load of hay pulled by a team of oxen. My aunt would bake bread in an outdoor oven every three weeks. Fresh bread was fabulous, but it soon became hard as rocks and had to be chopped into chunks and soaked in large bowls of *pasta e fasioi* to soften up.

Swinging two buckets from a shoulder bow, I would be sent to *el Barbol* to fetch water. This was a nearby natural spring, shaded by ancient chestnut trees. I once saw a beautiful salamander there, purple with yellow spots, lying in the wet moss. This image is still engraved in my mind. I drank with pleasure from the rim of the bucket. The bucket now lights these bedroom walls where the cows are forever coming home from the pond.

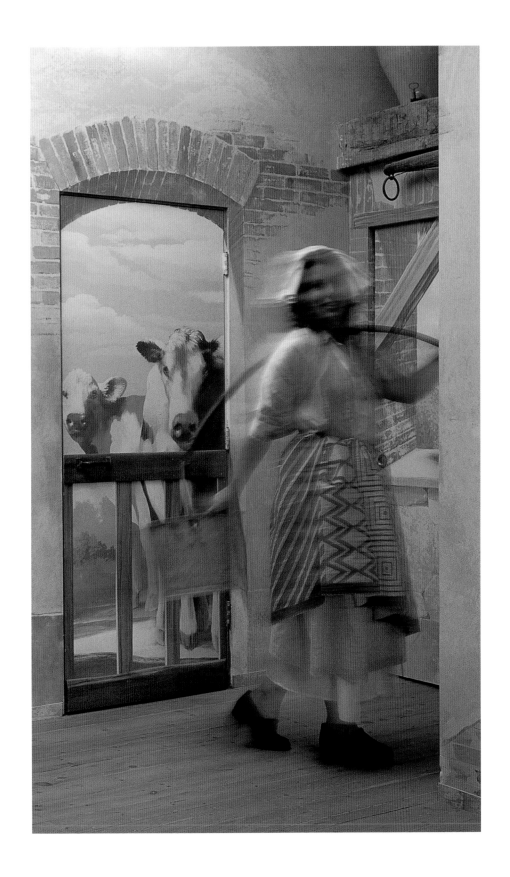

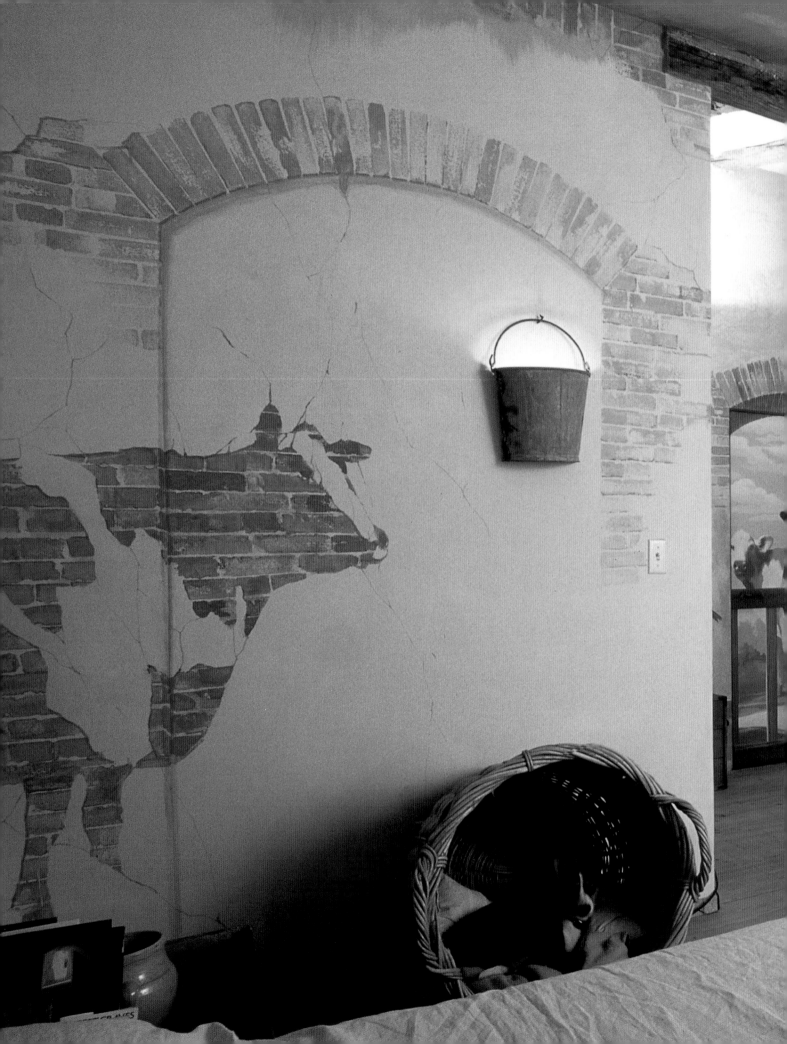

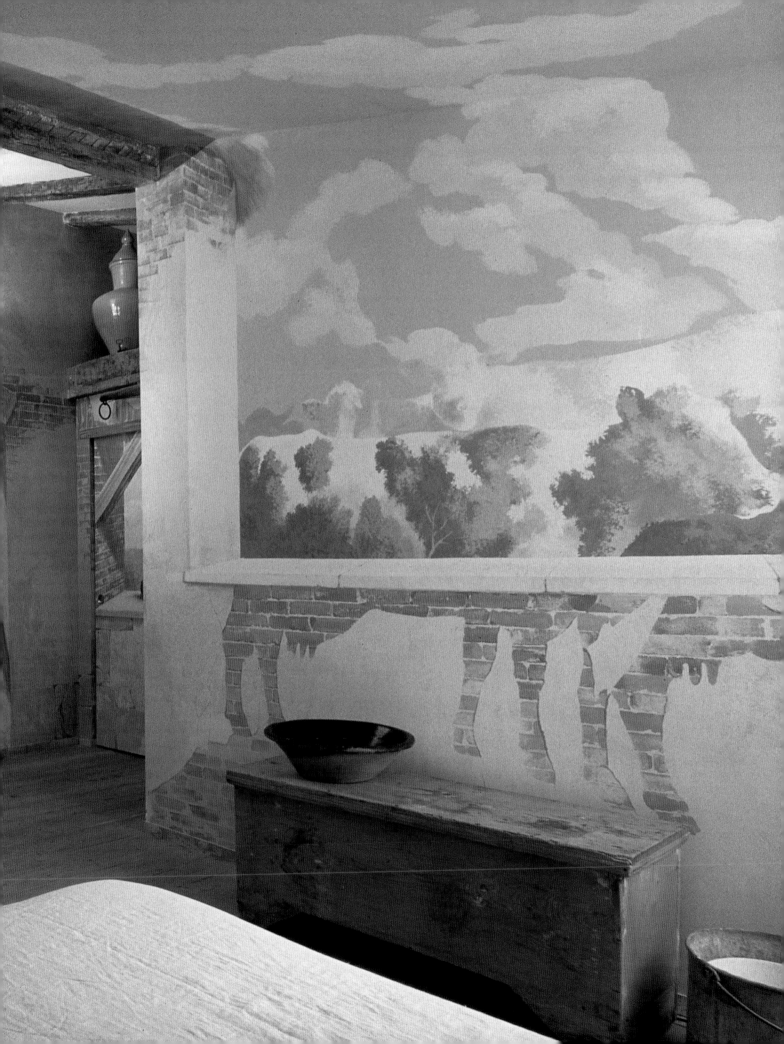

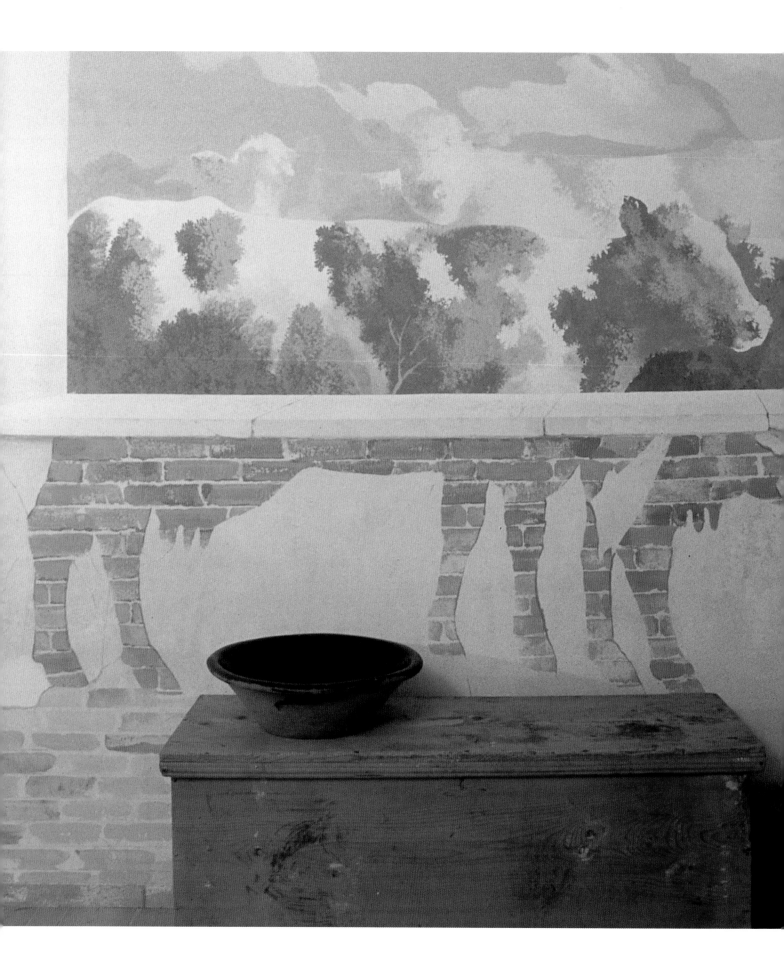

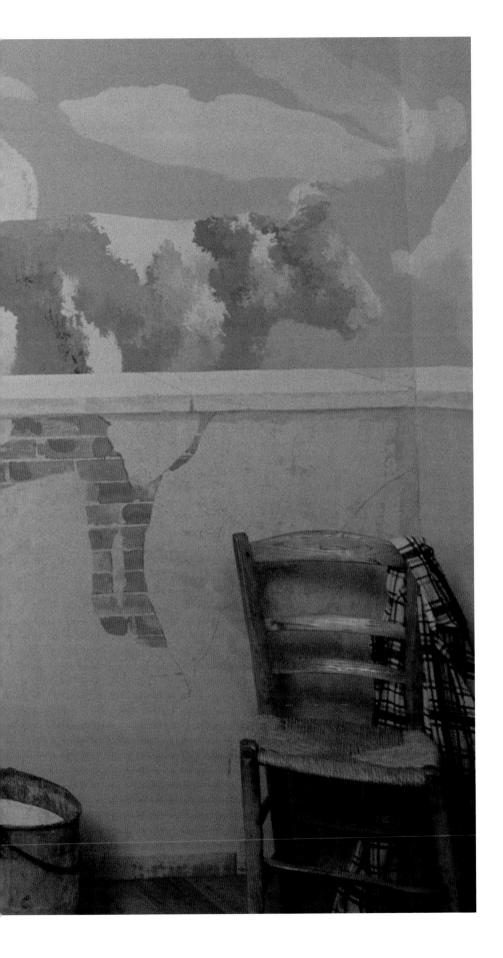

To evoke the feeling of those childhood days, I selected natural materials to create this room—recycled wooden planks on the floor, old beams on the ceiling. The blanket chest and straw chairs are relics from Asolo. The headboard on the next page is a plywood silhouette of a cow with a head that swings on hinges. This cow is the strongest image in the room. The other cows fade away, dissolved with magic surrealism into bushes, patches of fallen plaster, and clouds.

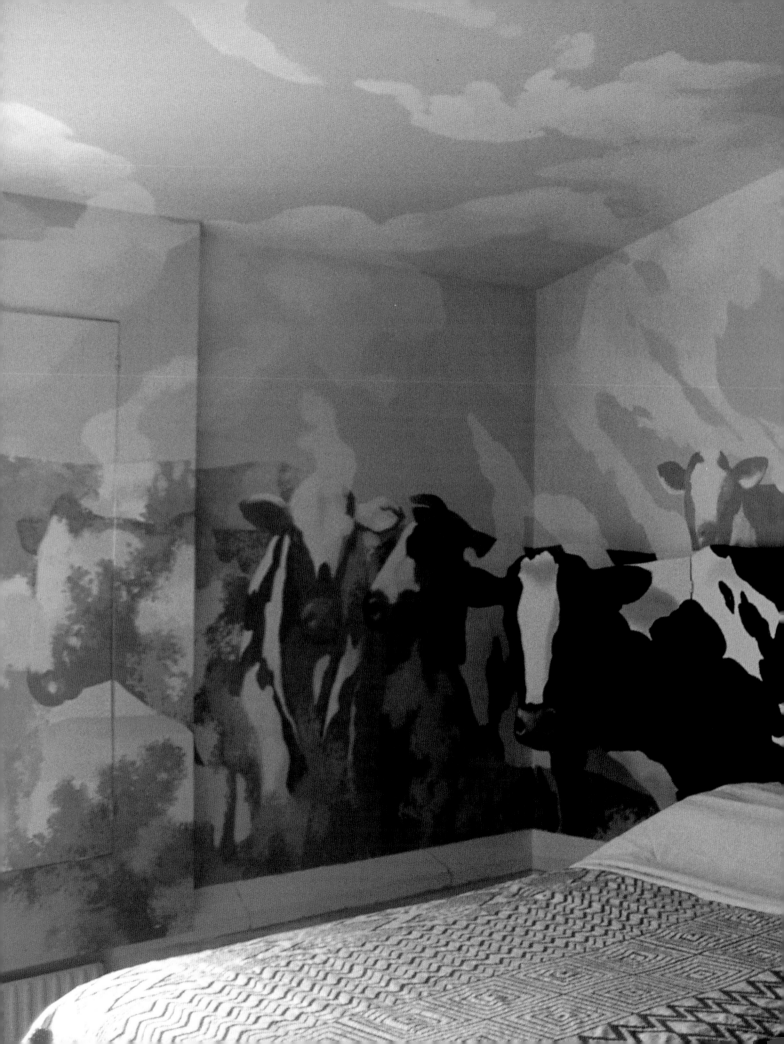

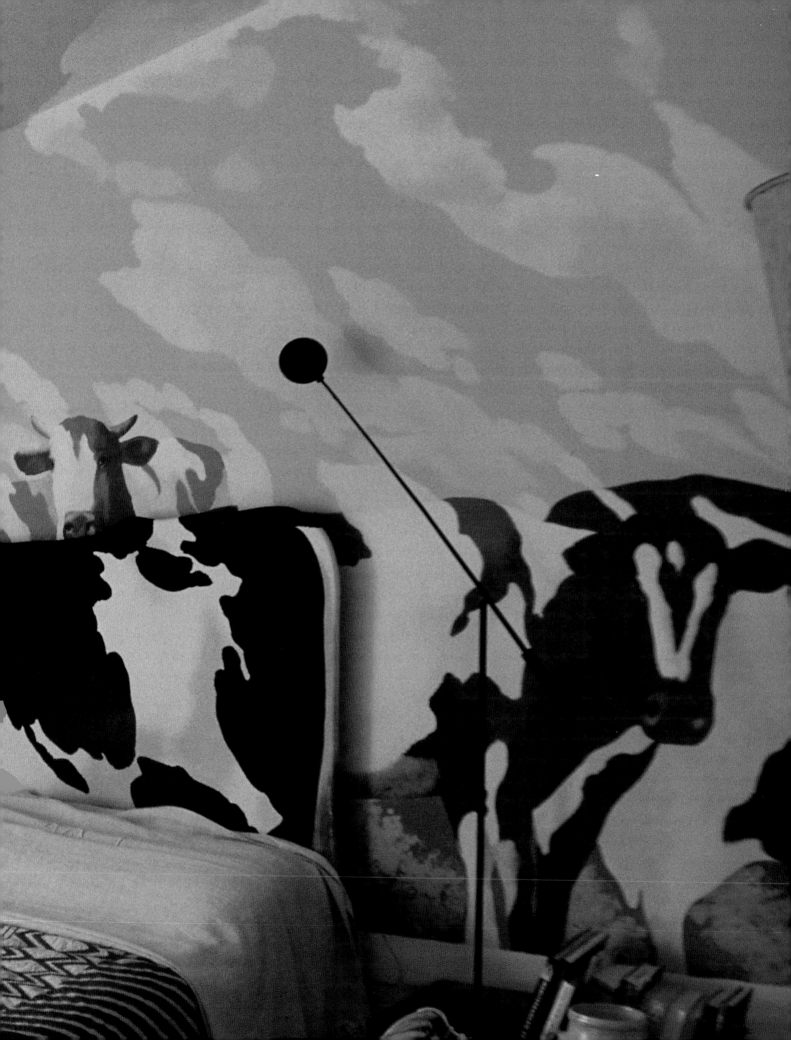

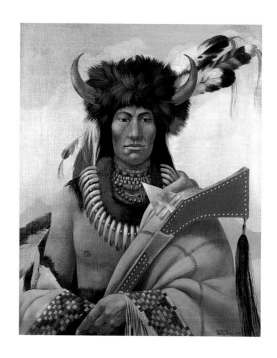

Exotic peoples from faraway lands, especially the Native American Indians, have always appealed to my imagination. I envision myself projected back into the early nineteenth century as a painter-reporter like Karl Bodmer or George Catlin, wandering wide-eyed into Indian territory. In all honesty, I question if I would have had the courage to venture to the New World in those rough times when Native American culture was at its peak. However, I indulge in the romantic vision of "noble savages" appearing in full eagle-feather trappings in the foreground of an unspoiled landscape. Well, it is the prerogative of an artist to imagine enthusiastically, to relate, to identify, to impersonate. I appeal to the understanding of American Indians to excuse my overpassionate interest. I assure that I study, research, and consult references when approaching a subject such as the Sioux or Fox warrior shown above and the Blackfeet maiden on page 93. This room is only meant to offer a theatrical splash, although it forces me to admit that the dressed-up "ghost-like" Indians appearing here go hand in hand with *The Girl from the Golden West,* Puccini's very first spaghetti Western, and that my "redskins" are made up with a dab of the tomato sauce of my wit and improvisation. Just as bad as the frontier day photographers, guilty of sticking on an extra feather or two to boost the image of the noble and obliging savage.

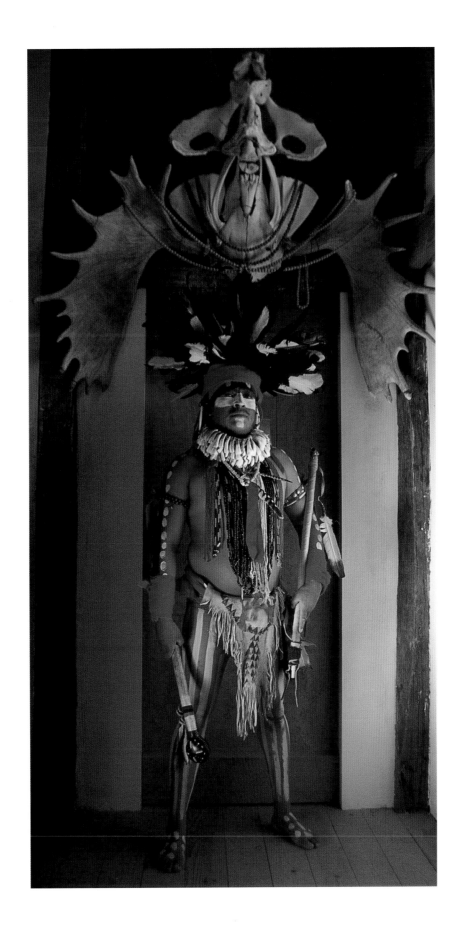

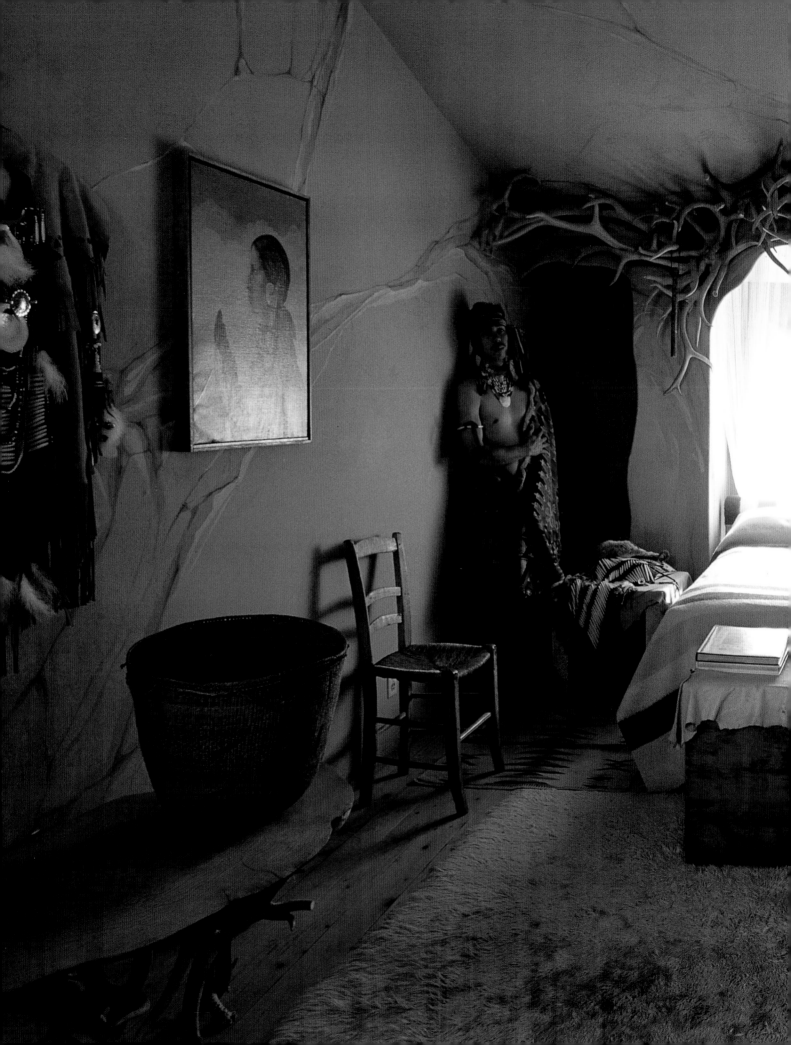

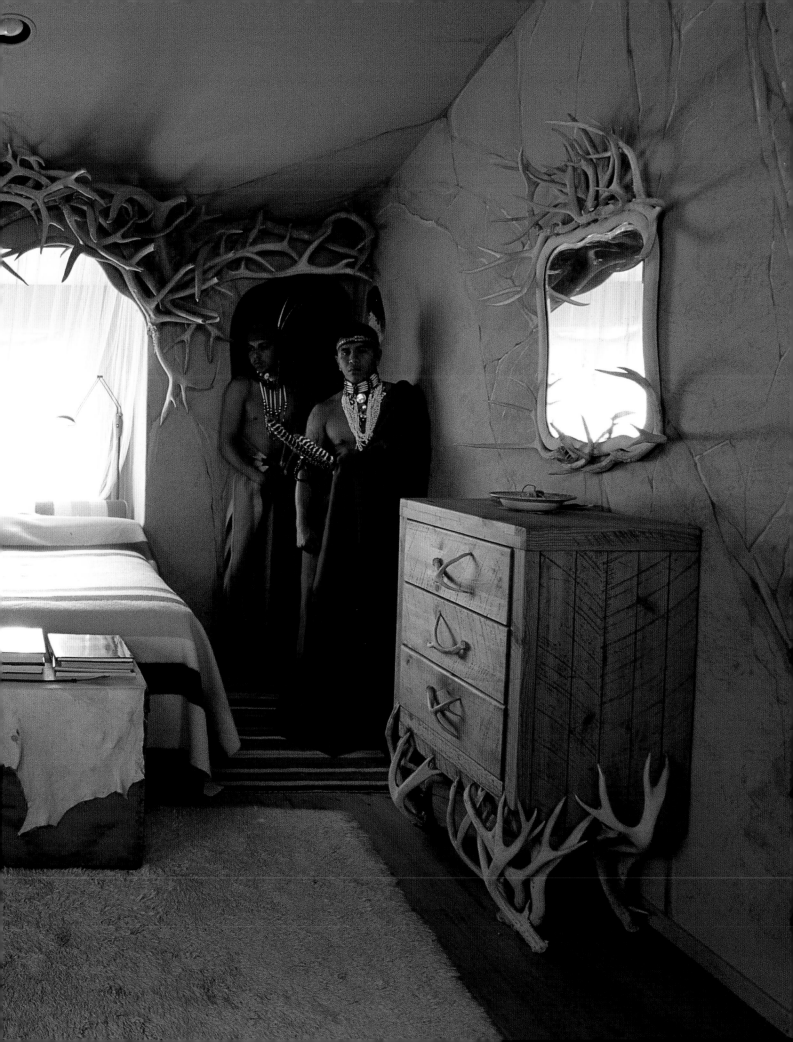

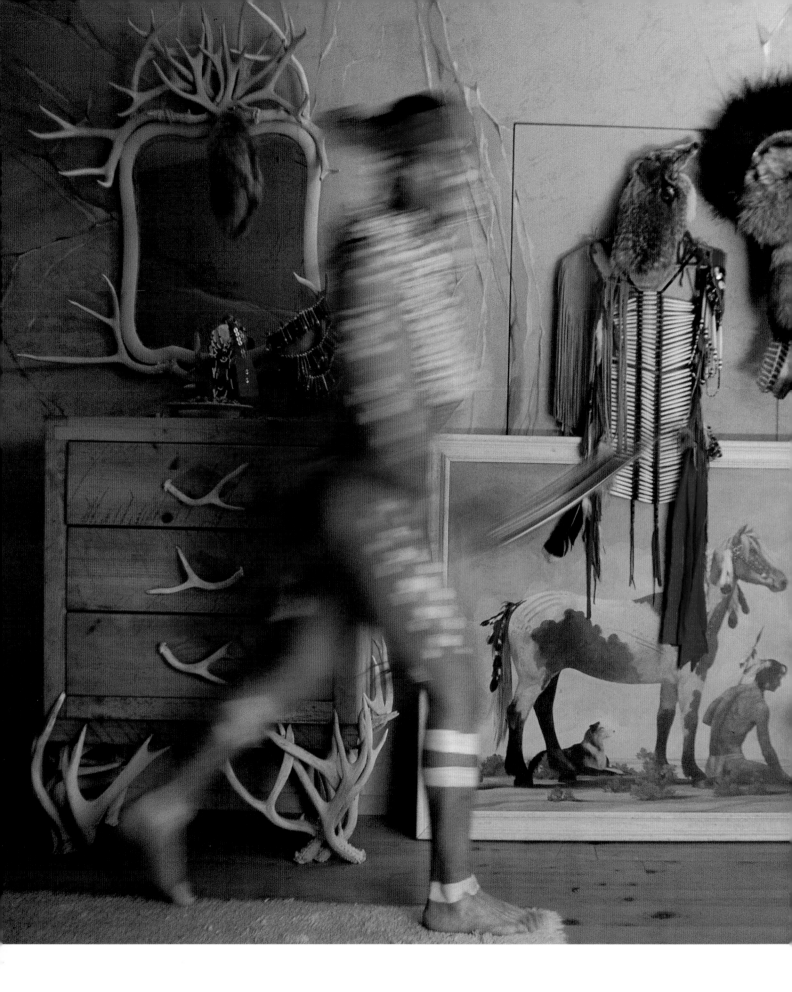

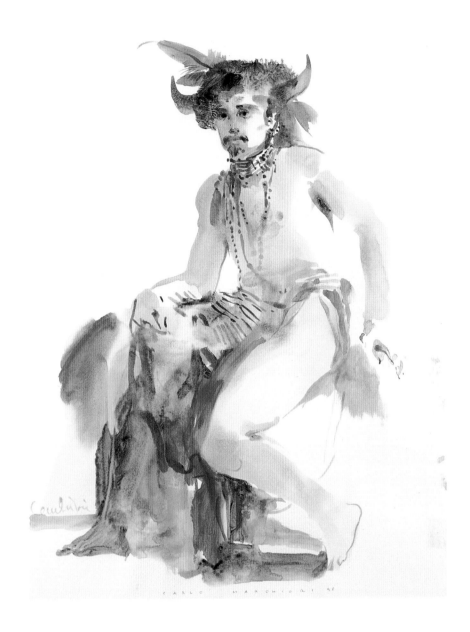

As with the phenomenon of chinoiserie, the notion of fabulous New World indigenes tickled the imagination of the eighteenth- and nineteenth-century Europeans. The artist then was always at hand to dress up the vague descriptions brought back from distant lands by merchant sailors. Oh, how I envy Catlin! He was right there with them, while I have used models dressed as Indians. The watercolors done in fast strokes, however, give enough hint of those glorious figures.

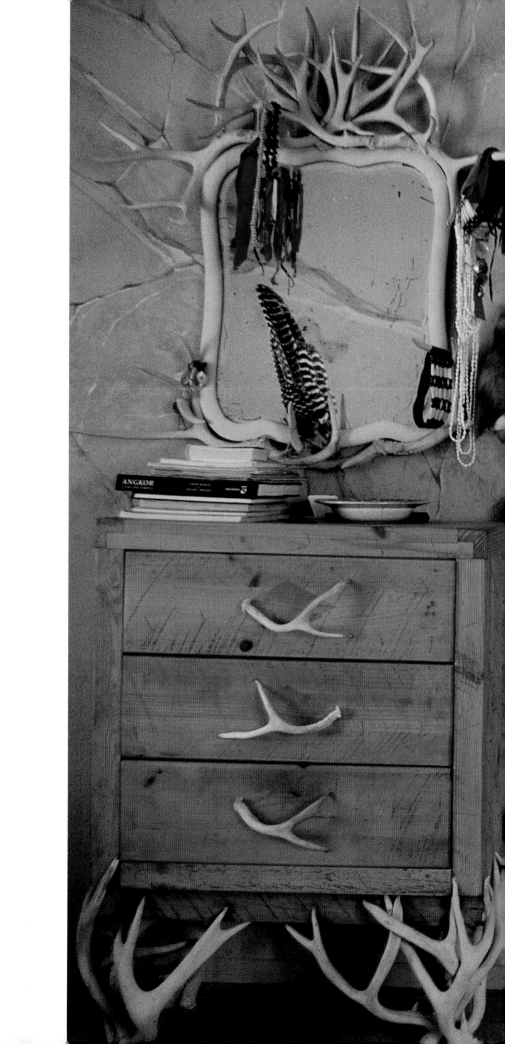

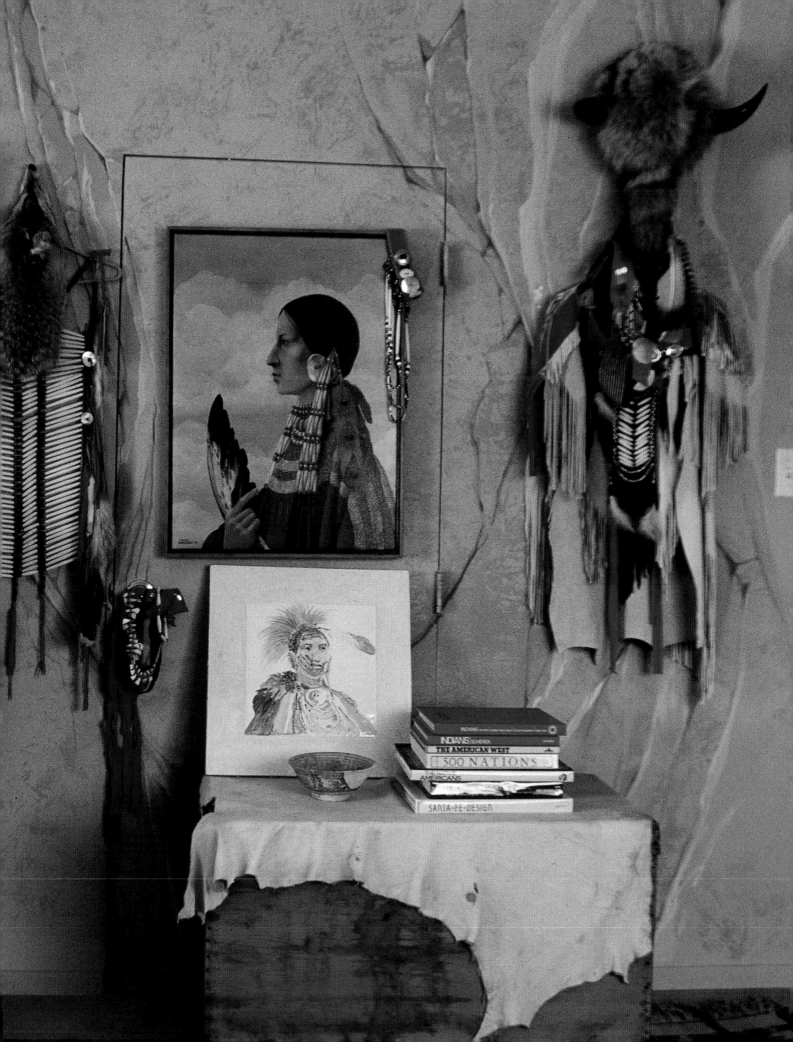

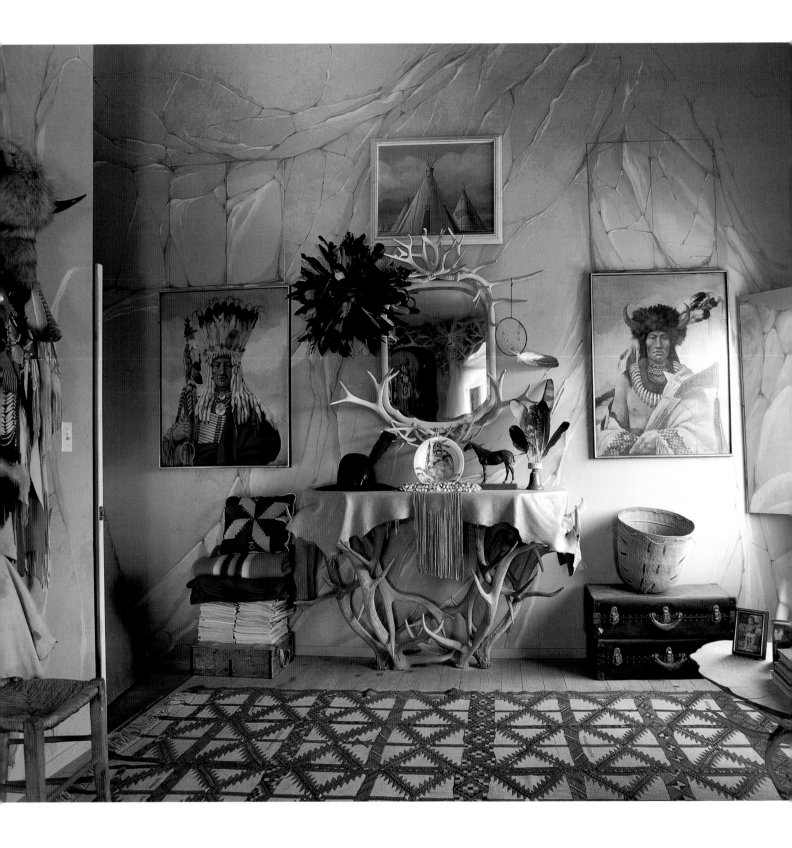

The walls are painted to resemble a cave or cliff dwelling; the furniture is "glorified" with moose, elk, and deer antlers; and the "costumes" are all my own sartorial buckskin and beadwork creations. Some real eagle feathers are a proud possession. Hunting, I assure, was done only at flea markets from which I brought back trophies of cast-off elk racks, wooden shoe forms, and Navajo and Hudson Bay blankets.

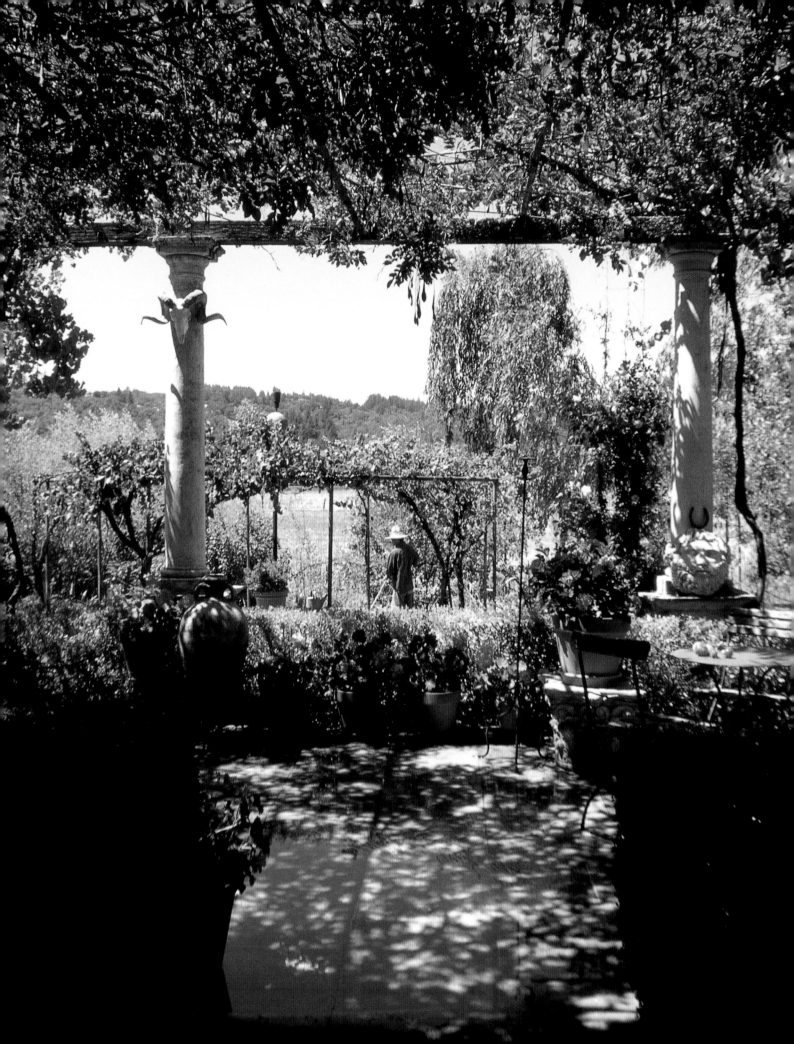

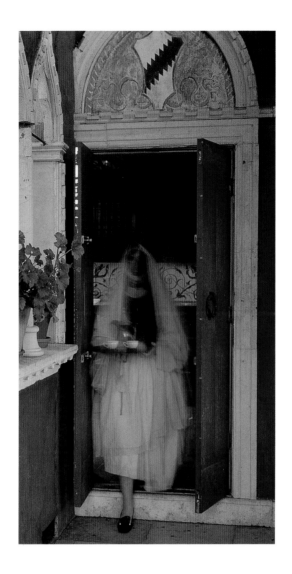

I t is one of those radiant summer mornings, and Colombina brings me coffee to drink under the pergola . . . in late afternoon, it would more likely be a glass of red wine. Is this *la dolce vita?*

In cold climates, one is a prisoner of four walls, and even if the rooms are furnished with the latest in comfort and fashion, one is captive still. But in California, the outdoors can be the living room, furnished by Nature. Her creatures, foliage, and vistas are the ideal decorations for the comfort of the soul, and engage it in animistic meditations.

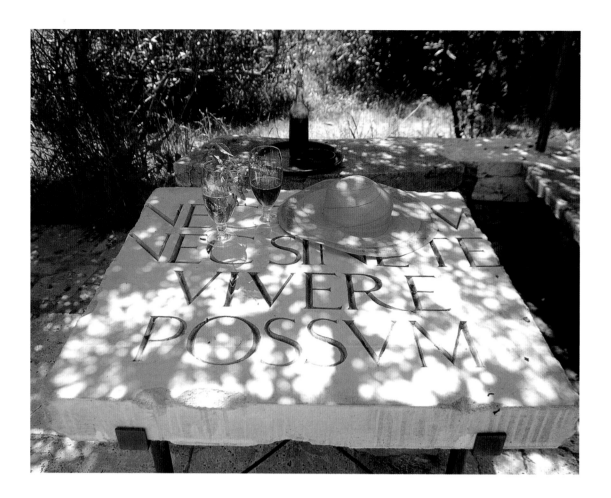

Alfresco means to be outside, as part of nature, perhaps dining under the stars, in the cool of the evening. There is no better place for indulging in such pleasures than this side of the villa. In April, the wisteria takes over in a purple glory, berserk with bumblebees. I wanted this side of the house to set off, in bright oxide red, the Gothic Byzantine style of the windows and architectural trim. A glass of wine brings a toast with many promises, but "I cannot live with or without you" stipulates the Latin inscription on a Roman slab turned into a garden table.

For the house and garden furnishings, I rely on "finds" that I come across at flea markets, garage sales, and, price permitting, antique stores. Mismatching is acceptable, and I prefer "beat-up" old things, already lived in, like the old garden chairs seen here. Time has given them soul and turned them into dear old things.

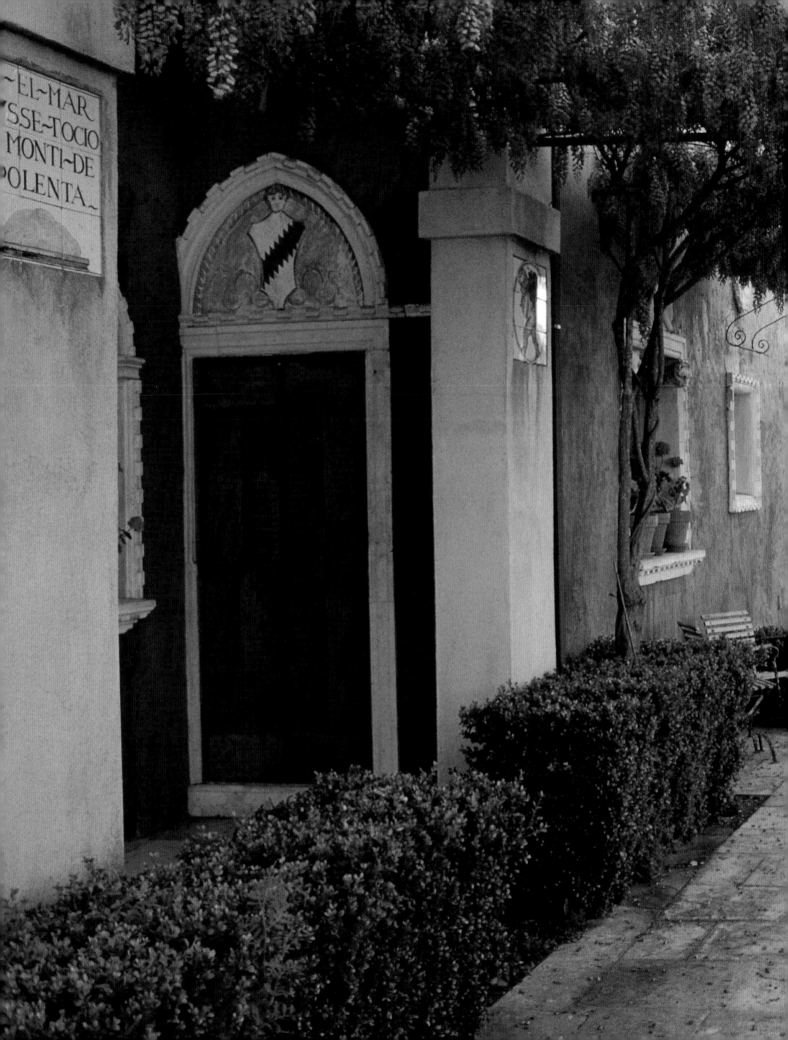

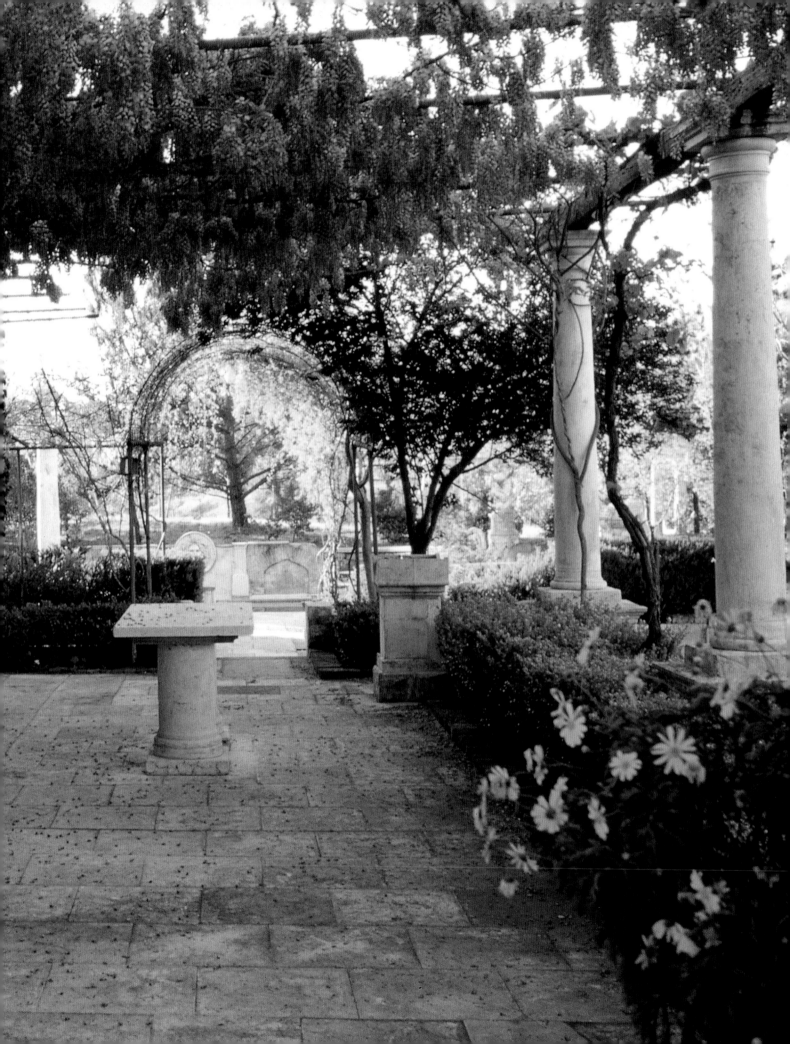

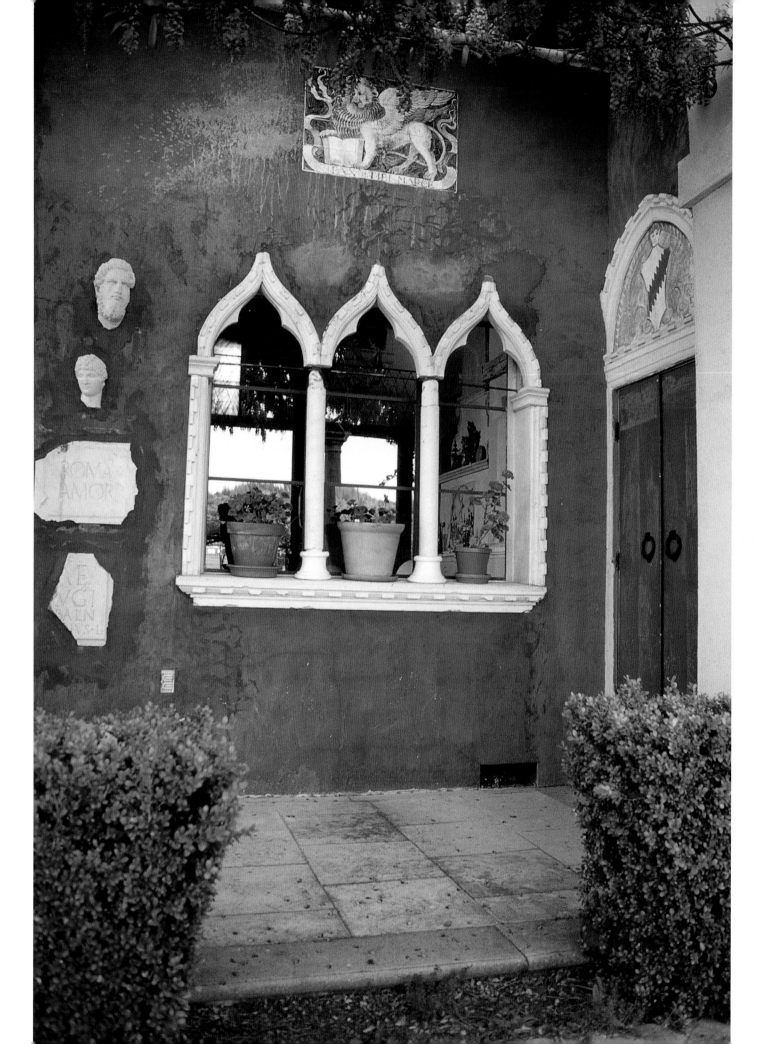

I researched the Venetian Gothic stone trim around the window, which is done in the *denti de can* (dog-tooth) pattern. I made an original in wood, took a mold of it, and produced the final trim in white cement to look like Istrian stone. High on the wall, a ceramic tile panel of *el Leon de San Marco* declares the site Venetian soil. Roman stone fragments, broken bits of history, complete the adornment of the red wall, evocative enough that, at a glance, Mount St. Helena in the distance could be mistaken for Mount Vesuvius.

Springtime is my greatest ally in enchanting the visitors at Ca'Toga. They are dazed by the profusion of trees in bloom surrounding the monuments in the garden, and warmly compliment me for such visions. The secret for the show is simple. I banish from sight all modern clutter: cars, appliances, plastic junk—all are tucked out of view. We are suspended in another era, a time of water fetched from a spring, candlelight, and old rusted furniture. In such a setting, one may be inclined to feel that a tomato still tastes as it used to in the good old days.

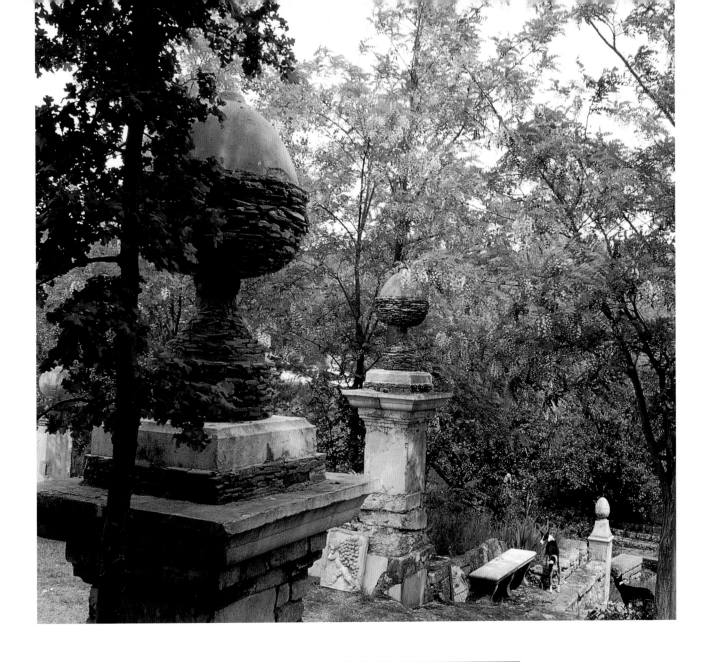

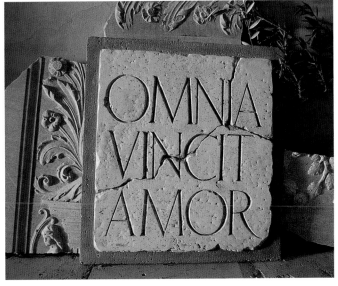

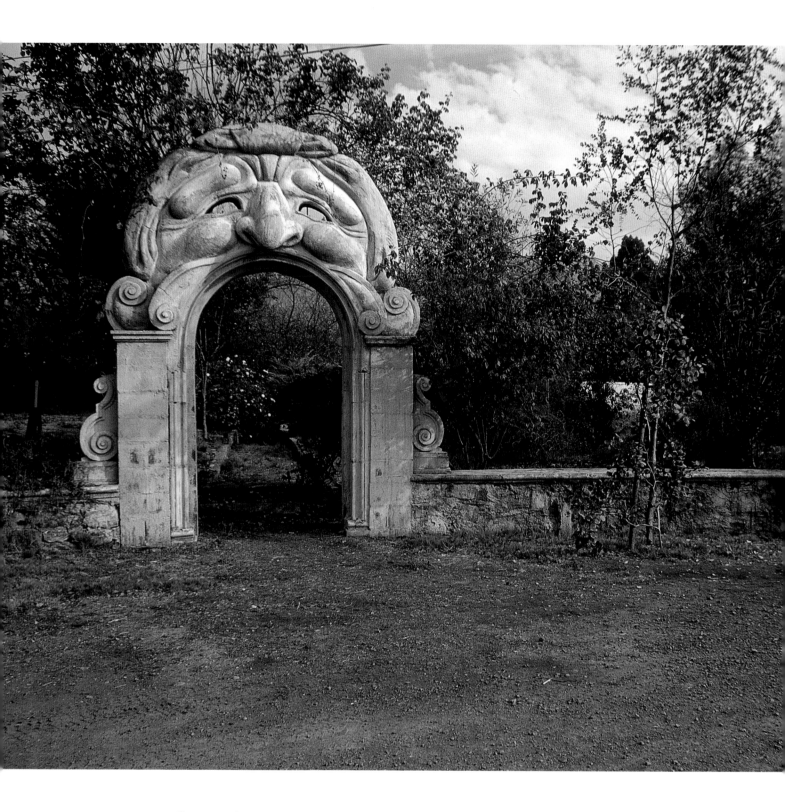

The Pantalone and Arlecchino gates were literally improvised. On an eighteen-inch-deep bed of wet-packed sand, the "masks" were carved in negative, cut in sections by means of sheet metal flats, and the sections filled with concrete. Once the cement had hardened, the sheet metal was removed, and the pieces were carefully reassembled,

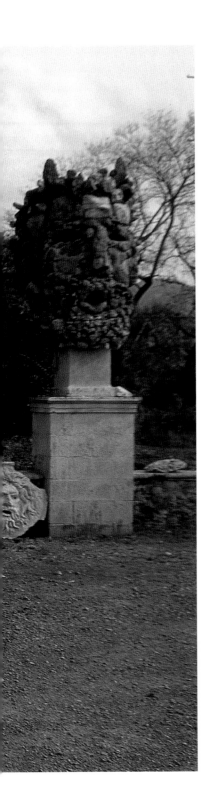

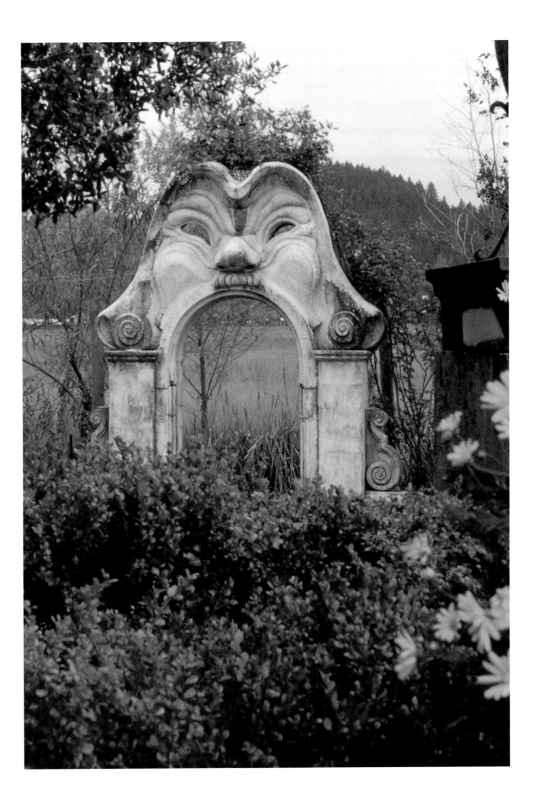

reinforced with rebar, and securely installed onto a nine-foot-high archway and pillars. All this was done by hand labor, without forklifts or heavy machinery.

The inspiration for these gates came from the Bomarzo Gardens with its mysterious sculptures and surreal mood. It was another shot in the arm to my imagination.

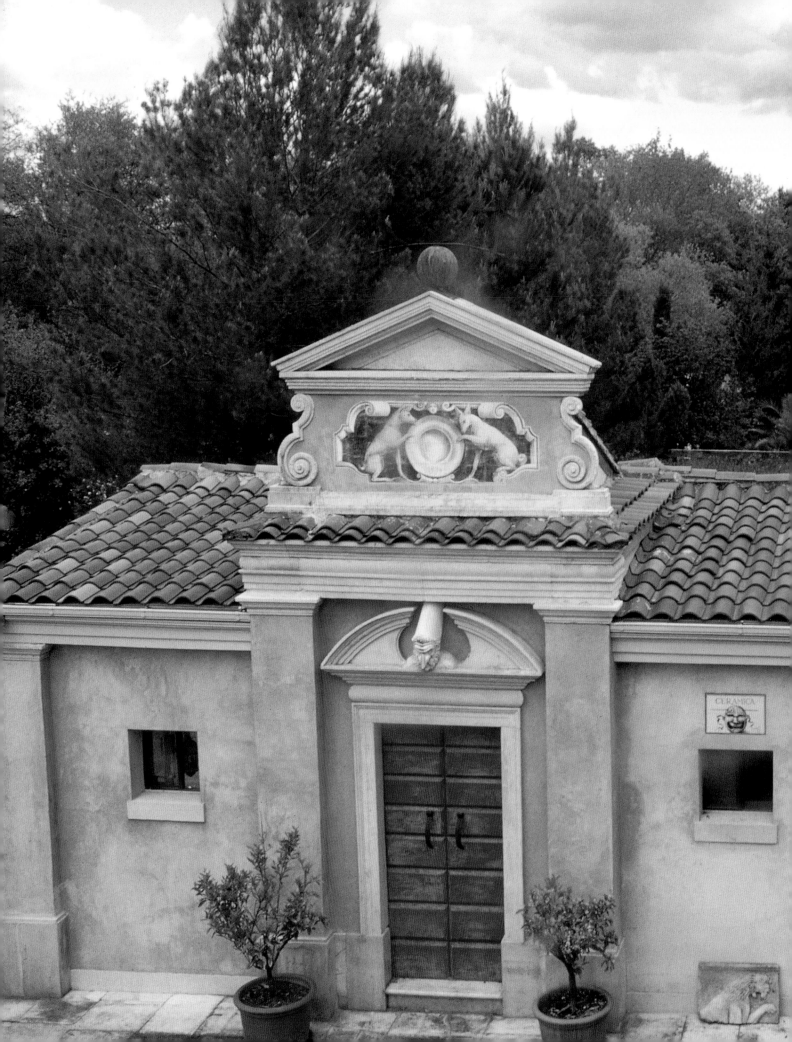

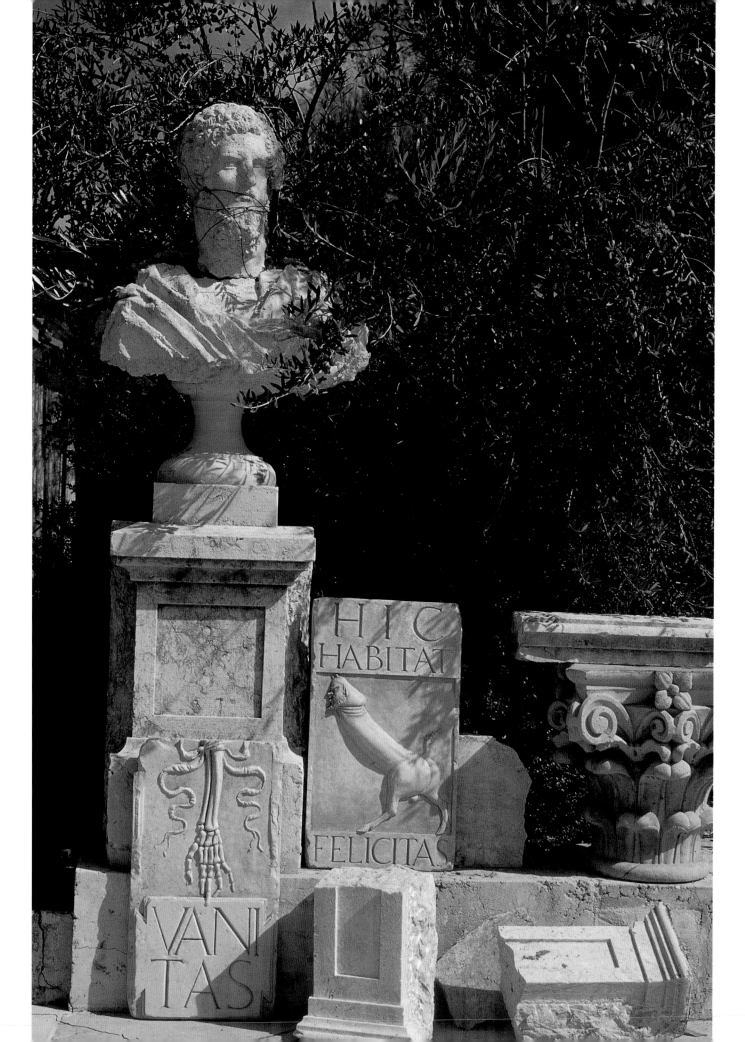

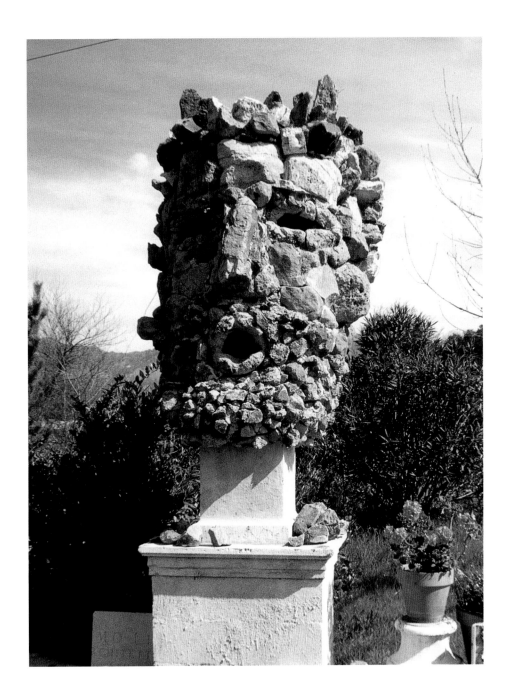

Hic Habitat Felicitas is my bas-relief version of a Pompeian bordello sign, carved in stone. "Here Lives Happiness," as it literally declared. The unidentified Roman emperor seems disinterested in *felicitas* or *vanitas*, and gazes through olive branches in stone peace. During the Triumph, a slave would ride in his chariot, holding a crown over his head. Did the slave repeat in his ears, "You'll be ruins, nothing but ruins"?

Pan is as old as the fieldstones of which he is made. One by one, the stones were balanced and stuck together from the bottom upward with a little cement. I wonder if he wishes for an earthquake to return him to Earth. His head is hollow: my hope is that birds would nest in it, so I could see them fly out of his eyes and mouth.

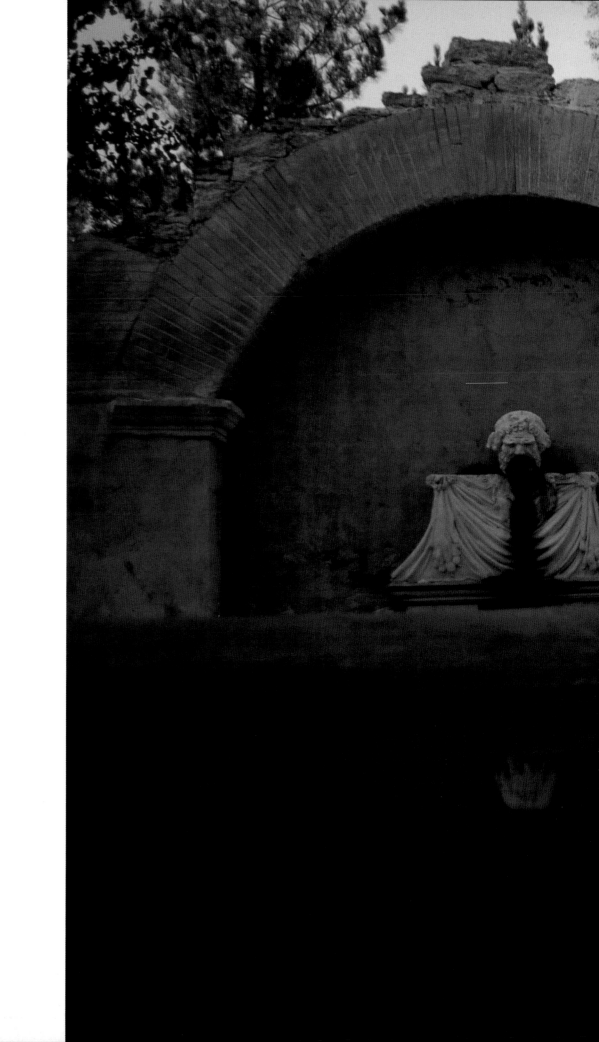

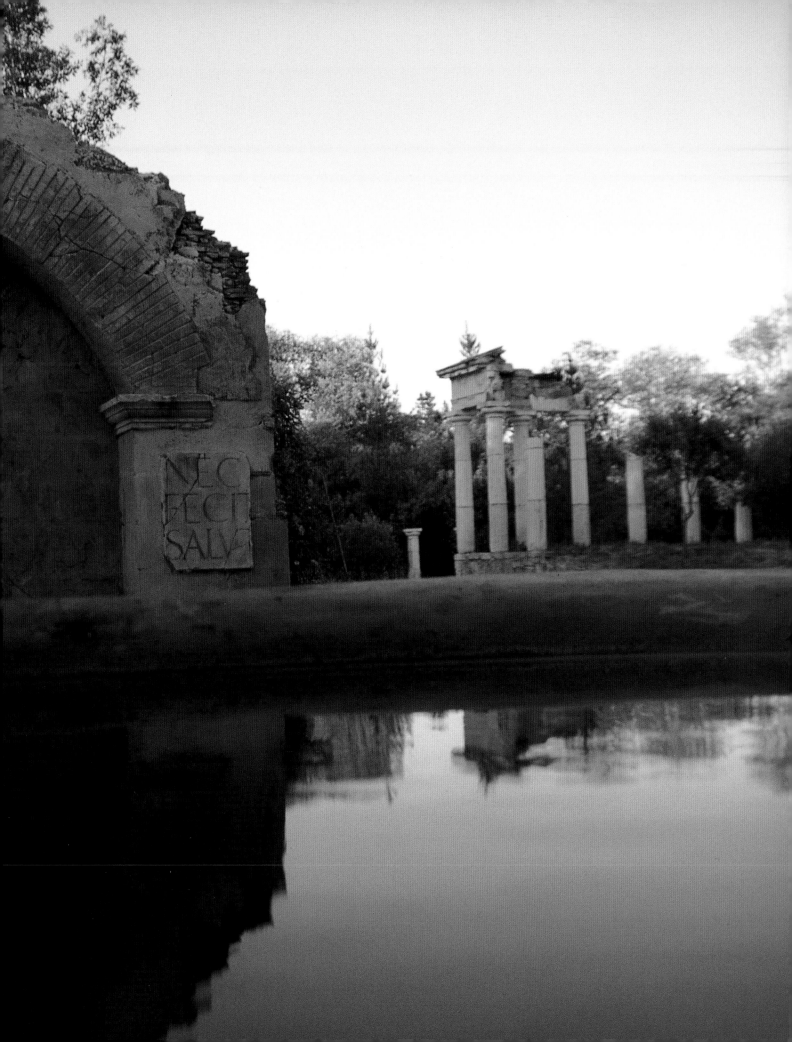

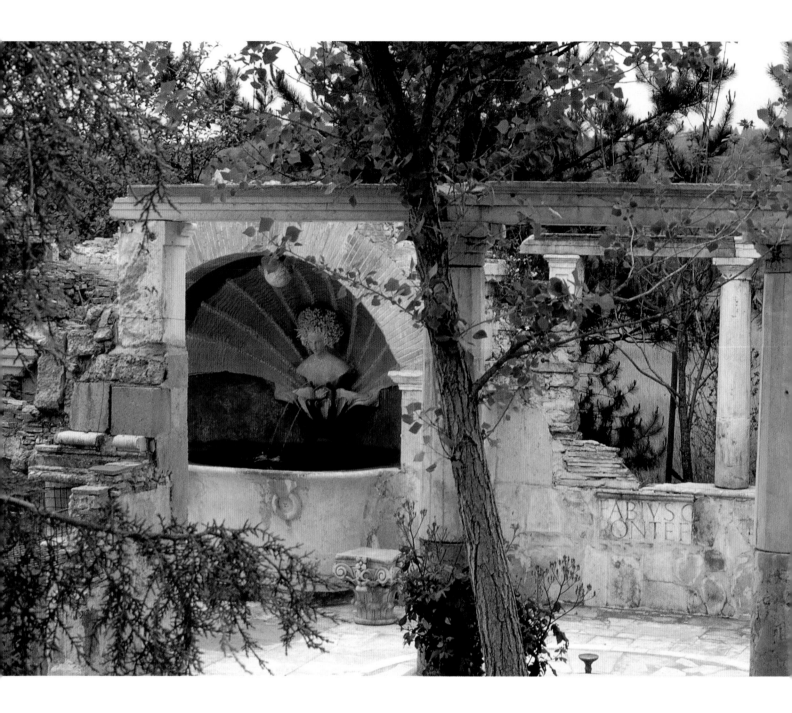

I've adopted as my soul-uncle the Roman emperor Adrian. He was a frustrated architect like me, and I admire the mad vision that made him immortal. His Villa Adriana, with its great bath complex, inevitably fanned my fervent pagan aspirations, as have the Villa d'Este at Tivoli and the nearby Bomarzo Gardens.

In a few months, *Le Terme Adriane* was conceived and realized on the same old frugal cement recipes. A well was dug, tapping into the natural thermal springs below,

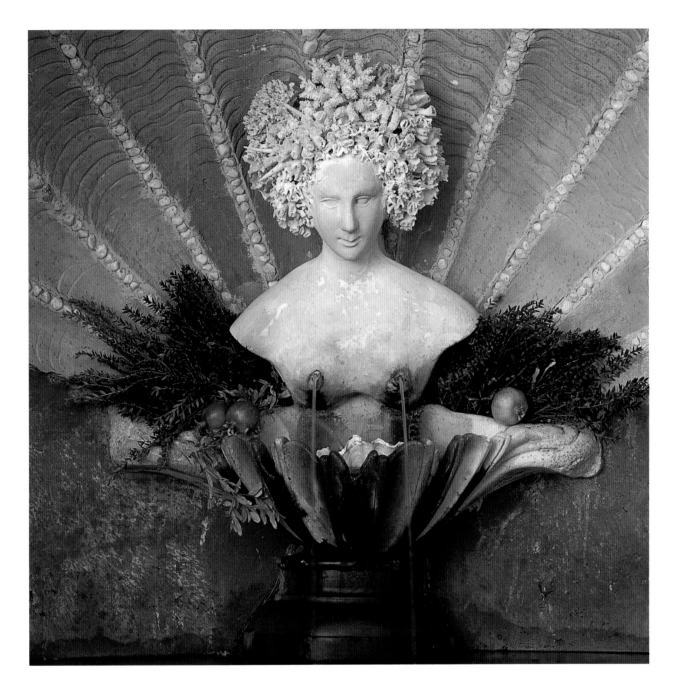

with the result of hot water at around 95°. A "Roman" tub and a sarcophagus were built around a fiberglass and galvanized metal watering trough. They receive jets of water from the divine breasts of the goddess Venus and from the mouth of a Hercules gargoyle. Venus and Hercules are my two favorite Olympic gods—beauty and love, strength and courage.

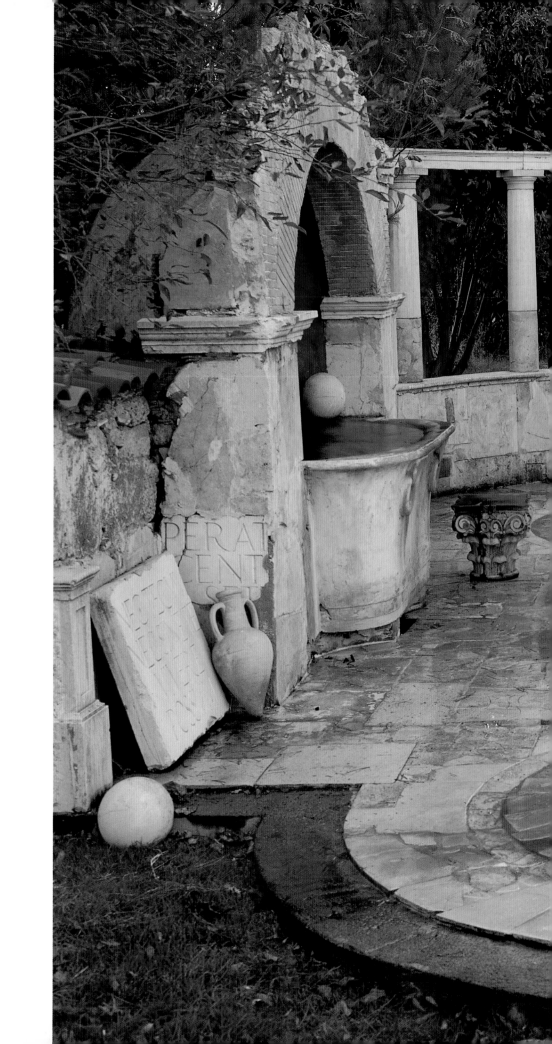

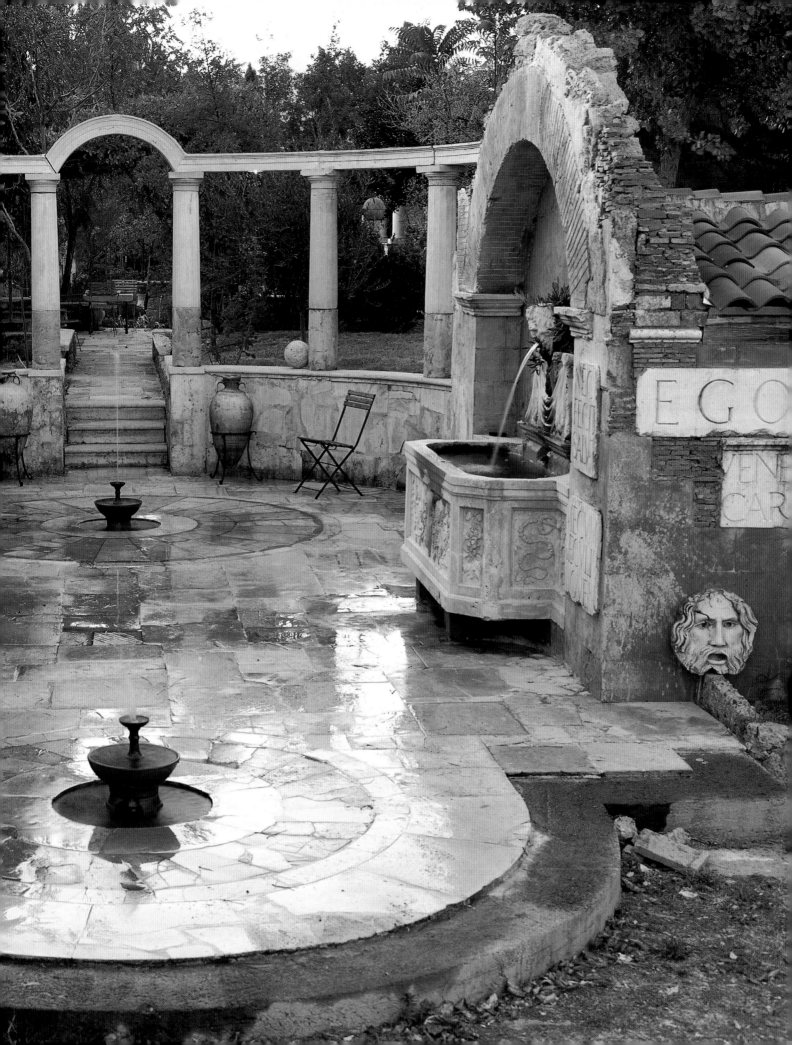

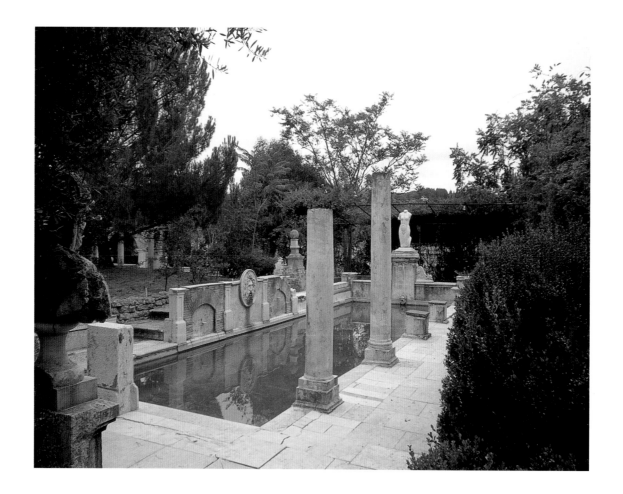

The swimming pool, a conventional twelve by forty feet in length, was a necessity in the peak heat of Napa summers. For lack of means and landscaping ideas, the pool contractor left me to resolve its final appearance. I never painted the bottom in the conventional Florida blue, and eventually, as the neo-Roman period crept in, I finished the pool with my Pompeian special—river god spouts, broken bits and fragments of cement columns. . . . Imported from Portugal, an eighteenth-century carved stone block is the base for a fiberglass display mannequin torso, transformed into a Venus by my magic touch. All these effects, near-antique solutions, are a victory in fighting the predictable trend in exterior design, a minor reconquest of the Roman Empire. (Eat your heart out, Mussolini.) At the end, it all conjures up a classical vision, where one can imagine the gods or demi-gods plunging into the Mediterranean gunite blue of this unpainted pool.

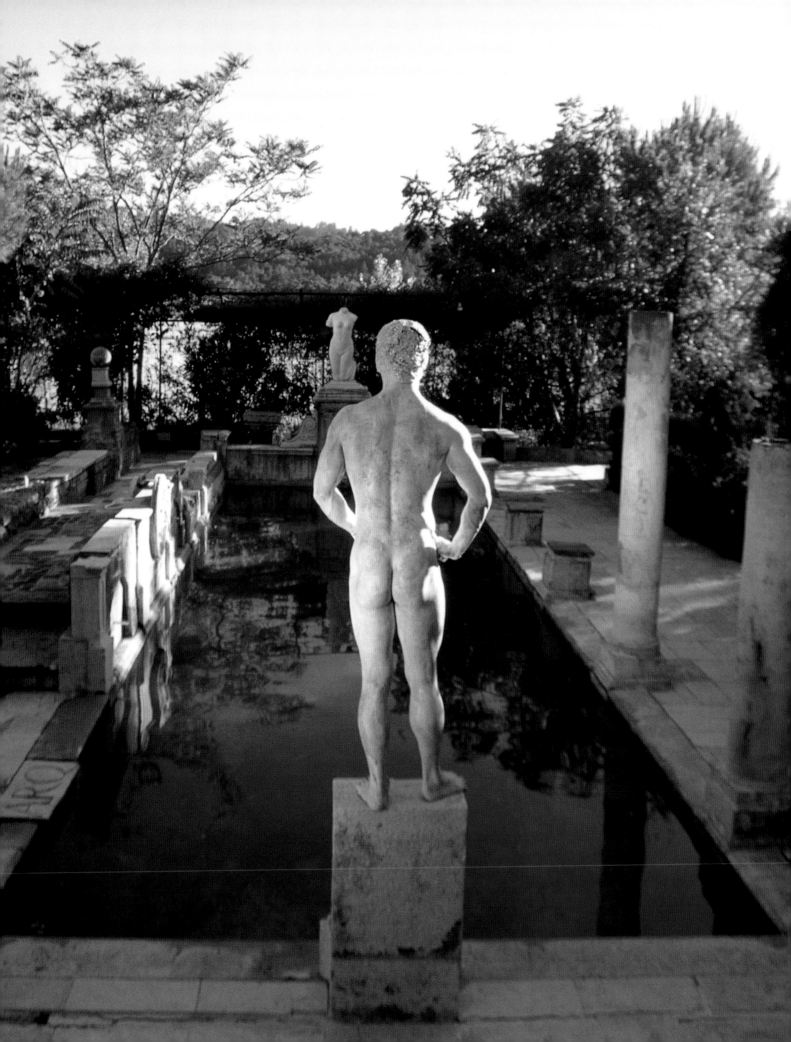

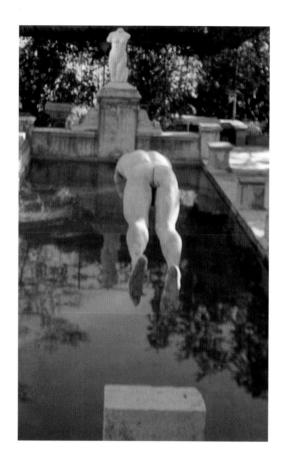

The Doric temple is one of my happiest achievements. Done in portable sections of molded cement, assembled, reinforced, and secured to the foundation, it was a miracle of eyeballed luck, scaffold hanging, and fair success at guessing on classical proportions. The entablature elements—architrave, frieze, cornice—and the metopes and triglyphs presented obvious concerns with proportion, and made me scramble for research on the Doric order through books and architectural treatises. To fail in cement would have been an embarrassment for posterity. Well, there it stands, a most eloquent and flattering complement to the glory of the Napa hills in the background.

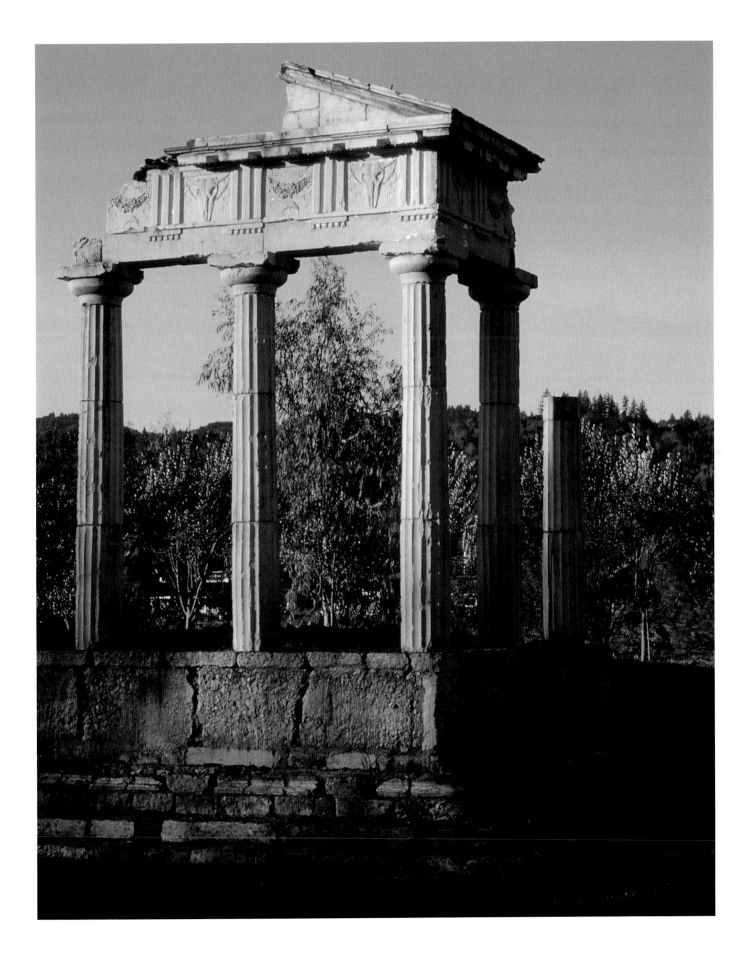

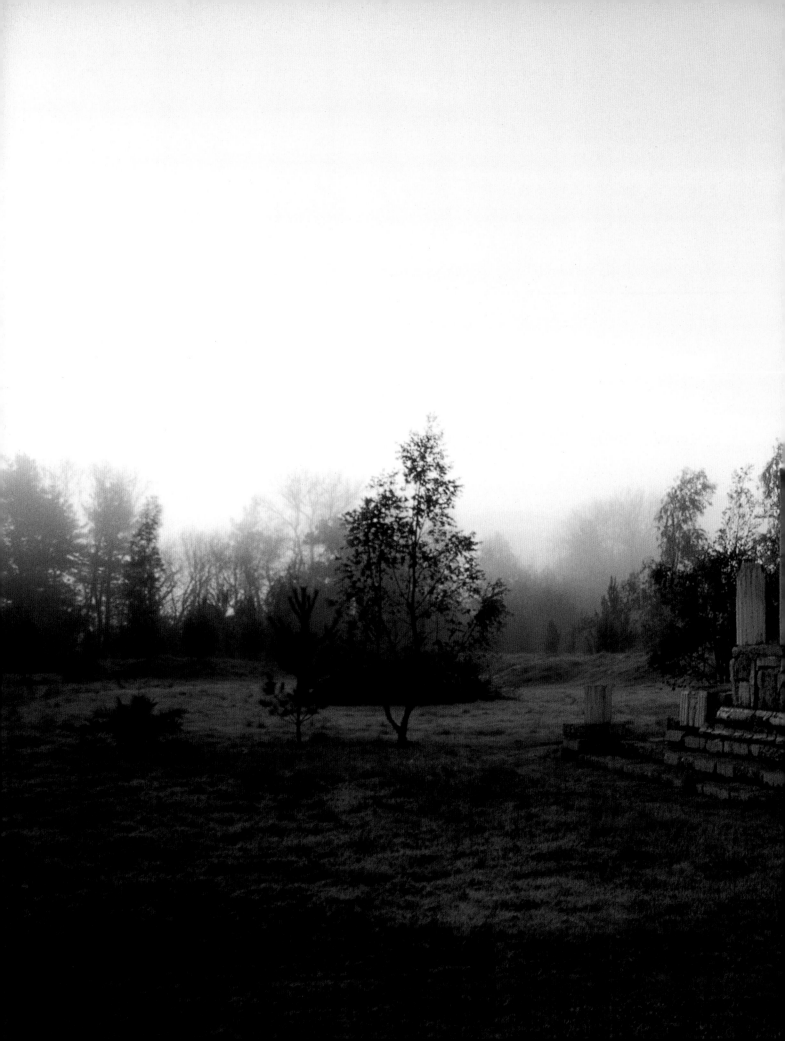

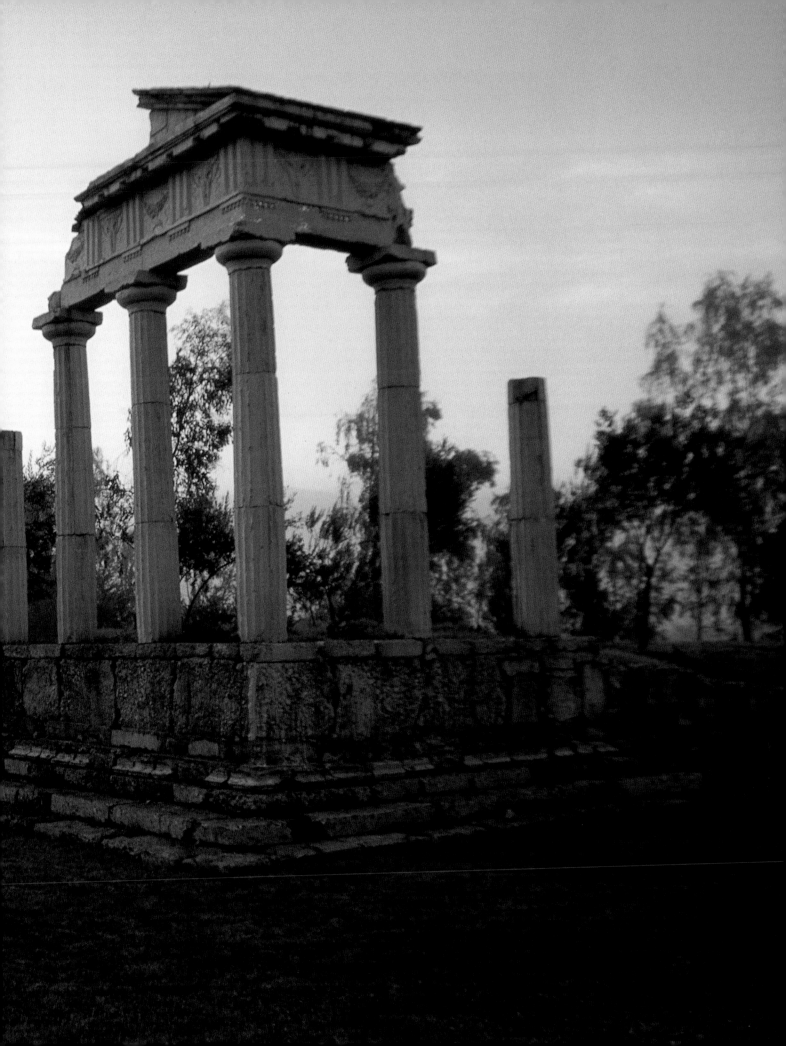

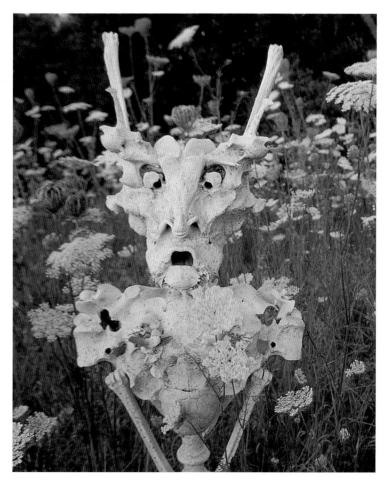

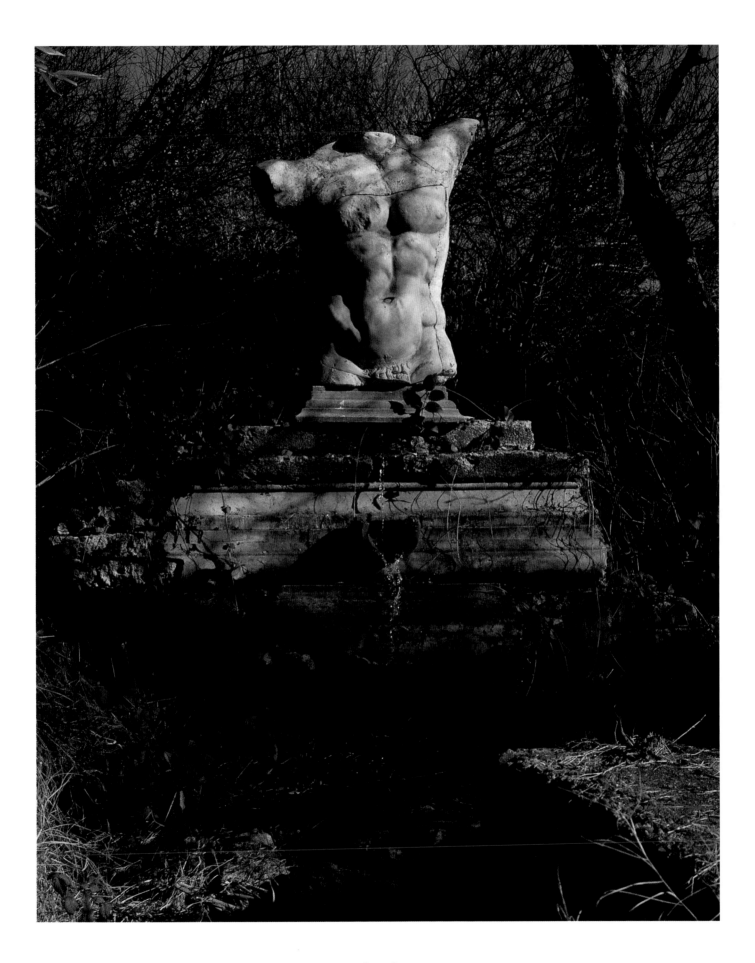

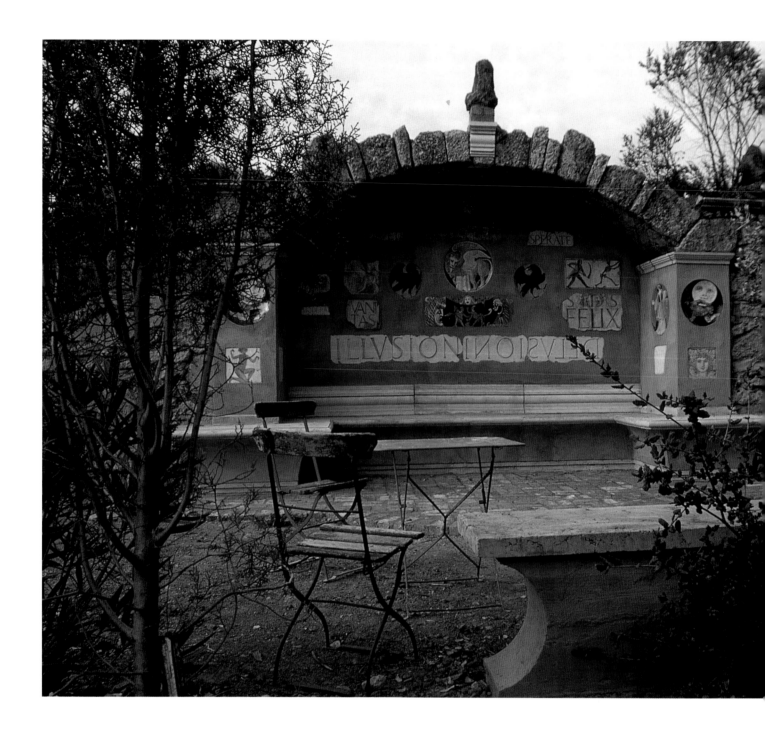

The ultimate leftovers and rejects from my ceramic kiln went to dress this pavilion of meditation, a shrine where illusion reflects delusion and the irony of our gestures. It lies alongside a shady path that leads you toward other expressive possibilities at the outdoor *Teatro Verde* and *La Grotta* (see pages 130–137)

On the right, a strong EGO seems to have suggested the plaque below: *VENE-TORIUM GLORIAE CAROLUS EREXIT,* written in stone, without modesty, and taking a risk with my high school Latin grammar . . . "Built by Carlo to the Glory of the Venetians."

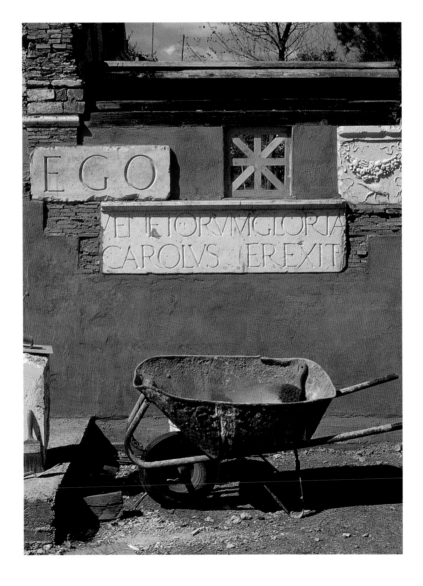

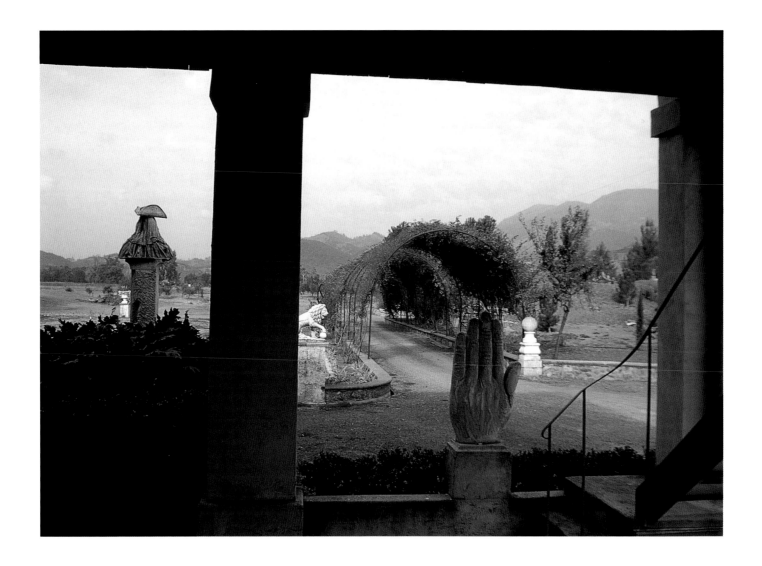

When I came to this five acres of greasy black clay, they were totally flat, and nothing grew there but some scruffy grass. I eagerly started planting trees with grand expectations, but also with a mild pang of sadness on the speculation that fifty years would have to go by to produce majestic results. Well, in only fifteen years, I have come to love the greenery that has taken root so far. Every fall and winter I keep adding to my forest of trees.

The presence of boron in the soil, due to the underground hot springs in this area, has a stunting effect on the vegetation. We had to amend it with truckloads of topsoil, fill, and manure to give the trees a fair chance to grow. Berms were built here and there using rubble from excavated public works projects in Calistoga. Inspiration turned plain-looking retaining walls into remains of ancient foundations, to which columns, ruins, and bits of statuary were added. This form of landscaping is one more example of my casual, bit-by-bit approach to solving a large-scale project. I refrained from falling

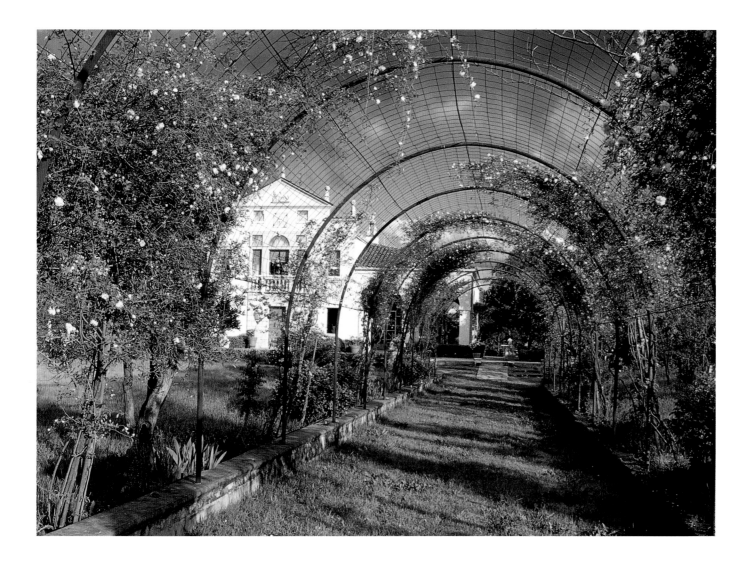

into rigid landscape schemes where plants, bushes, trees are committed to their locations by a pitiless plan, and predictably there they are. By my uncharted method, ruins crop up, earth berms prelude eventual archaeological discoveries, trees grow anywhere. The whole suggests an ancient site, destroyed, abandoned, taken over by time and nature, and finally redeemed, revealing clues to ancient riddles.

I'm sure I inherited my passion for construction from my father. He was addicted to cement and brick laying, and at his happiest when building extra rooms, fences, walls. . . . Like him, I am literally in heaven when I am in the great outdoors, in the sun, with a little breeze and the shade of a passing cloud, working on a masonry project and building garden follies. The angels are my Mexican helpers, who chirp away in their hilarious Chihuahua Spanish. They came to me with the wisdom for economy and for shortcuts in solving construction problems. From them I've learned not to throw anything away, and that there's always a way.

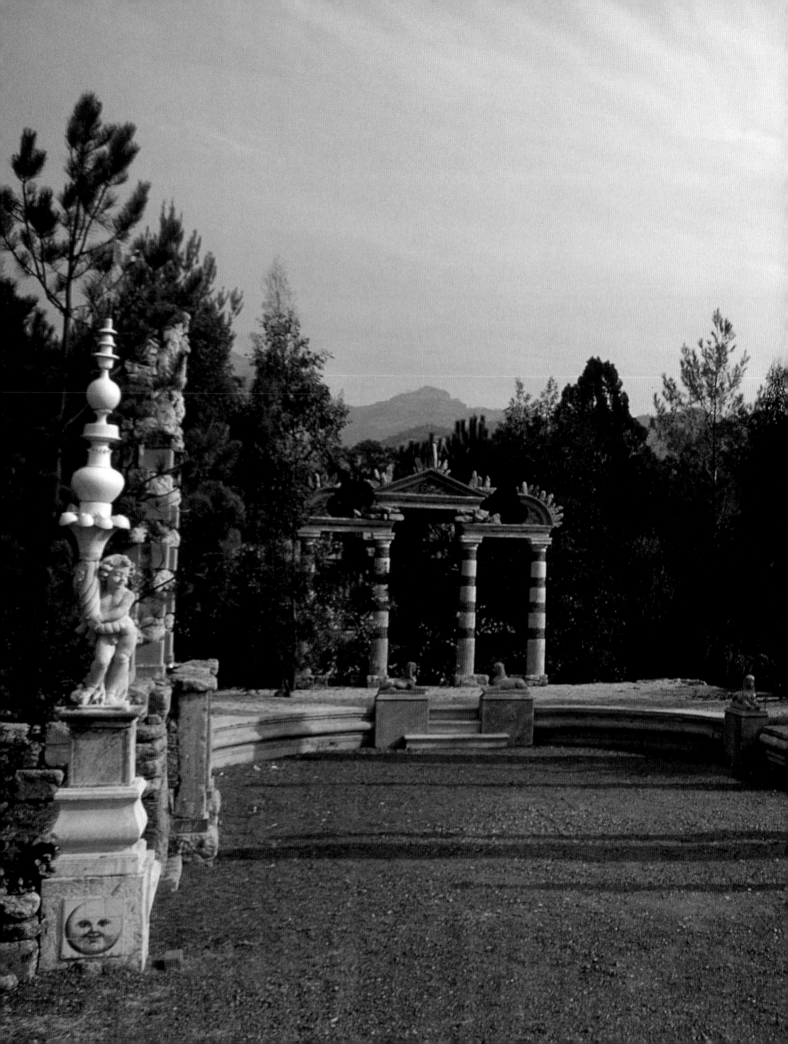

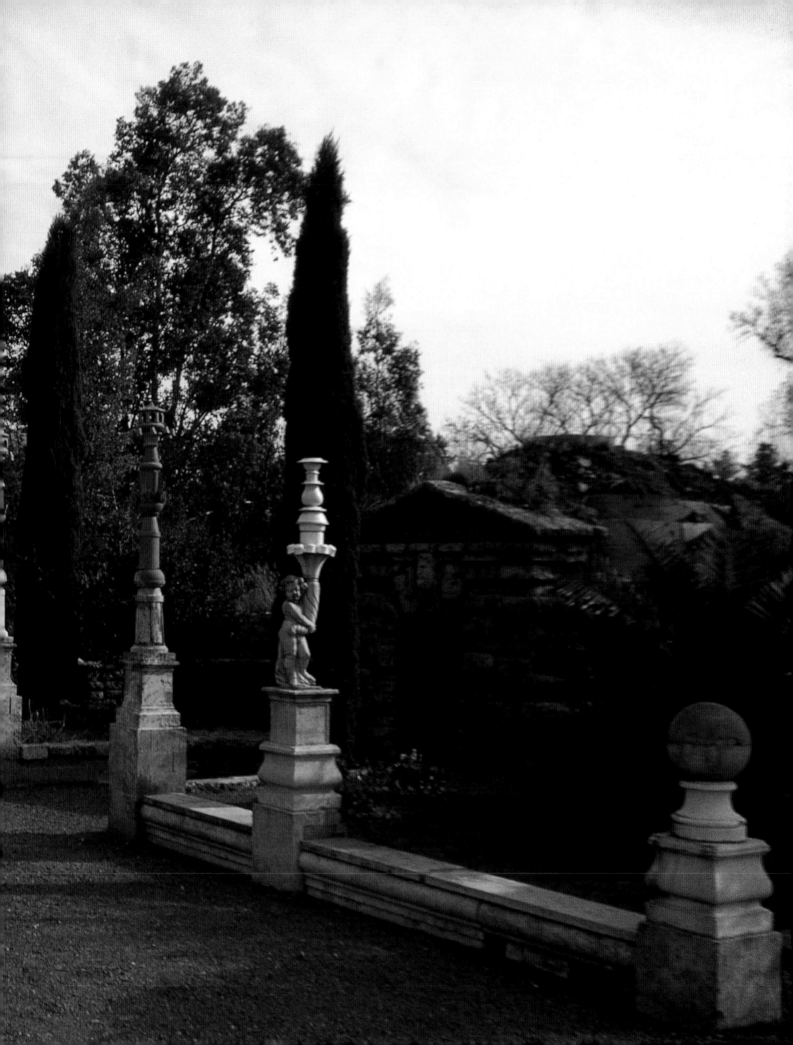

La Grotta, *Il Teatro Verde,* and the surrounding pinnacles come out of a delirium with Renaissance symptoms. Who knows why I do all this, I wonder, with a chuckle of satisfaction in getting away with another folly. Endless truckloads of road and sidewalk rubble were dumped at the villa some time ago and needed to be processed away. To do that, I had no choice but to embark on some sizable projects . . . that turned out to be *Il Teatro Verde* and *La Grotta.*

Il Teatro Verde consists of an elevated stage area retained by a curved wall graced by four small sphinxes. Four columns made of large cement *rigatoni* and broken bits of roof tile stand as a backdrop against slow-growing but nonetheless green foliage. Using chunks of cement even as ornamentation over the pediment proves the effectiveness of my usual "throw-anything-in-the-pot-it-will-taste-great" attitude. On this stage, the local theater group presented a clever performance on the *commedia dell' arte* theme on the occasion of a summer event at the villa (see page 148).

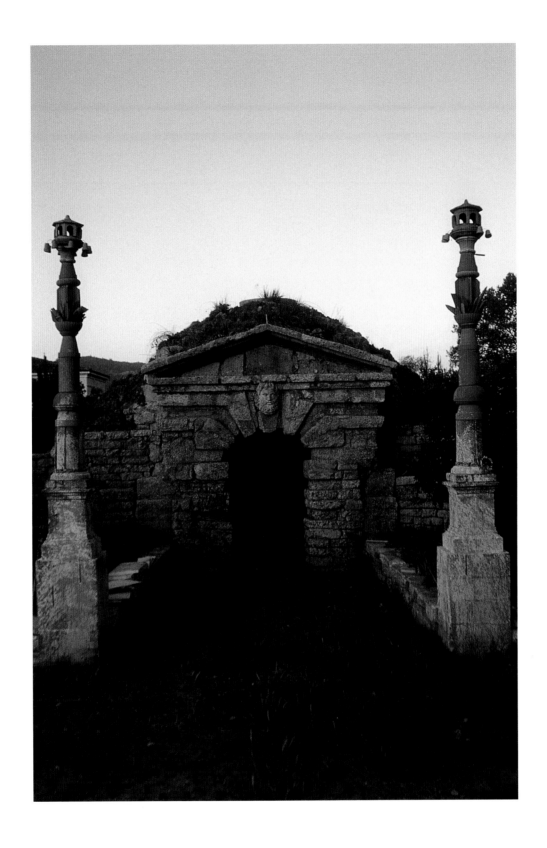

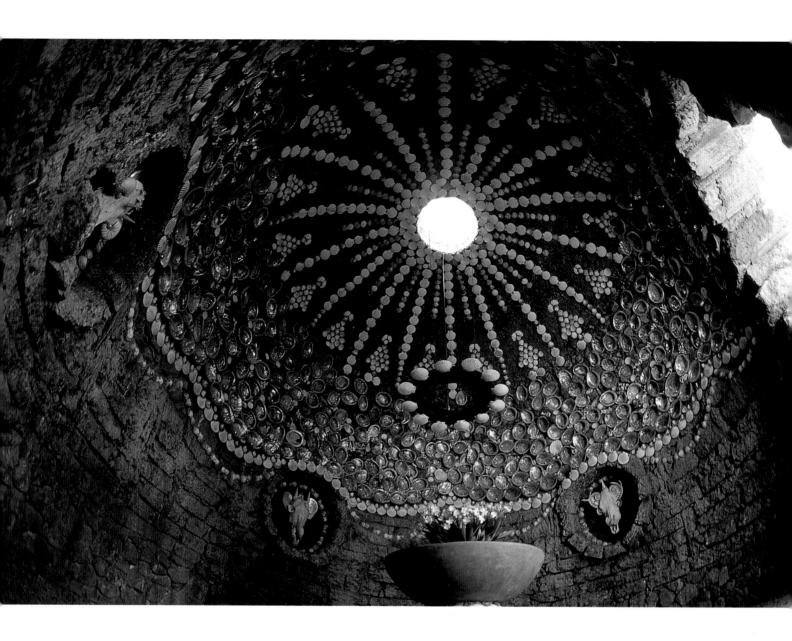

The round cell of *La Grotta* is fourteen feet wide, and its dome oculus opens at the height of fourteen feet. Recollections of the Pantheon in Rome veered me to this folly. Its construction was improvised on Italo-Mexican engineering wits, woven rebar, metal mesh, and Scotch-taped abalone shells, all secured for posterity by a hundred buckets of concrete mix. In an Aegean sparkle of seashells and mother-of-pearl, three round niches house cow and horse skulls enshrined as primordial gods. In the center is a large round table where guests gather regularly at evening dinner parties. Lit by hundreds of tiny candles, it is indescribably fantastic. (For more views, see pages 152 and 153.)

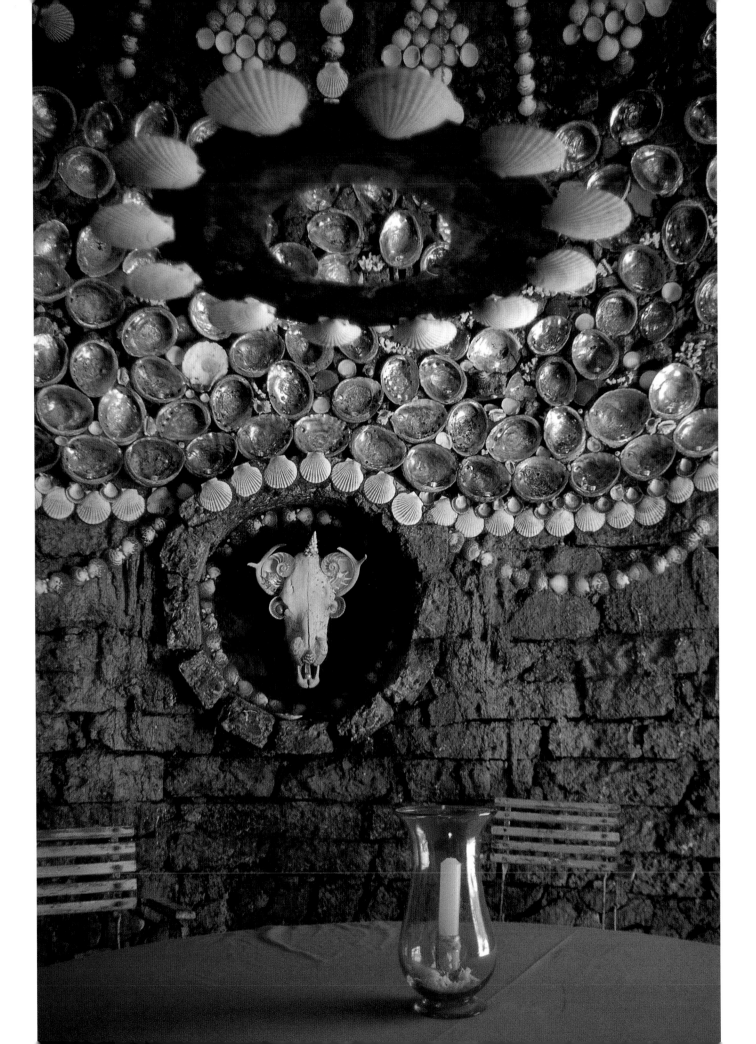

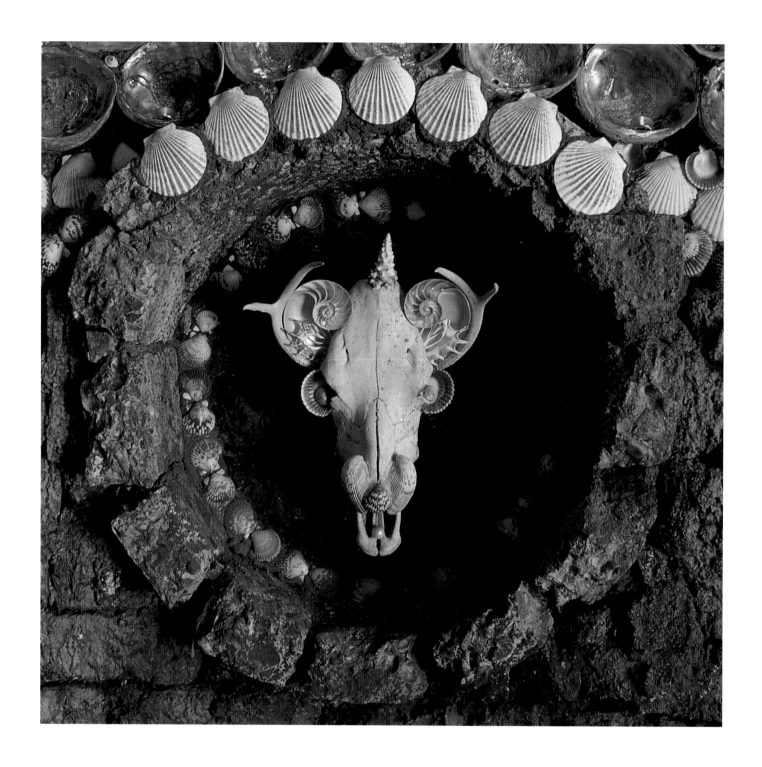

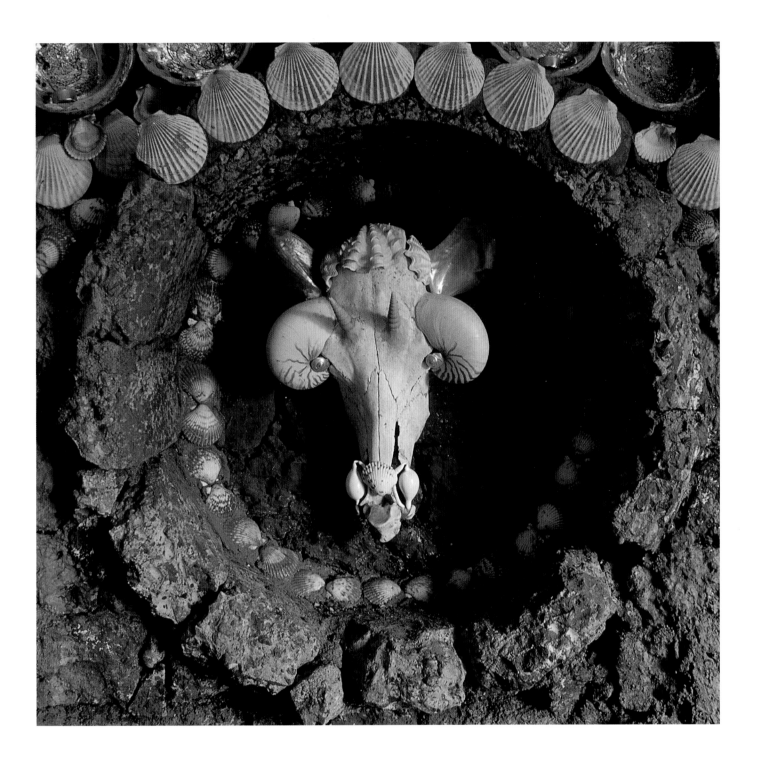

It is always Carnival time at Ca'Toga. The tenant ghosts, the figures in the frescoes, keep the masks of believe or make-believe permanently over their faces. The villa is, after all, suspended in time, unconcerned with clocks and calendars, as if shrunk and sealed in a glass globe set atop a miniature music box. When the visitor comes, he winds the key, and the tinny notes of the minuet tickle time recollections: he shakes the globe, and the confetti snow whirls about in Carnival magic.

Venice as a city is a filigree marble garden, an extravagant environment, all man-made art—beautiful, but artificial and unreal. The lack of connection with nature, trees, or wide-open fields makes one uneasy—it is a gilded cage. From this cage, Venetians could not help but crave escape and seize on any pretext to celebrate or claim freedom. It was a desire for *passatempo,* an evasion for a few hours. The Carnival then turned into a solid institution, and this "festival" with roots in the ancient Roman Lupercalia became a vital part of life. The church struggled to control it, but couldn't prevail in taming the excessive abandonment of the people. The sinners wildly hurdled over all mortal or venial lines traced by the church. Even the stern, if benign, oligarchic government attempted to curb or even prohibit the use of the masks by law. To no avail. The Venetians would rather wear the mask of the devil.

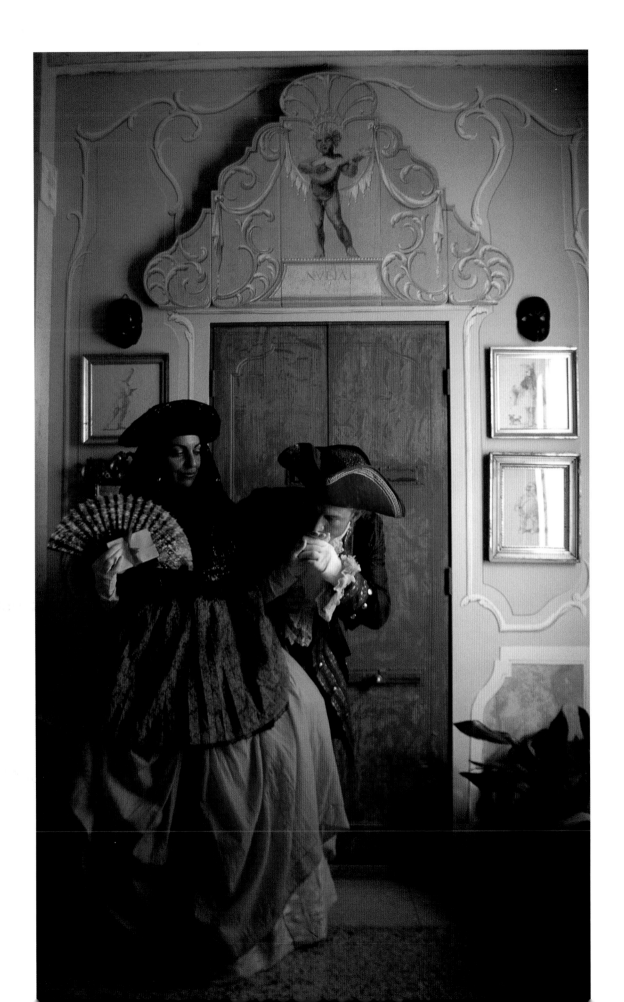

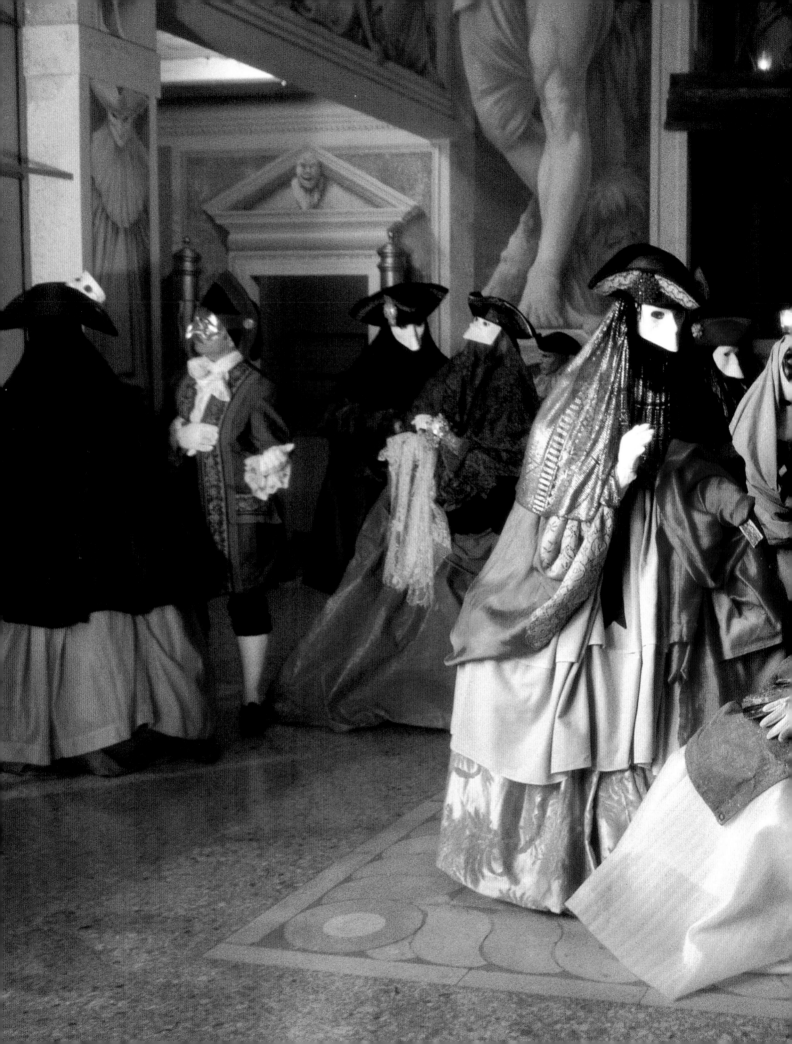

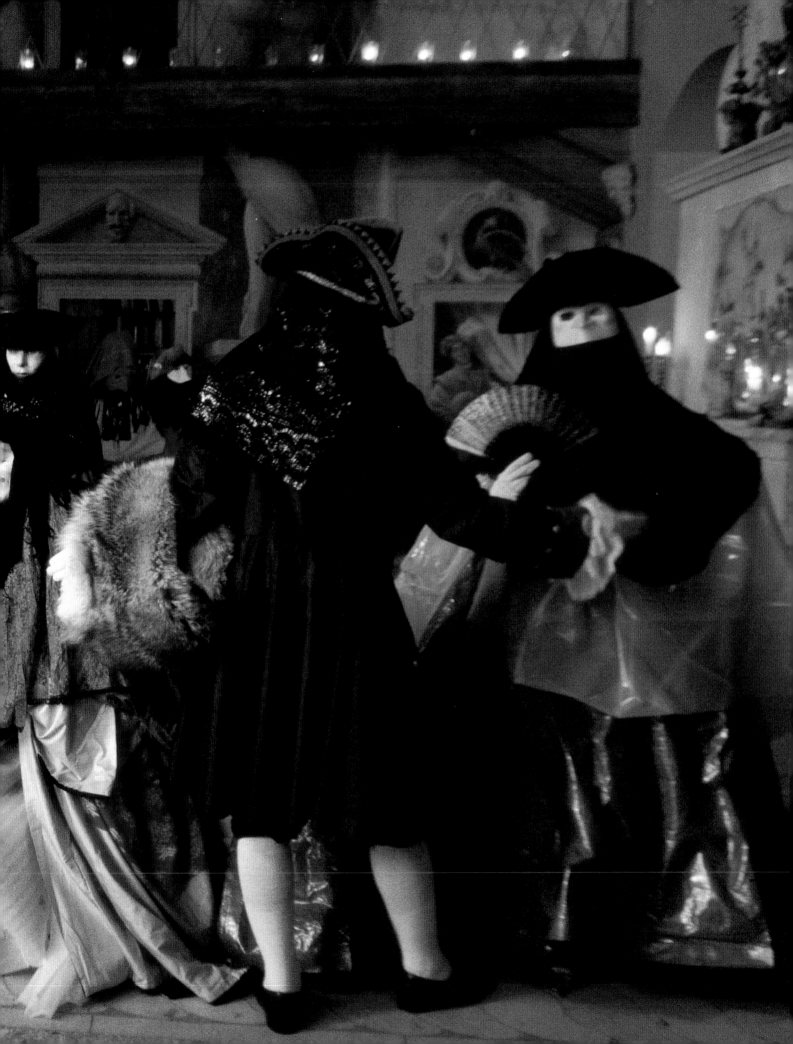

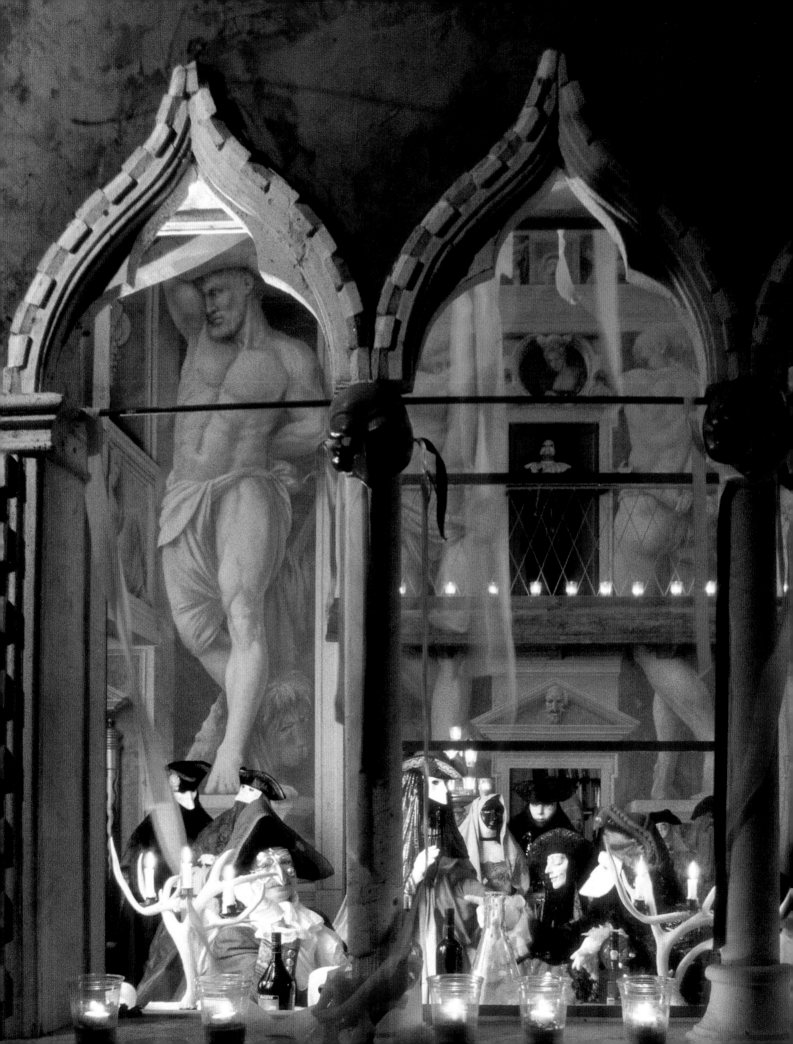

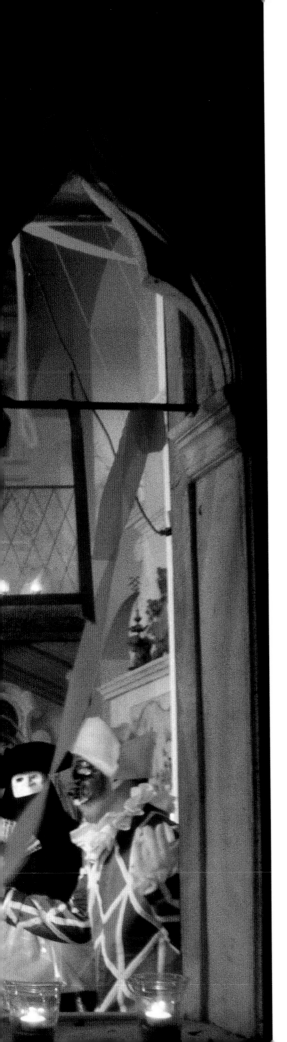

The Carnival there opened officially on Santo Stefano Day, December 26, and built up to a crescendo toward Fat Tuesday. Venetians would escape the restriction of their *salotti,* their tiny winter living quarters, into the wide unbridled space of the public stage. In the brisk, clear air of February, the young people would take to the streets, bundled up in ridiculous getups, crowding the *casotti* at the fair, eating *fritole e galani* in the piazzas. *Vin caldo* would excite them, with the complicity of the masks, into malicious, zany naughtiness. Venice in the eighteenth century enjoyed far greater freedom than any other European city of the period. It was the Las Vegas of those days, and all Europe would flock to her Carnivals to dazzle in the ephemeral reflection of happiness.

The *palazzi* were open to *feste* and gala banquets. Masked and bold with anonymity, the colorful mob would crowd the *botteghe di caffè,* the *malvasie* bars, the *casini,* or dance, stroll in the piazzas, and play pranks on the old folks.

Women in Venice were emancipated, or at least were admitted to every circle of society. A married lady would be attended by a *cicisbeo,* or serving cavalier, with the tacit consent of her husband. The effeminate *cicisbeo* would see to her whims, take her to the theater, to the cafés, to visit. The theatricality of elaborate fashions, social protocol, and status required a highly choreographed presentation, especially to maintain and strike *la bella figura* in the streets or piazzas. It required incredible attention to score a knockout blow—*far colpo*—in the grand entrances—so teatro became... religion! To this day, fashion is *tutto*—everything.

A glimpse of the elegant formalities, the élan, in the social intercourse of those days remains in the canvases by the Tiepolos and Guardi, the music by Vivaldi, and the plays by Goldoni, whose dialect still singsongs, maliciously gallant, in today's vernacular. We can still hear Arlecchino addressing a passing courtesan, she sealed in a sardonic *bauta,* he declaiming in exaggerated reverence: *"Lustrissima, schiavo vostro"* (I am your slave, oh illustrious madam). In a mocking petulance, he continues, *"Schiavo vostro—schiavo—chiavo—ciavo... CIAO."* And in that final declension is the charming, carefree Venetian salute that has been adopted by today's trendy, international culture... *ciao.*

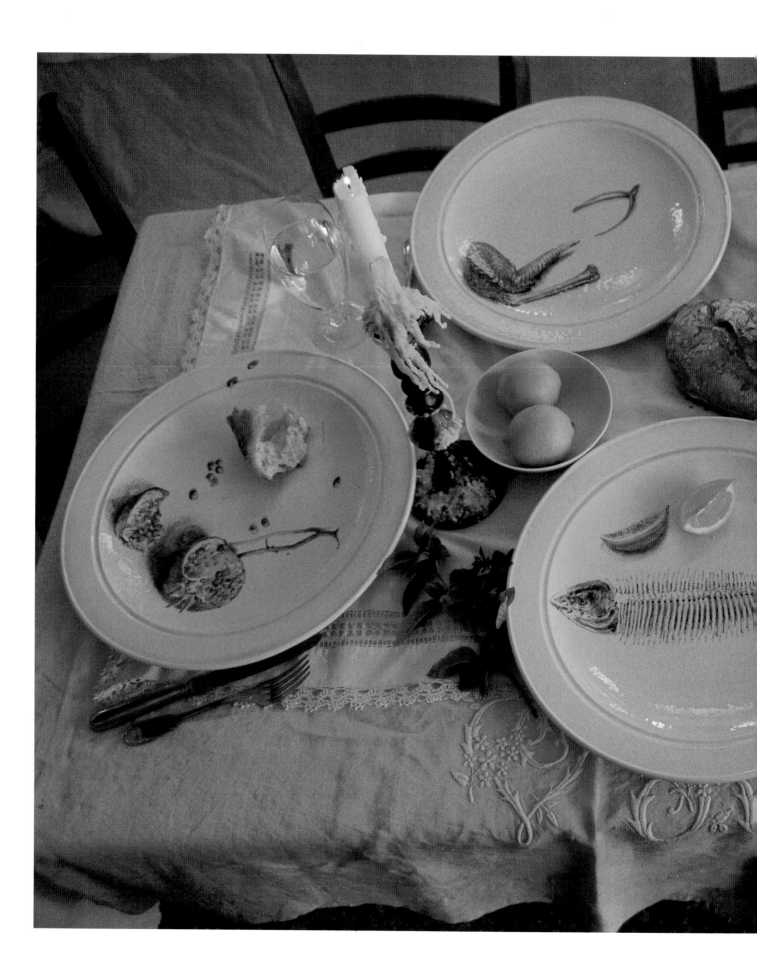

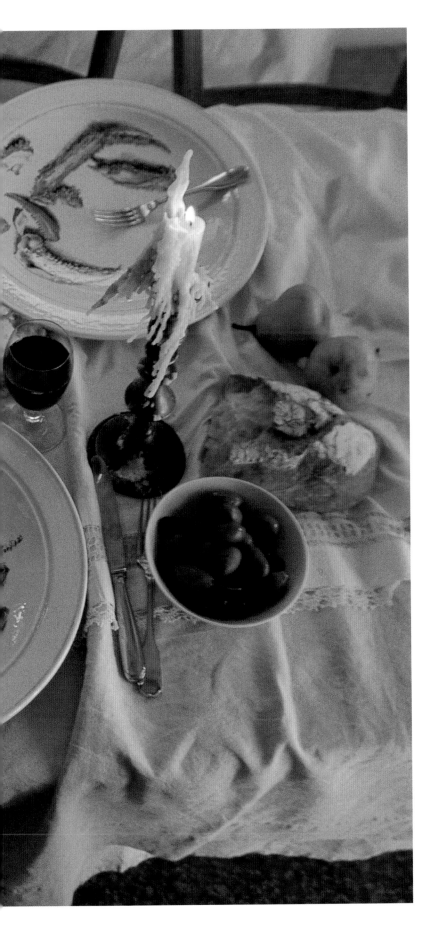

The game of illusion versus reality may fool the eye for a second, but never the stomach, so these plates are obviously another *scherzo di Carnevale*. They are to stimulate a curious desire for the spreads that the Venetian cuisine would put out on festive occasions. For sure a lot to eat, always with plenty of fish. . . .

Bacalà Mantecato (Salt Cod)

Sepe Nere (Squids in Ink)

Sardele in Saor (Sardines in Vinegar, with Onion)

Bigoli in Salsa (Spaghetti with Anchovies and Onions)

Risi e Bisi (Risotto with Sweet Peas)

Polenta e Tocio (Polenta with Chicken in Tomato Sauce)

Sopa de Tripe (Tripe Soup)

And more and more, while the sweet tooth went for *Baicoli, Zaleti, e Bussolà*, a baked treat made with both wheat and corn flours. These were enjoyed with sweet wine in the *malvasie* bars or with coffee and chocolate at the *botteghe di caffè*.

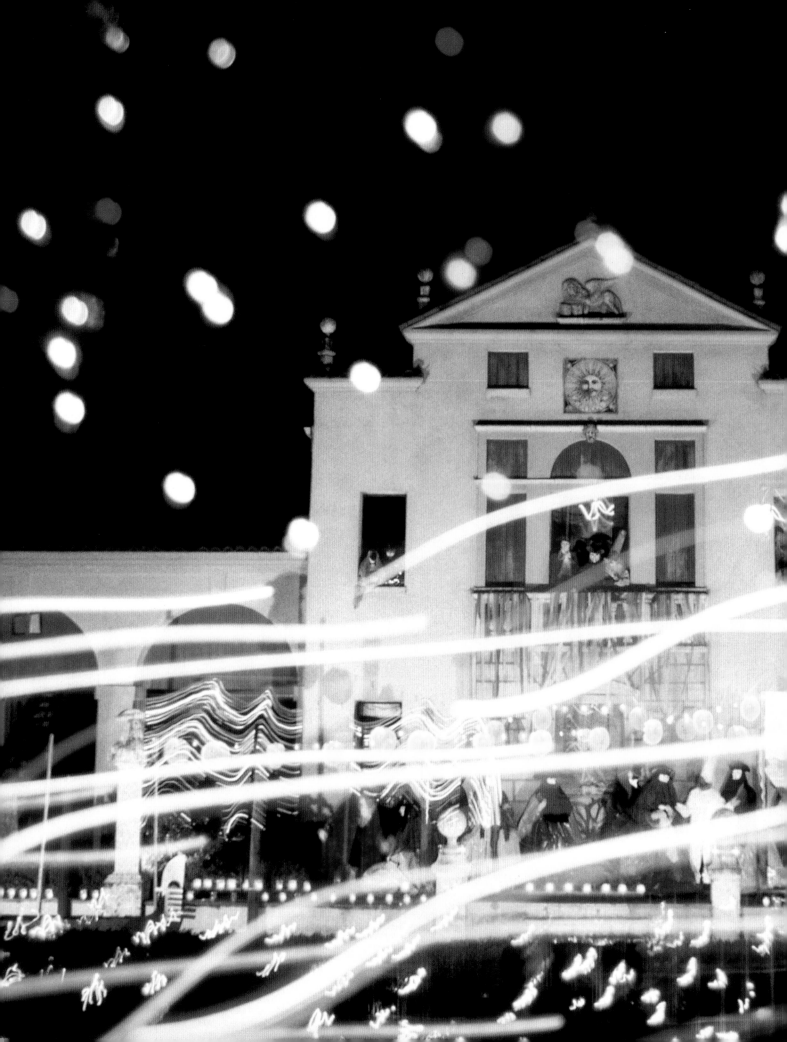

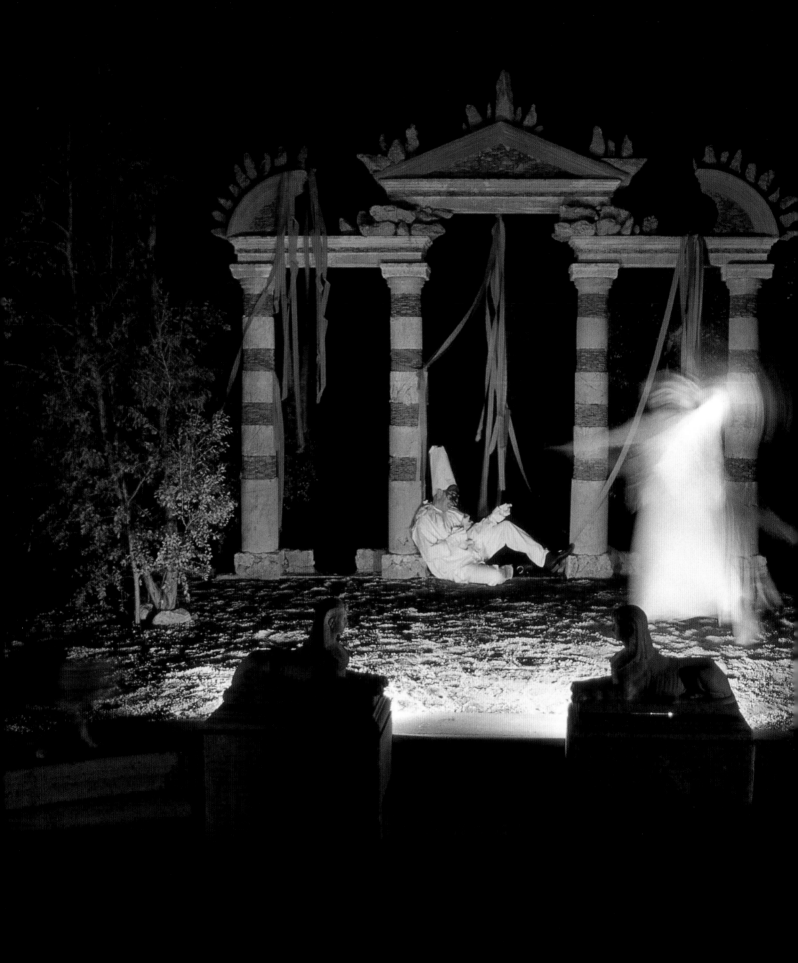

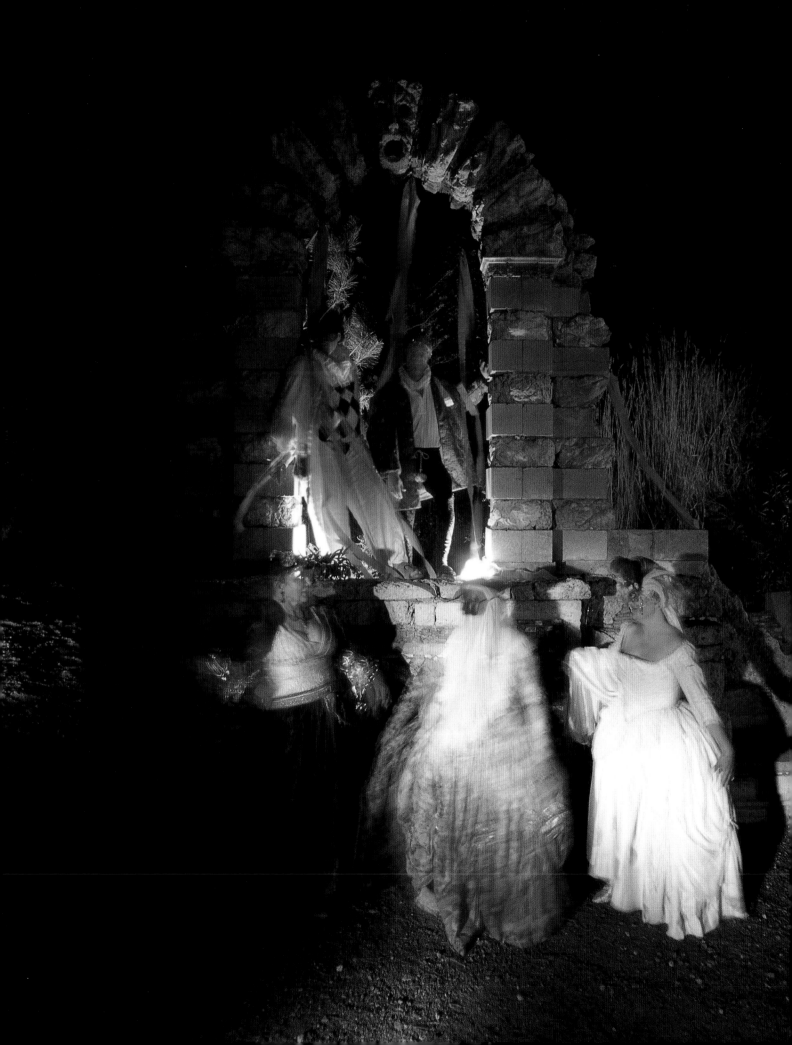

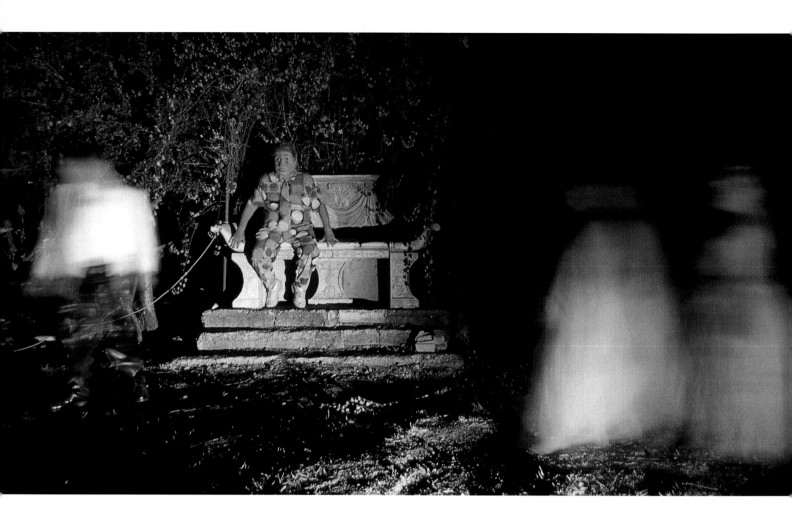

Pulcinella, Arlecchino, and Dottor Balanzone appear in the confetti-strewn piazza playing games and stirring up laughter. Then come Tartaglia, Rosaura, Brighella, and Pantalone with Colombina, all following some patricians clad in colorful capes and hats. All these characters from the *commedia dell' arte* would then reappear on an open-air stage where impromptu farces were performed with the hilarious participation of the audience. Carnival was a theater where everyone was actor and spectator. In fact, all of Venice was a theater. In the eighteenth century, the city boasted six public theaters. The Carnival season opened with a variety of stage programs, with plays by Carlo Goldoni and Carlo Gozzi. Vivaldi would write scores for the operas and for the *concerti delle putte,* the all-girl orchestras from the orphanages.

Pantalone dashes out to welcome the dinner guests who have come to the country for *la villeggiatura,* the summer vacation. The hot and humid spells of Venetian summers would make people literally scramble *a goderse le arie de campagna,* to the balmy air of the countryside, to seek relief in the cool spacious hospitality of the villas. Tonight, the guests will be served dinner *alla grottesca,* in the grotto.

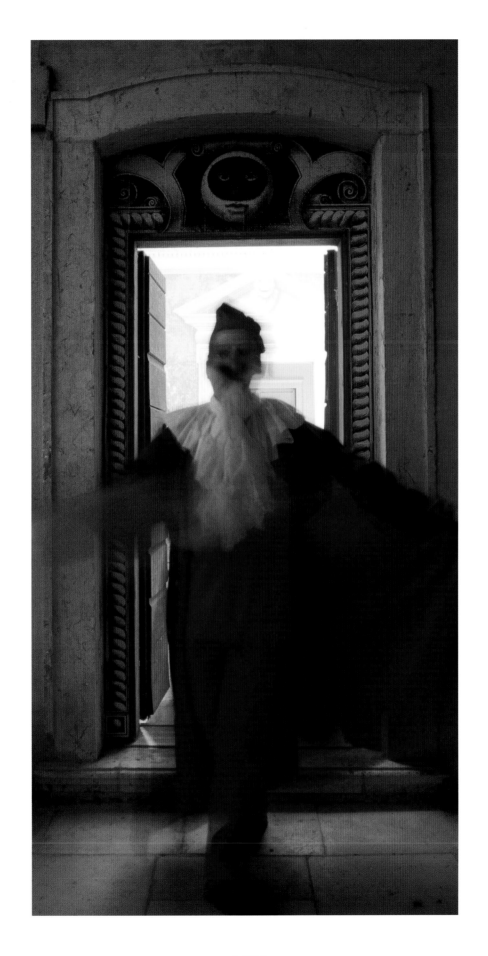

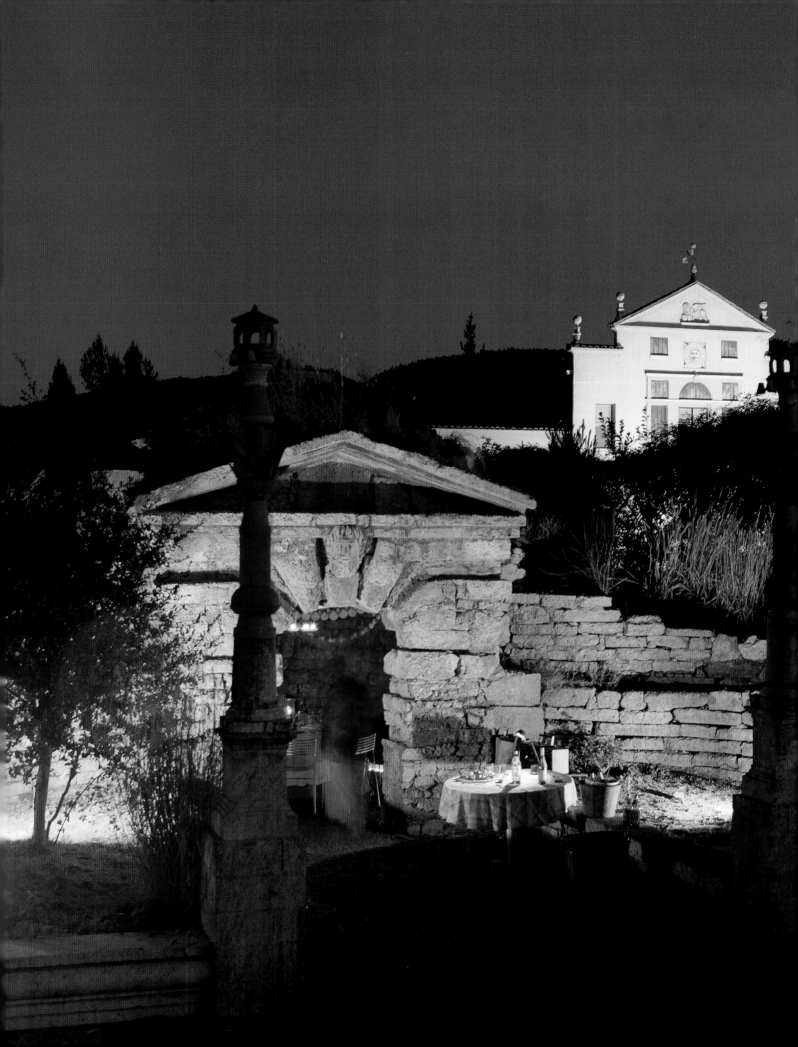

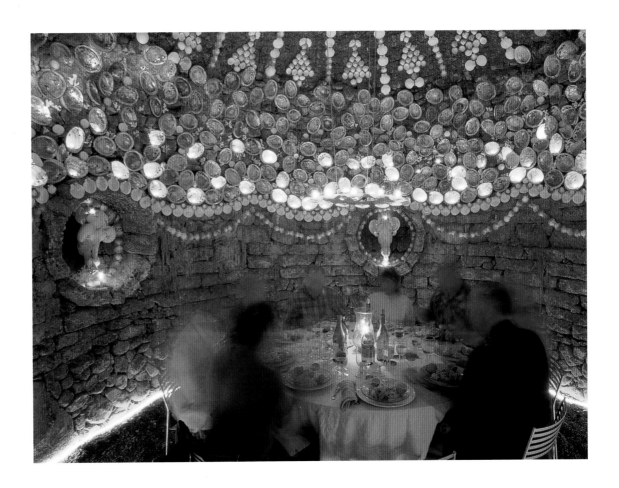

Dear Carlo and Tony,

I dreamed all night about 500 candles sparkling in 500 seashells. Thank you for a magical evening in your grotto. We loved every moment, the company, the food, the wine, and the fantastic place. You are a genius Carlo and that dinner could have taken place 2,000 years ago near Paestum or Herculaneum. You give so much excitement and enchantment to the world, taking us out of daily drabness into the territory of the imagination. . . .

Saluti e complimenti,

Margrit and Bob Mondavi

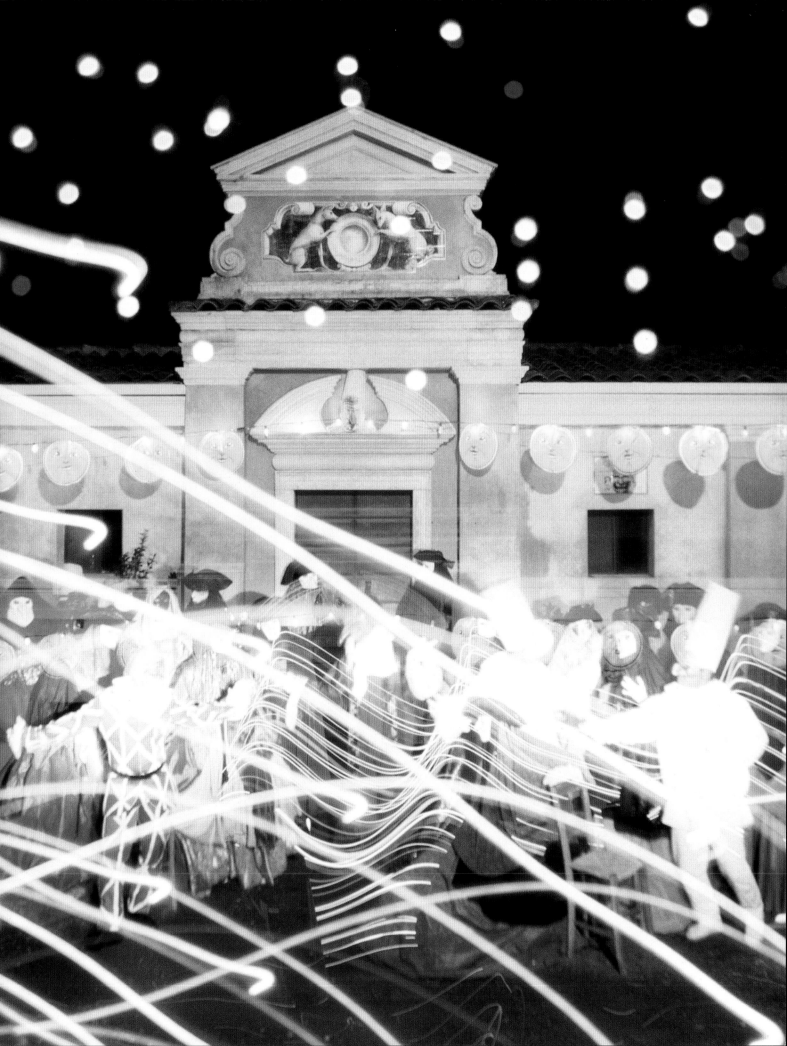

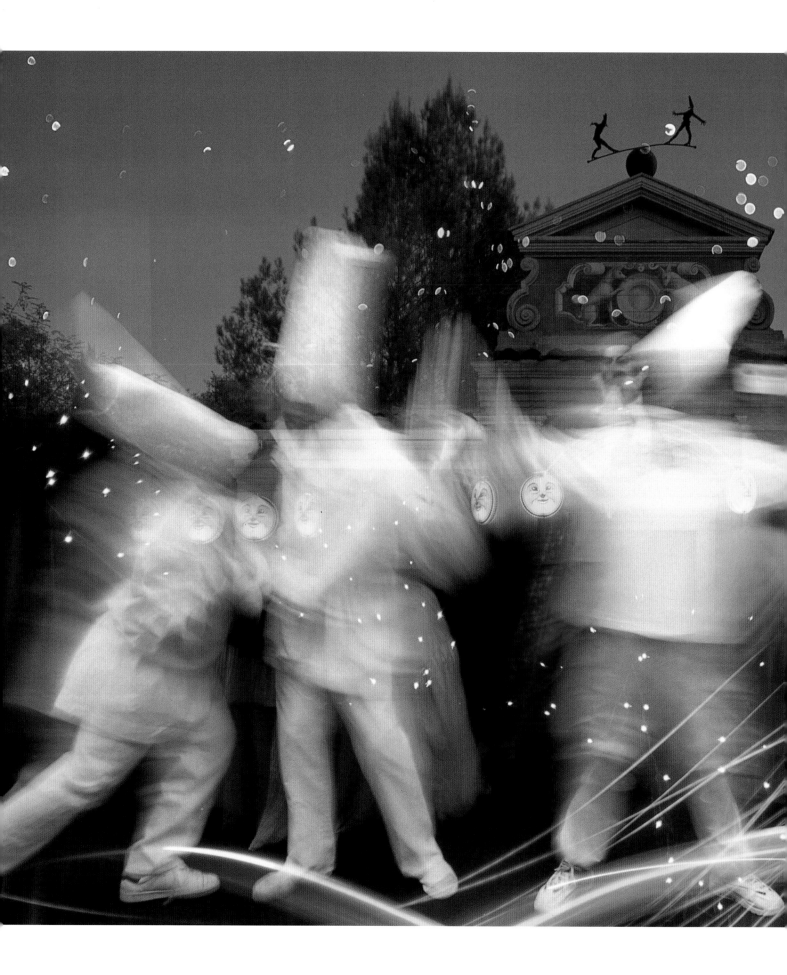

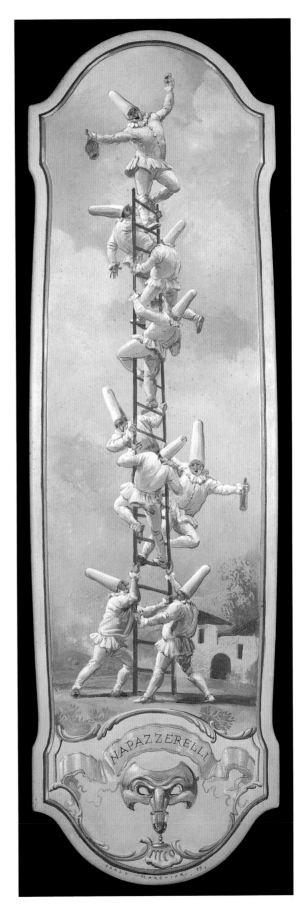

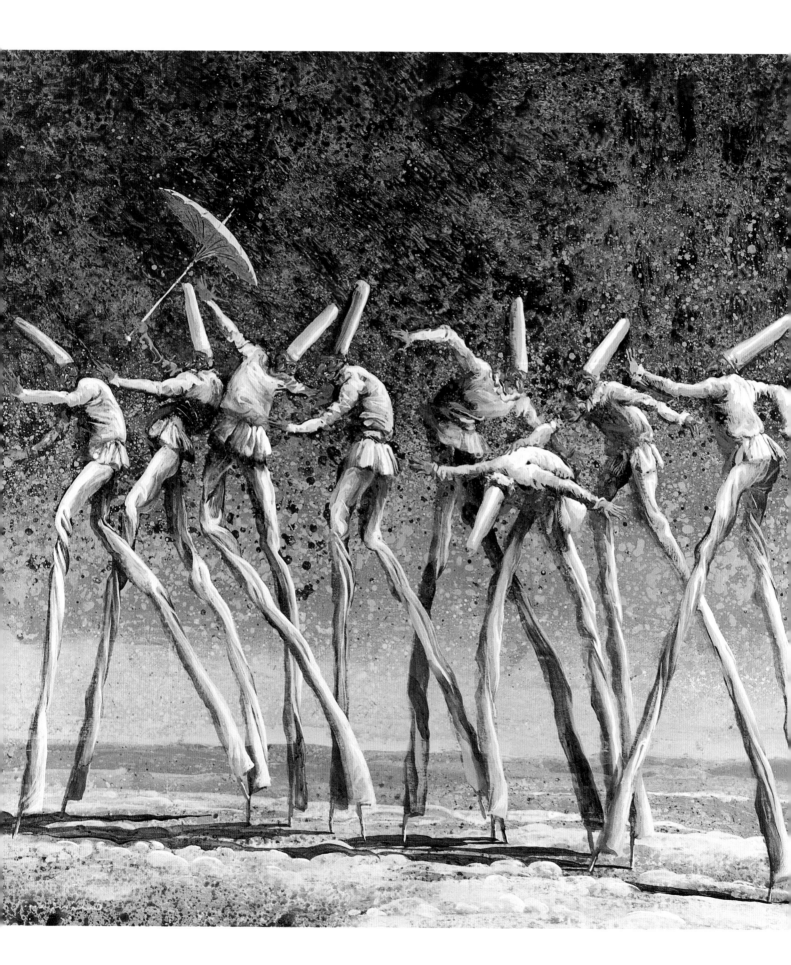

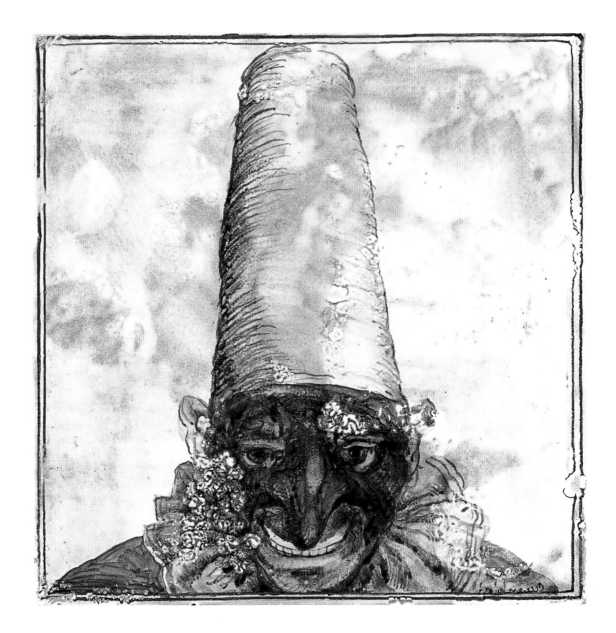

Pulcinella is one of my favorite subjects. He was the stock character from Naples, a melancholic complainer, his soul singing and crying at the same time, his stomach never quite full. He was a pathetic ruffian, always pulling pranks, always volatile in emotion, and forever the victim of bizarre situations. My Pulcinella comes from the Tiepolos, father and son, who favored this mask in their paintings. Their Venetian version differs from the Neapolitan prototype. The hat is taller, exaggerated to resemble that of a Turkish whirling dervish, and the mask is red with a larger nose than the Neapolitan black version.

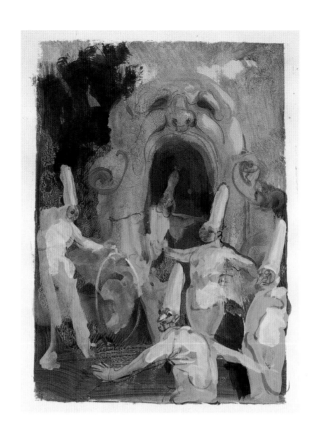

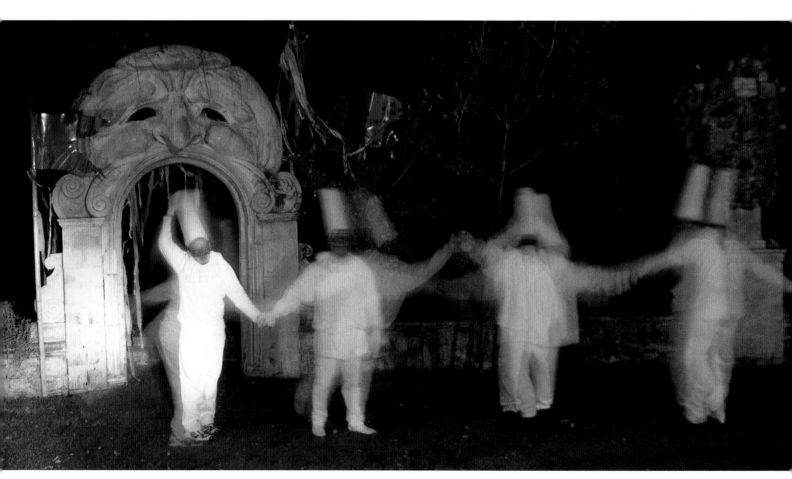

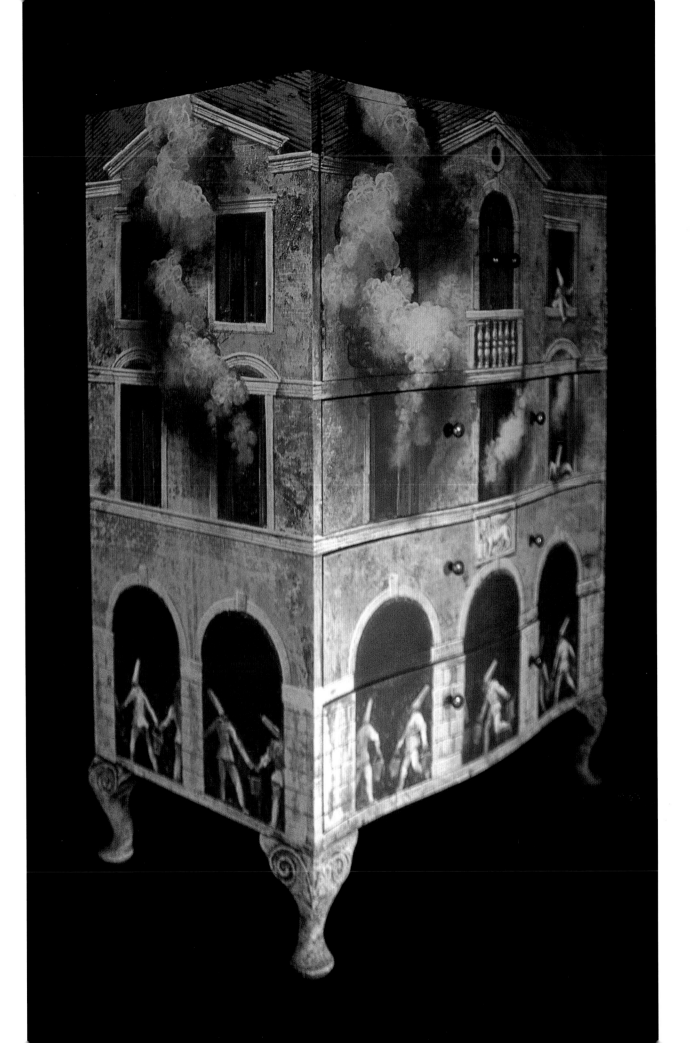

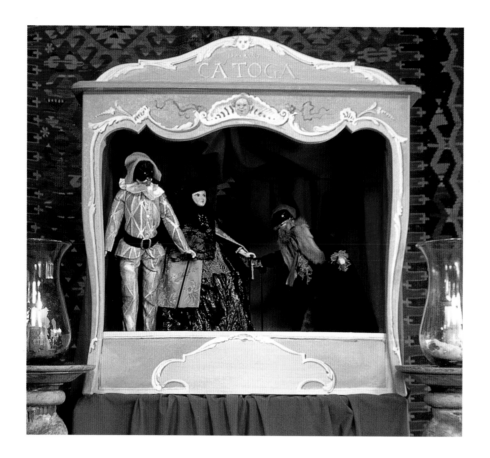

Le marionette were always very popular, and numerous *teatrini* would move about and set up wherever crowds were gathered and an audience could be found—at fairs, at marketplaces, or in the *campielli*. A *teatrino* would be called into the *palazzi* to entertain at children's parties or be invited to perform even in nunneries' parlors. Arlecchino and Pantalone have stepped down out of our own *teatrino* for a game of *briscola* in front of the fireplace. Arlecchino is the manservant, stupid, gullible, and forever hungry. He is also witty, vulgar, and shrewd, and we see him here once again trying to cheat poor Pantalone.

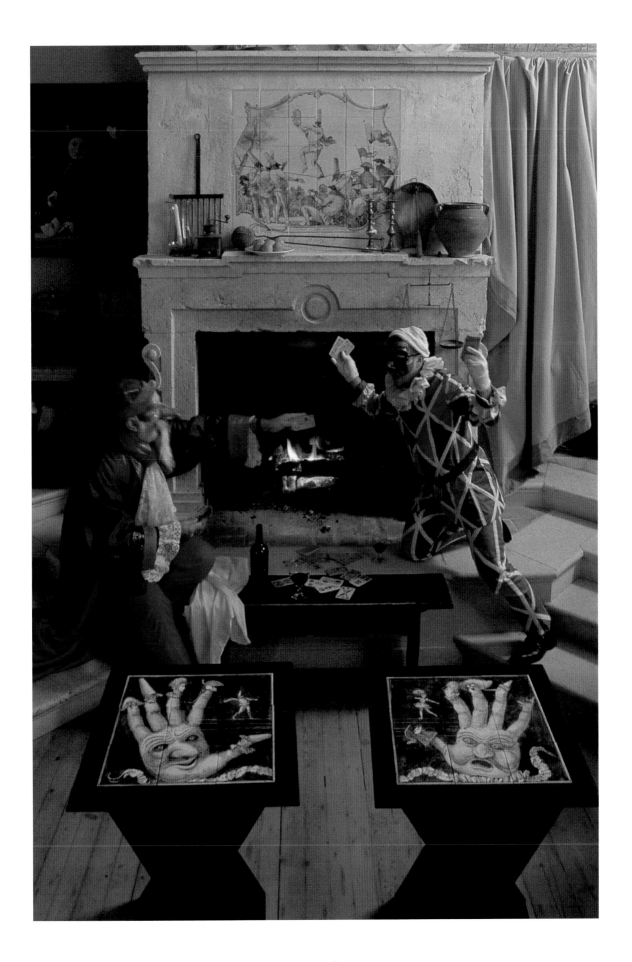

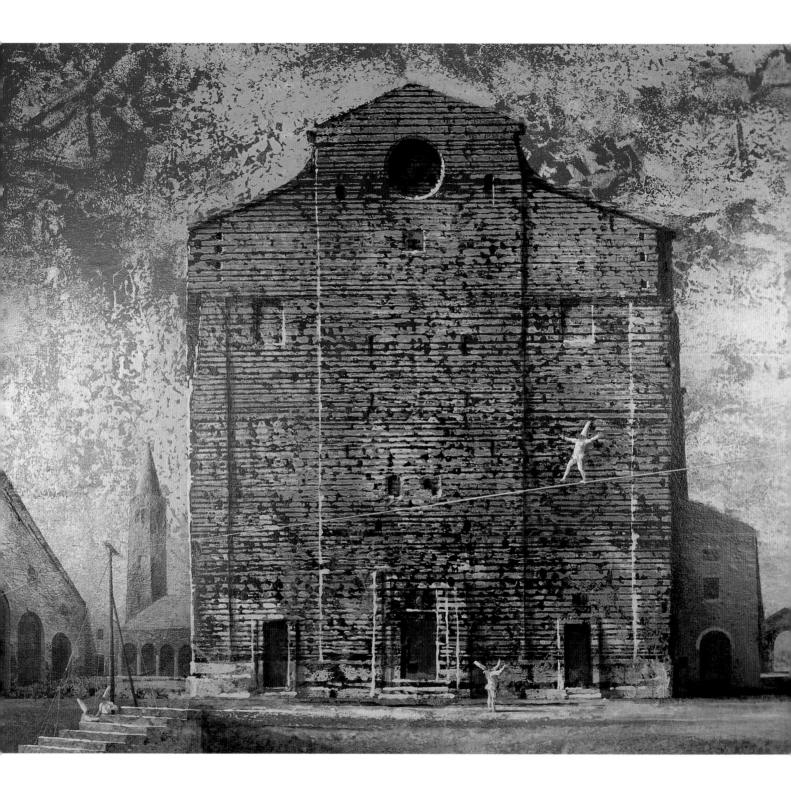

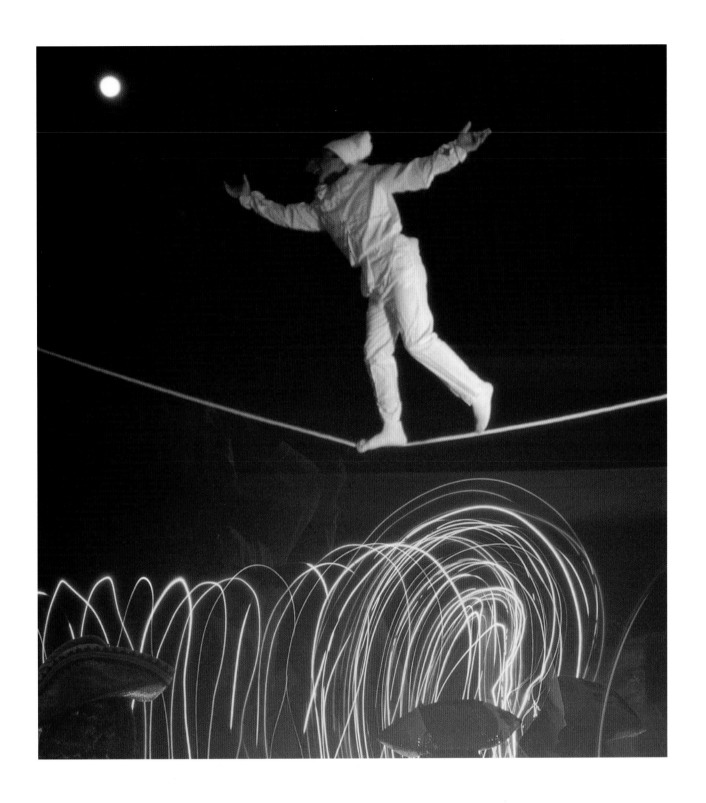

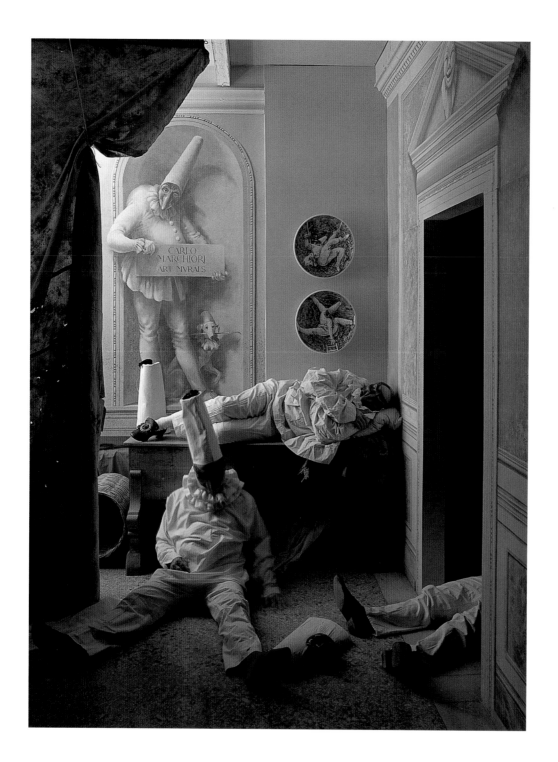

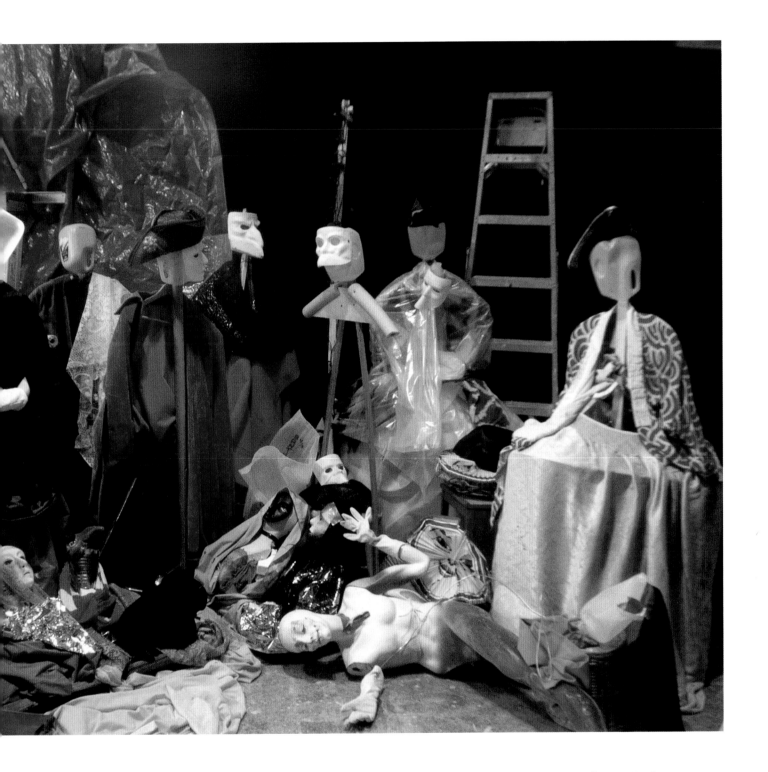

The morning after the party is Ash Wednesday. After the excesses of Carnival, rational reflection gives us a new perspective on our wayward abandon, the passions and the laughter. We realize it was illusions, vanities, puppets, ghosts, tinsel, and confetti. The people we met and danced with were fashion silhouettes, mere coat hangers draped in elegant artifice. Was it a strange beautiful dream, we ponder, as we sip coffee under the wisteria trellis.

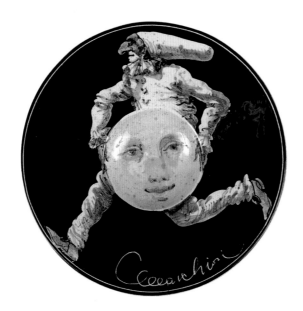

It is work, work, work, and I love, love, love it. When on a holiday, after two idle days of sightseeing, I start chewing my nails or redecorating the hotel room. I usually take along a sketchbook, paints, and brushes and end up sketching away while other tourists are taking souvenir snapshots.

Ever since I can remember, I have always been engaged in one creative project or another, just like my father, who was a Sunday jack-of-all-trades. I became familiar with wood, cement, paint, plants, animals, and the tools of each trade. Two incidents from my childhood are still engraved in my memory. In kindergarten, a nun teacher drew circle after circle on the blackboard, until all the circles turned into a bunch of grapes! In another scene, my father showed me how to build a toy chair with sticks of wood and some nails. These very first lessons left me exhilarated and launched me on what has become an endless hunt for pleasurable creative achievement.

I attended art school in Padua, at the Instituto Pietro Selvatico, with an initial trepidation, warned that an art career was a path to hard times. My mother discouraged me, my sisters showed a moderate interest in my scribbles, but my father gave me the green light. He's the one who would surprise me with the present of a watercolor set purchased at the Thursday market in Bassano.

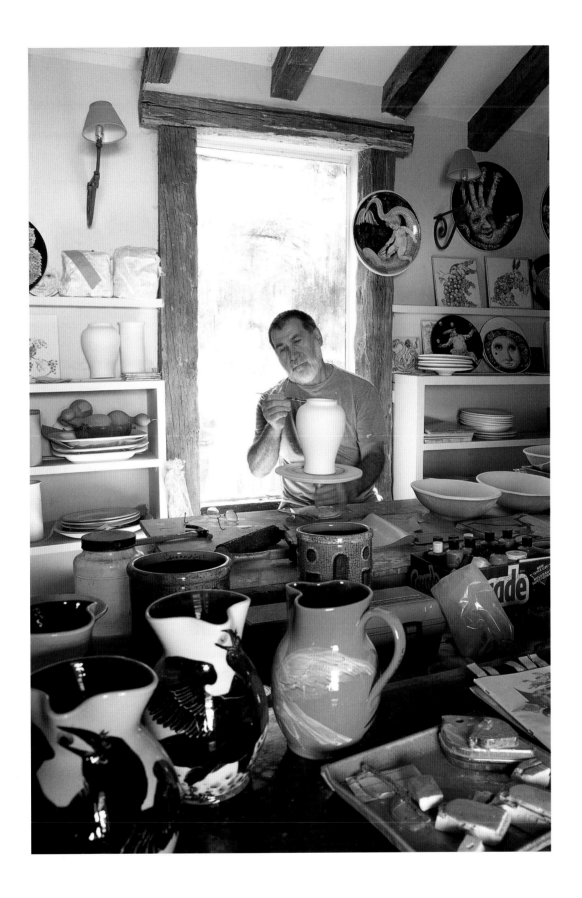

After years of working in commercial art, film animation, and editorial illustration, I eventually got into the trompe l'oeil fad, art-by-the-square-yard, for decorators, hotels, and casino designers, the sort of decorative painting specified to match color schemes and to blend with Muzak. In the past twenty years, I've managed to scatter a few murals in various hotels in Asia and the United States, but the artwork for Ca'Toga, my own, out of my head, has attracted more attention than any of these commercial projects, and has given me the most satisfaction so far. The murals in my home were done quickly, to make space and time for other commissions. Speed made them even more spontaneous, and the improbable subject matter made them more captivating than the predictable and somewhat dull projects I had been requested to do.

But the real art for me is in "resolving" a project. I usually devise an immediate shortcut to block out the monolith into the essential elements of clarity, logic, visual impact, and depth. I use live models for figures when possible. Otherwise I simply draw figures out of my head. I improvise, always with much economy and aiming well so not to miss the point, the theme of the work. Decorations are fine, but must hang on a solid structure. Proportion, composition, and only the essential details are considered in order to avoid cluttered themes and colorful but messy confusion. I plan shapes and figures on paper patterns and transfer them onto the canvas, so that the result is clear and luminous.

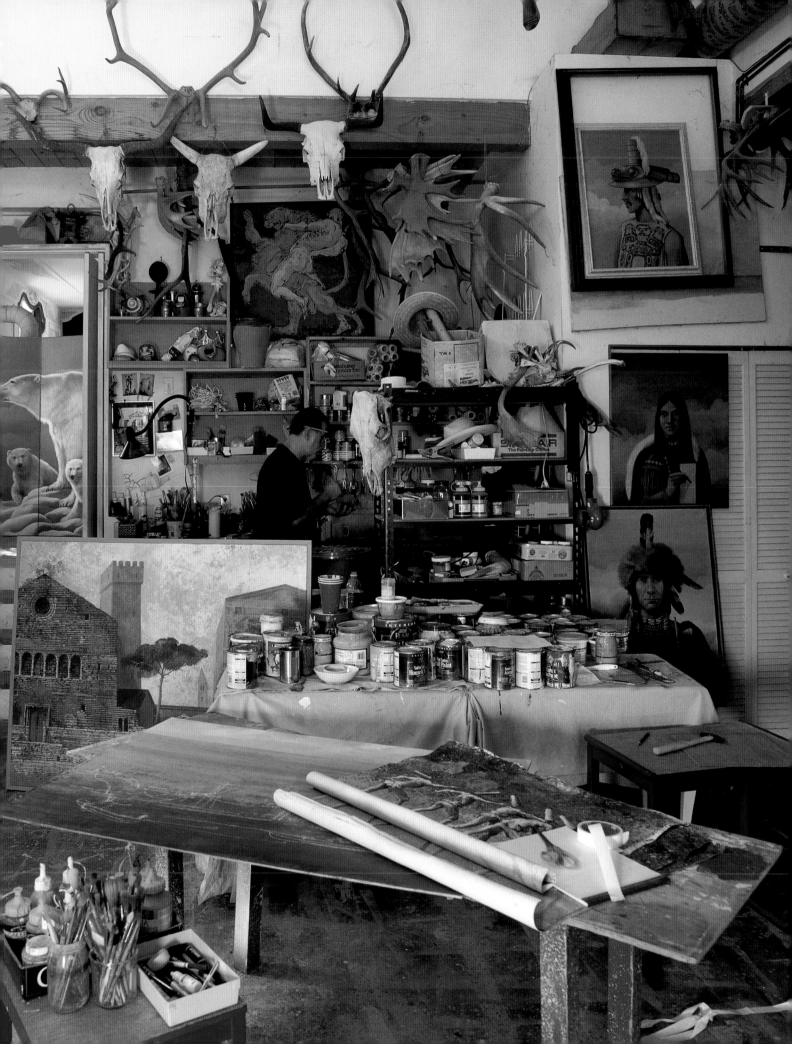

The colors I use are the palette of Renaissance frescoes—earth tones, terracotta, ochres—blended and hazed into an atmospheric wholeness. Except in bold works, I avoid bright chemical colors that are impossible to harmonize. Latex house paint crept into my acrylic medium years ago, and even with these paints, I get a remarkable result, to my clients' bewildered surprise. House paint gives a flat chalky look, very similar to ancient fresco technique. Real fresco painting, which I learned and practiced at art school, involves an elaborate step-by-step process of painting on applied-fresh-daily mortar on masonry walls. This process would be far too slow and time-consuming for my schedule and my limited patience.

This great quality of mine, my impatience, makes me productive in ceramic paintings, watercolors, and easel paintings. I decorate furniture with delight-to-the-eye inventions: the shortcut is impatience, demanding that I render the idea, the concept, immediately.

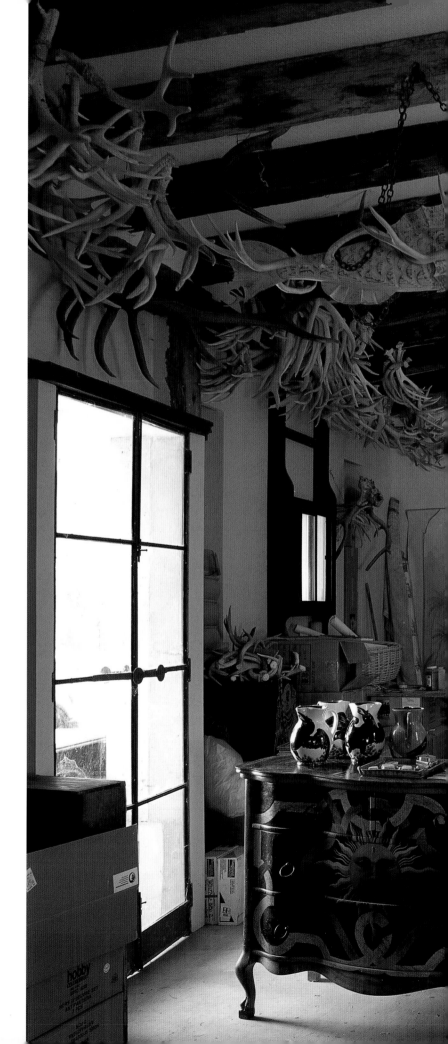

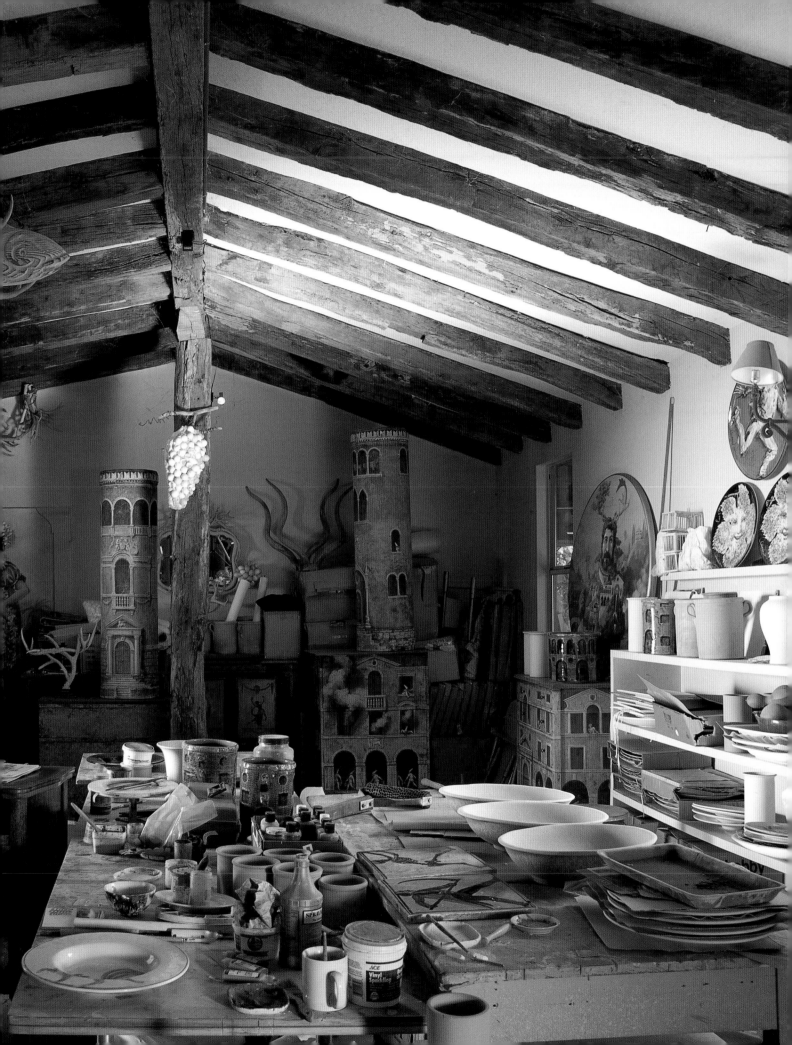

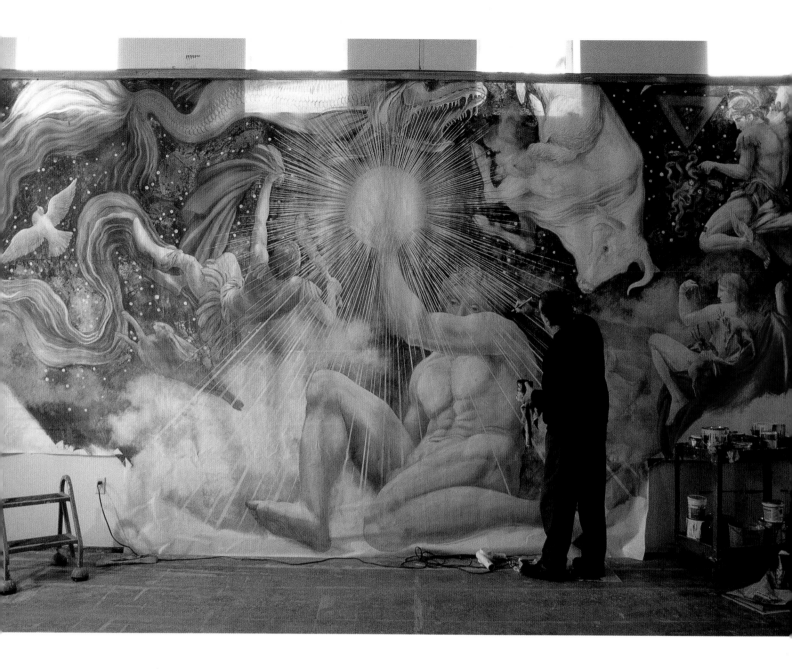

The practical solution to decorating a ceiling and avoiding the inevitable sore neck is to paint on canvas. For the ceiling at my gallery, I taped fifty-two-inch-wide strips of canvas together, one after the other, as I was painting along. Starting with the allegorical figure of Day, it took four months to reach the Night, forty feet later on this painting journey. Working from a movable scaffold, three assistants installed the mural with strong adhesive, all elated in their Michelangelo act. The endpapers show the complete mural.

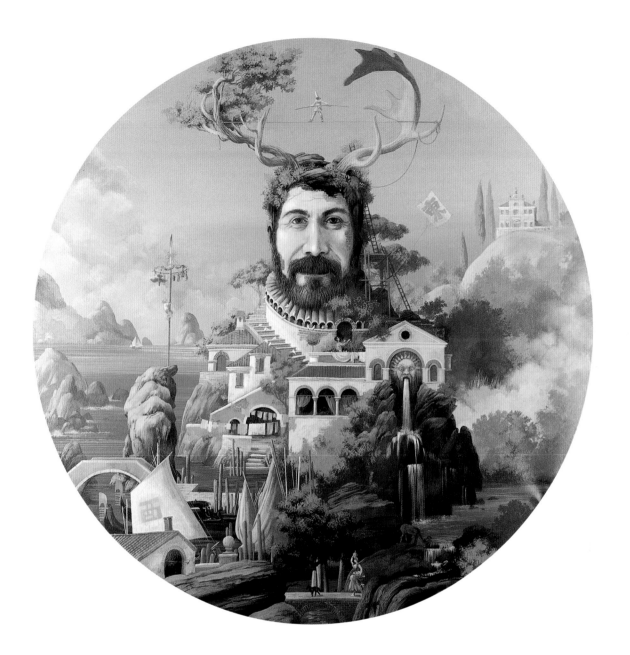

The round self-portrait I did a few years back illustrates the greedy euphoria of my wild imagination, where all is possible, all represented, all achieved by the flight of fantasy.

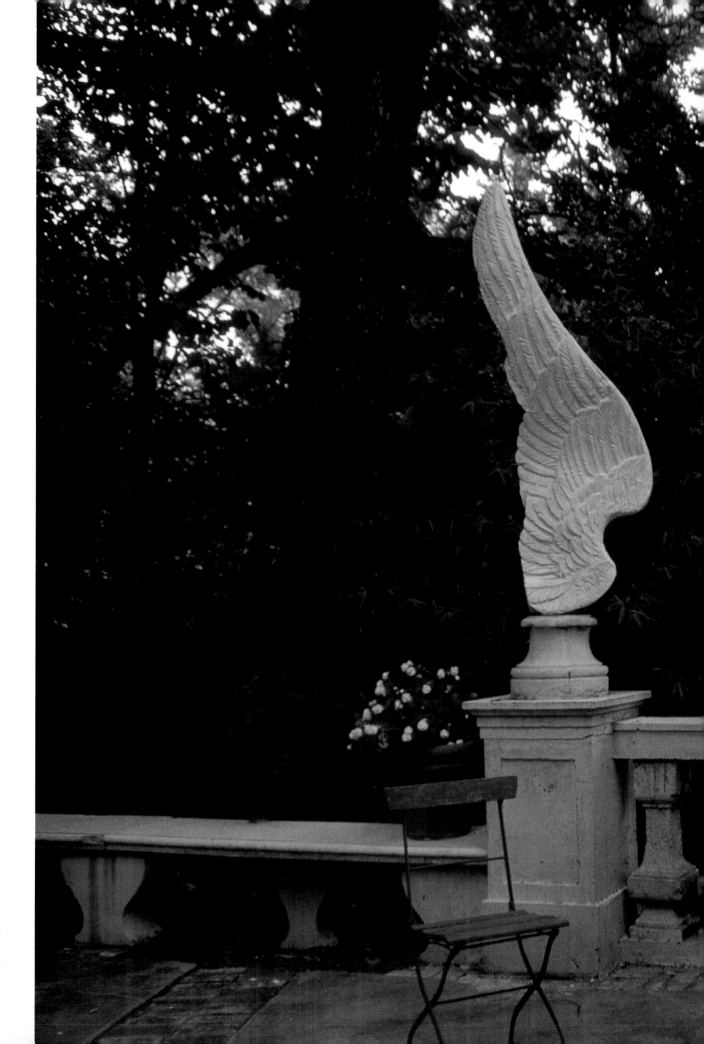

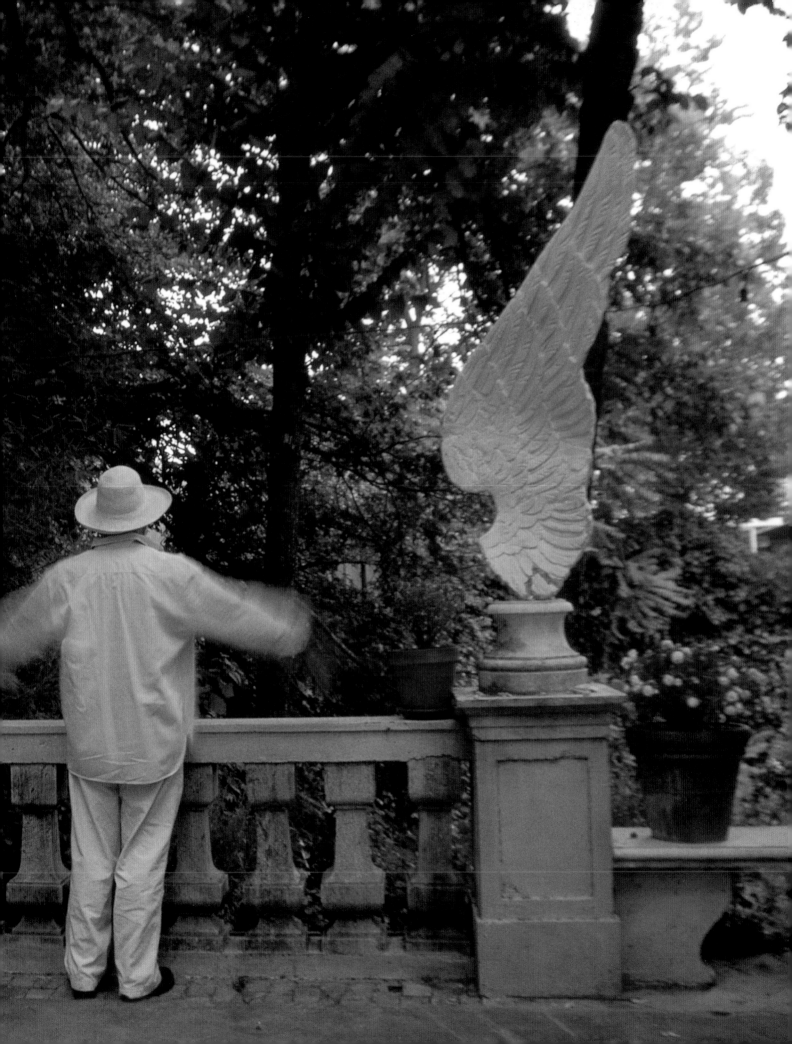

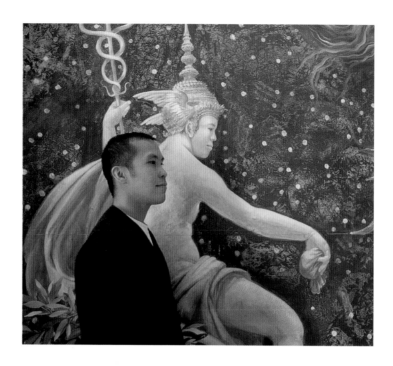

Tony Banthutham, who comes from Bangkok, Thailand, is my companion and partner in managing and coordinating my art projects. I painted his likeness in the role of a Thai-helmeted Mercury on the ceiling of the Ca'Toga Galleria d' Arte. This gallery, which is a separate entity from Villa Ca'Toga, was Tony's idea: he put the bug in my ear some time ago. The gallery was built in 1998 in downtown Calistoga in a picturesque setting on the banks of the Napa River. The building is a simple structure, designed to resemble a barrel-vaulted chapel of Renaissance proportions. Special attention was given to the entrance doorway, which is done in classic Palladian order. I myself framed it, molded it, and poured it in stone-finish white cement. I also poured the floor, an accomplishment in custom-designed terrazzo, then polished it with the help of my assistant, Juan Barrera. The ceiling is a glorious mural of the Ptolemaic constellation system, inspired by a famous fresco at Villa Caprarola near Rome. It was painted on strips of canvas and later installed onto the barrel vault.

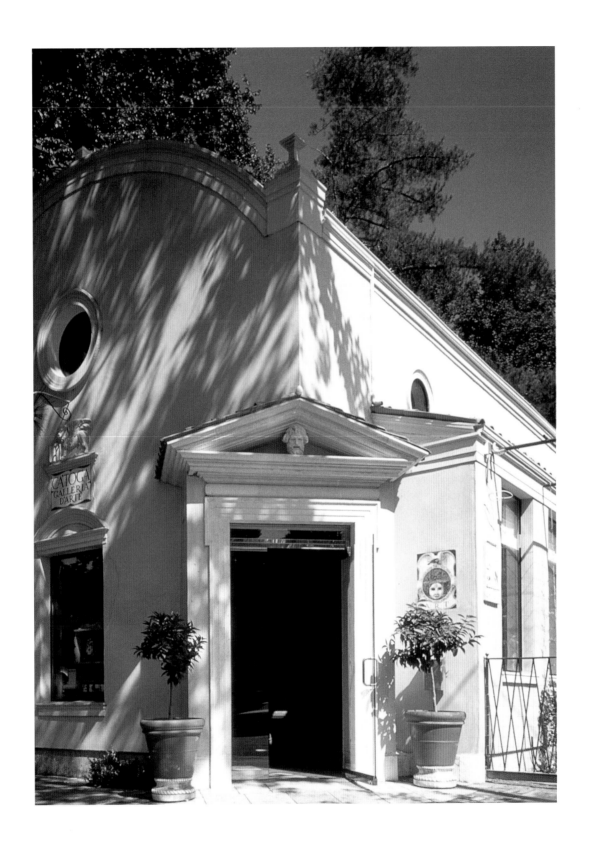

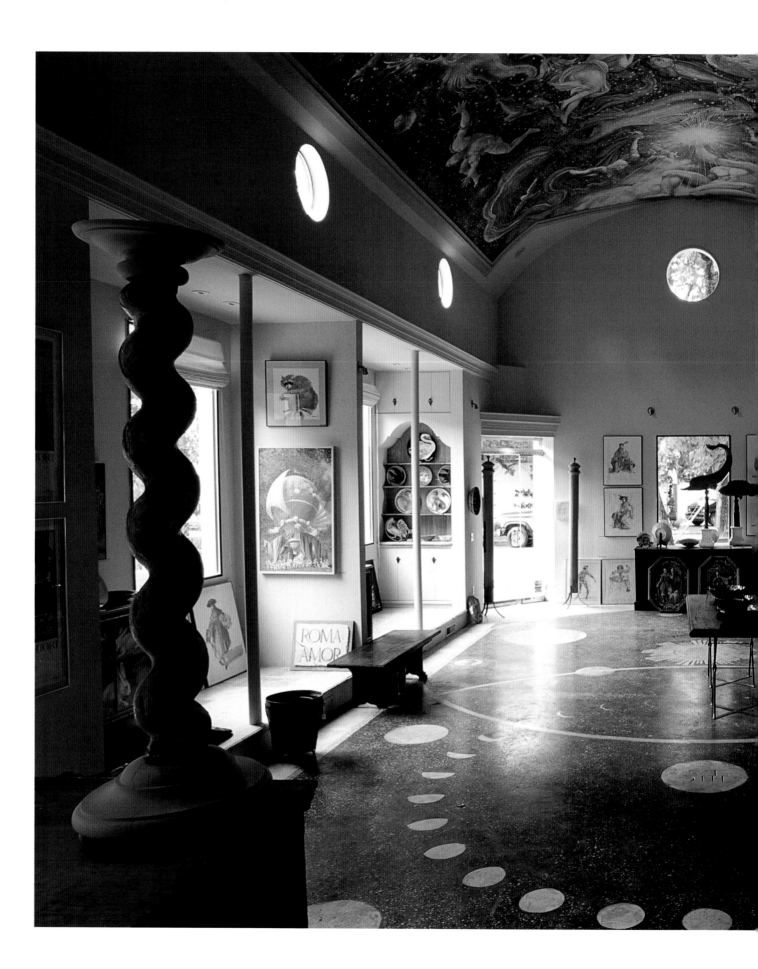

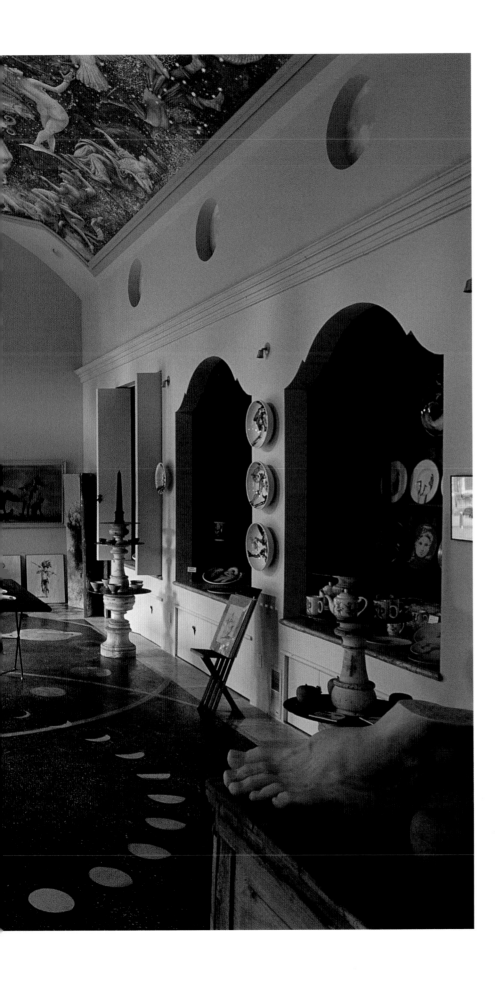

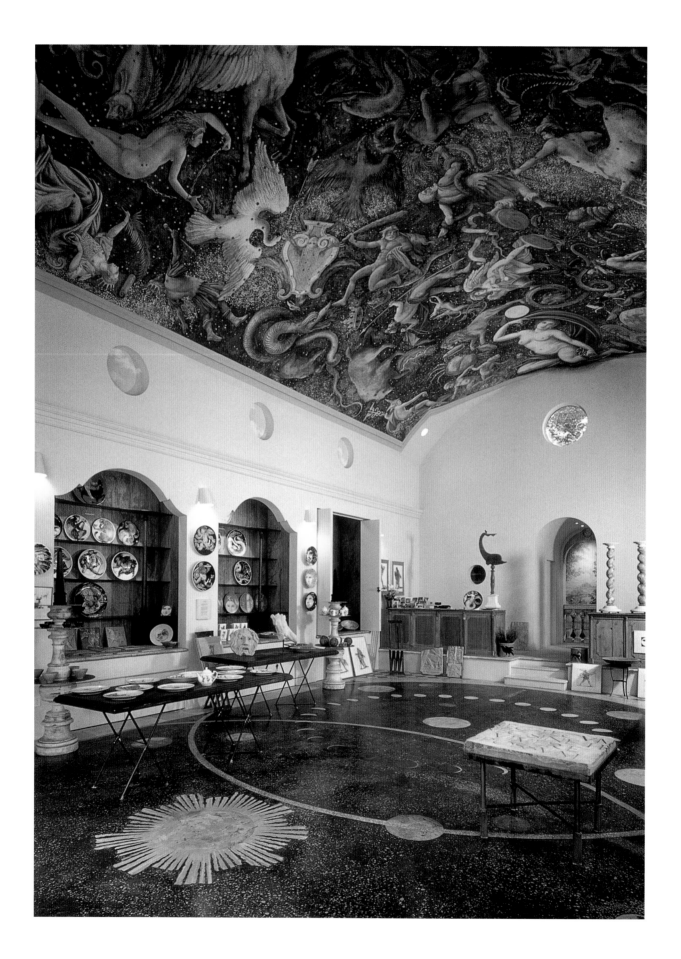

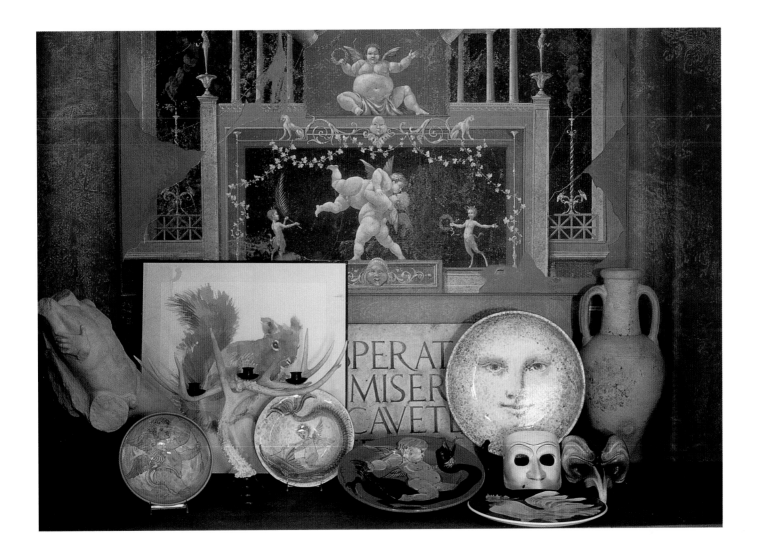

Except for a few antiques from Southeast Asia, the gallery exhibits my own work, exclusively. This keeps me busy in the constant production of painted ceramic dishes, watercolors, acrylic paintings, decorated furniture, stone plaques, and several series of porcelain dishes of limited edition. We also produce postcards, stationery, posters, and *giclée* reproductions of some of my most important paintings. The gallery has become a "discovery" destination in the Napa Valley, along with the valley's excellent restaurants and wineries.

Visit the Ca'Toga Galleria D' Arte at 1206 Cedar Street, Calistoga, California 94515; Phone: (707) 942-3900; Fax: (707) 942-3939; Website: www.catoga.com; Hours: 11 A.M. to 6 P.M., Thursday through Monday (closed Tuesday and Wednesday). The Galleria D' Arte also takes reservations for the special tours of Ca'Toga, which are offered weekly from May to October, on Saturdays only, at 11 A.M.

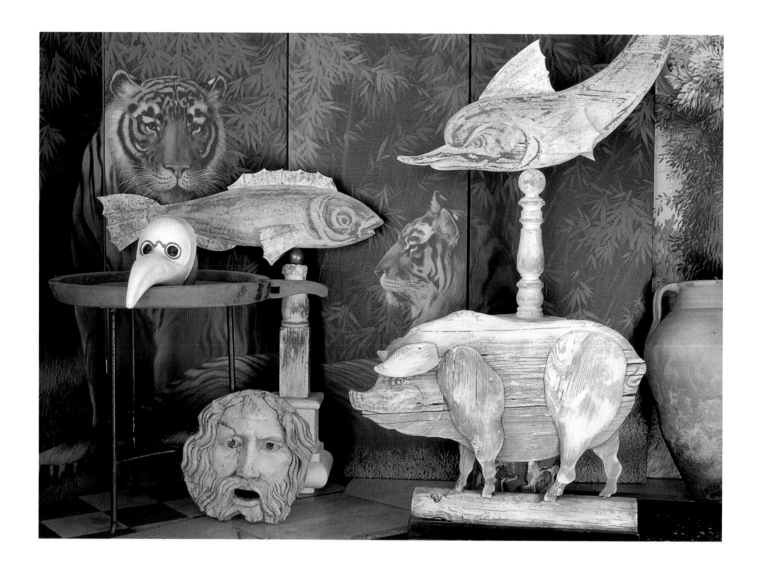

(above) Wooden sculptures of a pig, a fish, and a dolphin, made with old redwood planks to resemble folk weathervanes; a stone-finished mask of a Roman river god; a papier-mâché Venetian mask; an antique wooden tray turned into a side table; and an amphora from Tunisia.

(right top) The three small dishes are part of a ten-piece series of Pulcinella and Carnival vignettes. The six larger ones are part of a series of twelve-inch porcelain dishes entitled *Pulcinella Courting the Moon.* (right bottom) One-of-a-kind ceramic plates on the subject of *Acqua alta a Venezia* (High tide in Venice).

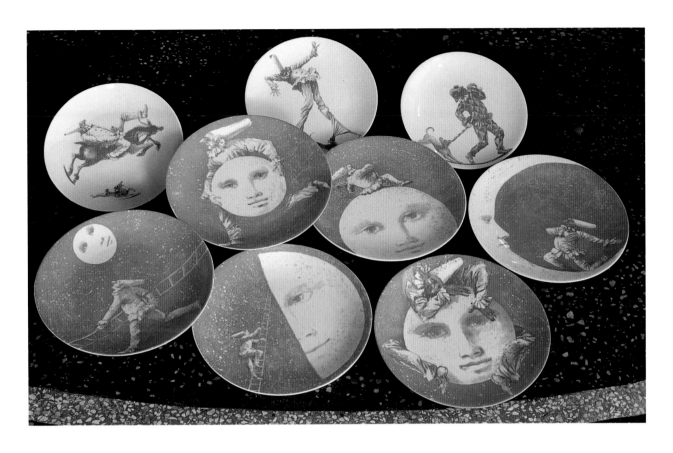

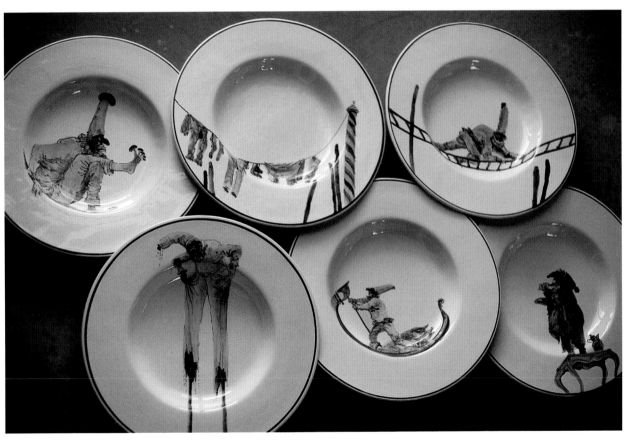

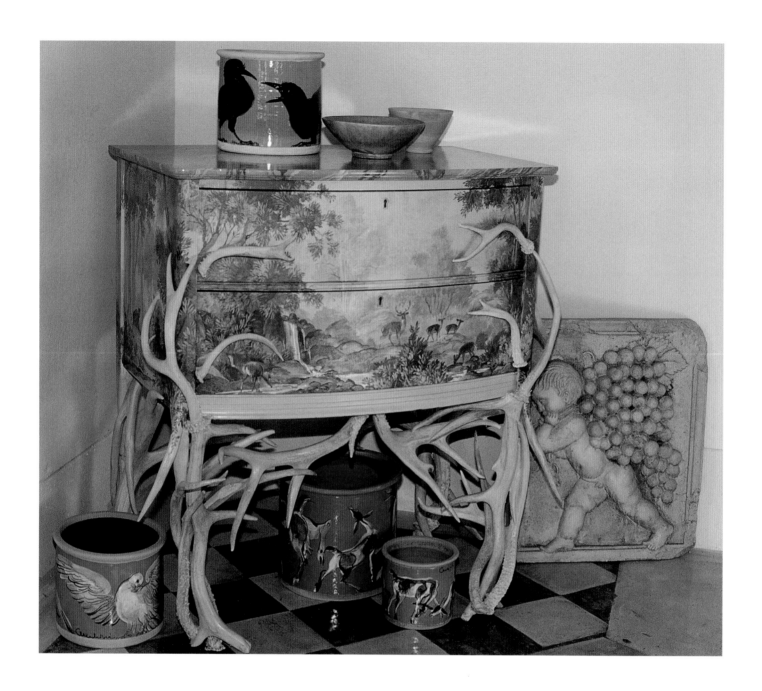

(above) An old cabinet was transformed into a unique creation with deer antlers, faux marble top, and forest greenery painted on three sides. The *putto* carrying grapes is a stone-finished plaque, a garden ornament. Cylindrical clay pots decorated in animal subjects are one-of-a-kind pieces. Bowls on top of the cabinet are restored fifteenth- and sixteenth-century Thai ware.

(right) A stone-finished slab with the Latin inscription "I cannot live with or without you" has been turned into a coffee table with a rusted metal base. Venetian papier-mâché masks and a ceramic vase, bowl, and platter are next to a deer antler candelabra. In the background are posters and watercolors.

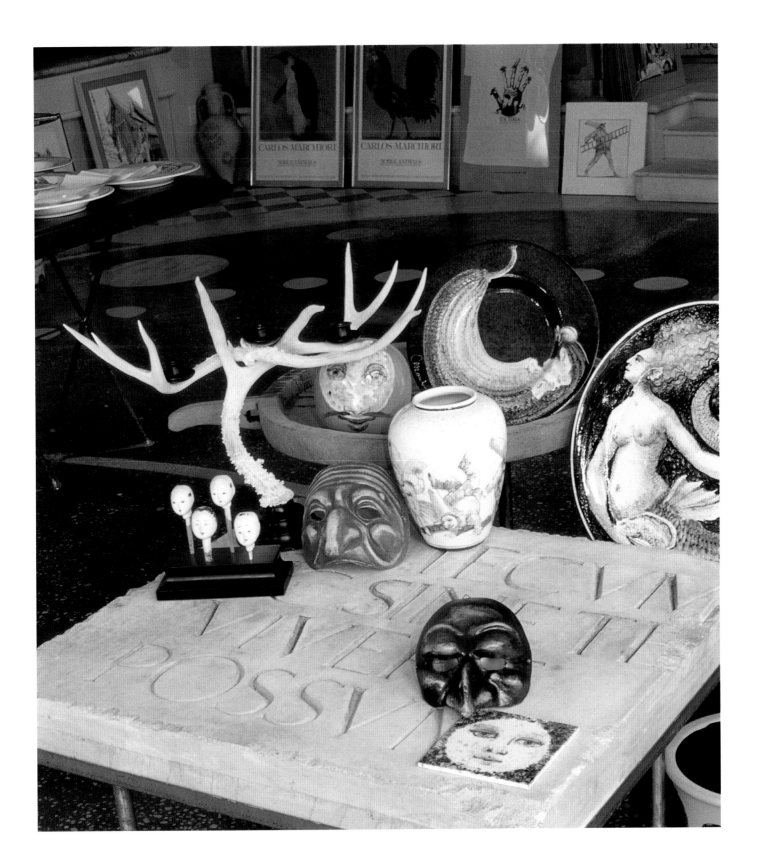

PHOTO CREDITS

Lance Austin
Pages 11, 180–81, and 182.

Tony Banthutham
Pages 2–3, 6–7, 104, 107, 174, 183,
184, 185, 186, and 187.

Bruce Fleming
Pages 17, 18, 22, 24–5, 28–9, 30, 32–3,
34 (right), 35, 36, 37, 38, 39 (top), 40,
42–3, 44, 45, 46–7, 48–9, 50, 51, 54–5,
56, 57, 58–9, 60, 63, 64, 66, 68–9, 71,
72–3, 74–5, 76–7, 78, 79, 80–1, 82–3,
86, 88–9, 91, 94, 95, 97, 115, 116–17,
134, 136, 137, 148, 149, 150, 151, 152,
153, 156, 157, 158, 159, 160 (top), 163,
164, 166, 168, 169, 170, 171, 172–73,
and 175.

Carlo Marchiori
Front cover and pages 4–5, 8–9, 10,
12, 13, 15, 16, 19, 23, 26, 31, 34 (left),
39 (bottom), 41, 52, 53, 61, 62, 65, 67,
70, 84–5, 87, 90, 92–3, 96, 98, 99,
100–01, 102, 103, 105, 106, 108–9,
110, 111, 112–13, 114, 118, 119, 120,
121, 122–23, 124, 125, 126, 127, 128,
129, 130–31, 132, 133, 135, 138, 139,
140–41, 142–43, 144–45, 146–47, 154,
155, 160 (bottom), 161, 162, 165, 167,
176–77, 178, 188–89, and 192.

Stephen A. Welsch
Endpapers and pages 1 and 179.

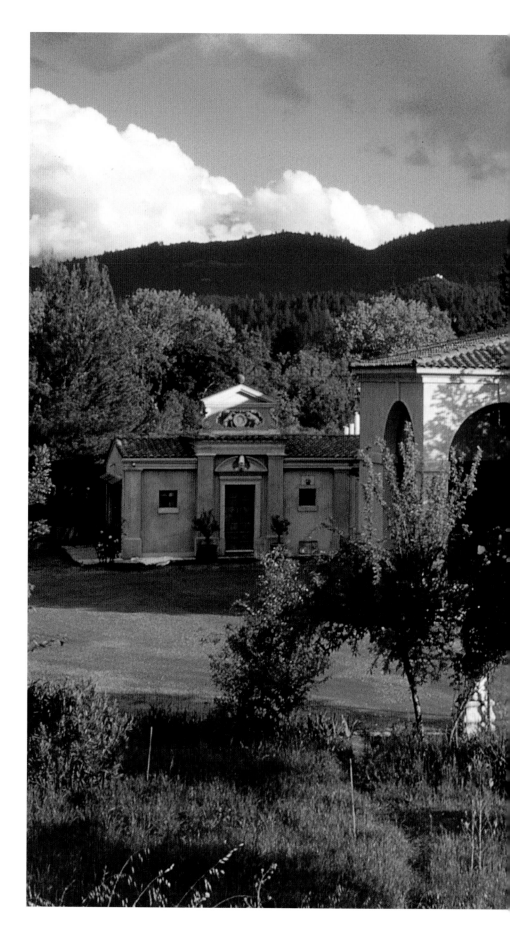

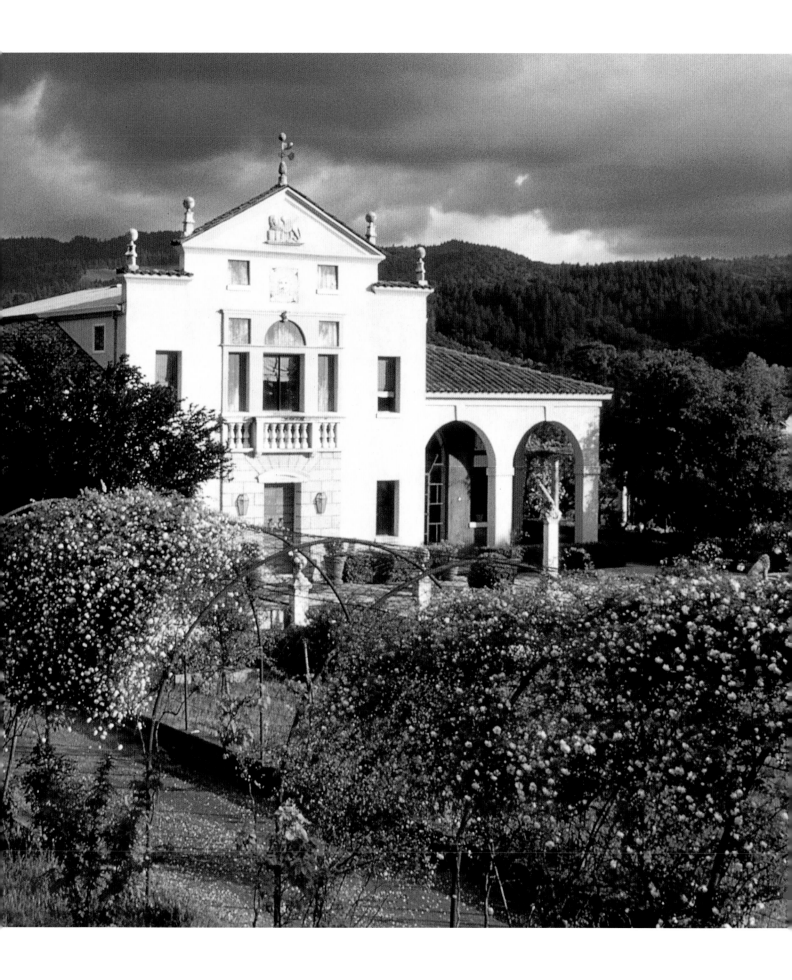

To the memory of my parents, Maria and Gaetano Marchiori,
and of Clara, Zaffira, and Elena.

To my family in the Veneto, Gilda, Emma, Tarsilla,
Maria, Camillo, Annamaria, Ernesto, Michele, Roberto, and Luisa.

To my beloved companion, Tony Banthutham.

And to my soul big brother, Alan de la Vigne.

I thank Paul Bonacci and Lucy Schlaffer; Robert Stewart; Andrew and Gina Batey; Martin and Valente Cuenca; Clint Hulse; Naoko Dalla Valle; Umberto Favret; Dick and Luisiana Gale; Ron Goldin; Jim Hanson; Peter and Pat Lenz; Amelia Lopez; Bev More; Robert and Margrit Mondavi; Sally Murray; Sam Nakamura; Lance and Terri Selmin; Mario and Maria Scuro; Diane Dorrans Saeks; Ted Ward; Mario Uribe; Phil Wood; Joann Deck; Marcelle Zonta; Gary Ronko; Loretta Radey; Juan, Carlos, and Antonio Barrera; Ernie Veniegas; Jim Annis; Felipe Barragan; Peter Weatherman; Christopher and Adele Layton; Rolf and Inge Penn; Yan Garcia; Sue Strek; Vera Zaarour; Chris Short; Alberto Laguna; Jorge Ramos; Julio Mejia; Daniel Torres; Marcos Aguilar; Barbara Wider; Ron Wise; William Williams; Thomas Bartlett; Silvia Cappai; Luisa Benetello Cardoni; Flavia Michelon Puppa; John Paron; Dan Bazzoli; Dennis Watson; Dan Farris; Myrna Caratti; Carla Schmidt; Patricia Johnson; Luciano Tempo Delletravi; Carrie Domogalla; Wilhelmina Grader; Moye Stevens; Ian Moller; Patricia de Martini; Dick Ryerson; Felix Santiago; Jackie Pometta; and Vickie Auerbach.

And finally, special thanks to Julie Bennett, Nancy Austin, and Jackie Wan for their great help on the production of this book.

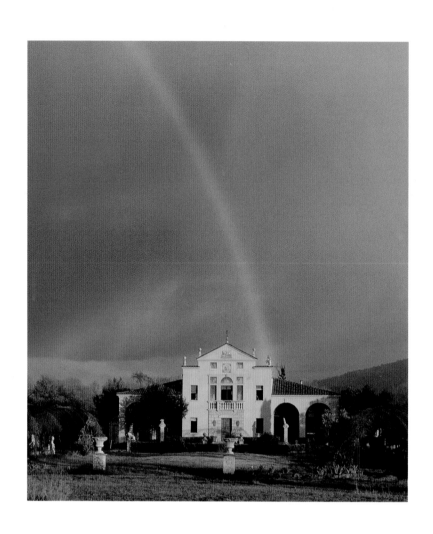